Disclaimer

I'm no lawyer; I am a filmmaker. So I cannot advise you what to do legally.
Any actions you take as a result of what is written in this book are your
own responsibility. Consider the advice herein to be of a philosophical nature,
not instructions as to how you should proceed with your career,
especially with respect to the law.

Copyright © 2008 by Tim Maloney

All rights reserved.

Published in the United States by Watson-Guptill Publications,
an imprint of the Crown Publishing Group,
a division of Random House, Inc., New York

www.crownpublishing.com
www.watsonguptill.com

Library of Congress Control Number: 2008935967

ISBN 978-0-8230-9921-4

Executive Editor: Candace Raney
Editor: Stephen Saffel
Production Manager: Philip Leung
Designer: Renata Dmytrowski/RD Design

1 2 3 4 5 6 7 8 / 16 15 14 13 12 11 10 9

First Edition
Printed in China

Get Animated!

Creating PROFESSIONAL CARTOON ANIMATION on your HOME COMPUTER

Tim Maloney

Watson-Guptill Publications
NEW YORK

Contents

For Hae-Jin

Preface

In 2002, Bright Red Rocket released what we believe was the first independent DVD compilation of animated shorts: *God Hates Cartoons*. Many of the pieces were racy, some were rough, but all had clear vision and an exciting new take on the medium. We had no idea how well this bizarre disc would sell.

God Hates Cartoons did surprisingly well, and we began to search for material for a follow-up disc. Yet the same issues plagued us time and time again, as artists and animators produced work that lacked technical excellence. These cartoons would work on the Internet but not on DVD, television, or the big screen—they were *too* rough and were drawn in a nonstandard aspect ratio.

My training is in film and video, subjects I currently teach at a university, so the technical specifications of high-quality images are punishingly familiar to me. What these cartoonists clearly needed was information. What started as a small pamphlet explaining a few key techniques has evolved into this book.

There are many animation books on the market, and there's a great deal of information on the Internet—much of it suspect at best. There is a need to clear up nagging technical misunderstandings and provide basic knowledge of how computers and video technology can be used to the greatest potential and yield the highest quality. This guide is for those who have personal computers and truly yearn to create top-notch animation. This isn't a primer on how to animate—for that, consult the list of materials in the back of this book. What this book will teach you is how to use the latest tools to apply techniques developed by past masters. Adapting those techniques can be difficult because of the proliferation of software packages and computing devices from which you must choose. Since we can't give each reader an entire computing system, preloaded with all the software you'll need, we'll do the next best thing—show you how to use what you already have at hand to produce the best work you can. We've also included a DVD chock-full of tutorials and additional resources.

There is a lot of technical information here. That's because you need to understand what's going on in the computer to make the best choices for your work. This book is about concepts, and although there are some step-by-step illustrations, the major goal is to give you an understanding that transcends particular tools and allows you to work well with any new software or hardware you encounter.

What it won't teach you is discipline—you need to develop that on your own. To animate you have to have patience, determination, and tenacity. Too many wild-eyed neophytes rush into the world of cartoons, few of them willing to shed the necessary blood, sweat, and tears. Not to mention the lazy wannabes, looking for the "hilarity" filter in the application menu, and the hot-shots convinced that the gin-soaked life of super-stardom lies just around the corner if only they can bash out a few quick walk cycles.

The road to Cartoon Hell is paved with their skulls.

As for you, I hope your computer is in good shape. You'll need it to make some funny pictures.

The Basics

What Computers Can't Do

Computers cannot create original artwork—you'll have to do that, whether with pen and paper or a graphics tablet. Similarly, they cannot place your characters where they need to be, nor can they create key poses—the extremes of action in a given movement.

Sadly, computers aren't at all good at inbetweening, either. This is when you create the intermediate drawings between key poses and determine the movement of figures. Computers don't have the organic components that make motions look natural—they have no finesse or style.

Yes, but what about 3DCG (three-dimensional computer graphics) programs?

Computers can, indeed, mimic the physics and math we've invented to describe the world, but cartoons aren't made by replicating *exactly* what we see in real life. The artist needs to exaggerate movements so they are more clear and vivid. Have you ever noticed that even in the most "realistic" drama, people do and say things they would *never* do or say in real life? The acting is close to "reality," but the dialogue is always better said, actions are better performed, the locations better lit, the people better dressed... The results are designed to be what we would like them to be, rather than what they actually are.

Similarly, computers are far too literal, and animators must compensate. Even at the major studios, where they develop advanced physics calculations and specialized math to govern the movement of 3D objects, they end up including manual controls so that character movements can be tweaked by hand.

What Computers Can Do

Computers are good for lots of things, which is reassuring, since otherwise this book wouldn't exist.

Cartoons that would normally take a single animator six months now take only a matter of weeks. The computer lightens the load on a great number of tasks, including finishing the art (inking), coloring it (painting), moving backgrounds, incorporating "camera" movements, compositing, creating double-exposures, adding effects, pencil testing, titles, editing, sound, and outputting the animation to various formats.

All of these tasks can be accomplished by you, at home. In addition, the computer makes it easier to develop a wide range of animation styles, whether it's stop-motion, limited animation, full animation, or 3DCG animation. Before the advent of the personal computer, most of these functions could *not* be done at home, and many of them involved hiring other people to do much of the work or renting expensive facilities.

At the same time, there's no reason to force the computer into your workflow. Computers are like very complicated electronic pencils. They are just tools, and the degree to which you use yours will be a reflection of your own process. If you draw better on the computer, use it.

If you draw better on paper, use that, and let the computer help you with other tasks.

Plus there are tasks for which computers are well suited and cost effective. Stop-motion is improved a hundredfold when you can instantaneously preview your animation, instead of waiting for it to come back from the film lab. And cutout animation—like *South Park*—is well within the reach of just about anyone who's willing to spend a few hours making transparency channels in Photoshop. Using a laptop as your camera and editing machine could save you hundreds of dollars and hours.

This book is platform-agnostic. It's possible to do high-quality work on whatever you have at the moment, because quality isn't as reliant on computing power as it is on pure creativity and technical know-how.

Currently there are three major operating system categories to which most computers belong.

Choosing the Right Computer

Linux

This is a free computer operating system known for its flexibility and extensibility. Typically Linux is used in big studios like DreamWorks, Pixar, and Sony. Of course, a major studio can afford to maintain a staff of people whose sole job is to make sure the operating system and

its applications are performing properly. The staff invents plug-ins, controls, and minor tweaks to software—often on the spot. The credits for Pixar's *The Incredibles* listed twelve people who were responsible just for the documentation of their proprietary systems—not to mention the dozens who were writing software on a daily basis.

But it's not necessary to have such a staff. Open-source software—software that is free to distribute and modify—flourishes in the Linux community. If you have an Internet connection you can be in touch with not only the developers on each software project but other researchers and hobbyists who are improving the packages daily. The speed of innovation and development on open-source projects can be unbelievably fast and just as reliable. Consider that 90 percent of the world's Web servers run on the free, open-source Apache software—it's still considered one of the most flexible and robust applications around.

Unfortunately, because there's so much flexibility, it can be tough to find a "flavor" of Linux that works for you. Linux offers the greatest amount of free software of any platform, but that includes the most junk, too. So Linux is for those who like to tweak their computers and get the maximum flexibility and power out of their system.

Windows

Windows, produced by the Microsoft Corporation, is found preinstalled on most home and corporate computers. It's an old operating system, but not a beloved one, nor a particularly stable one. There are lots of applications available for

3

LINUX OPEN-SOURCE SOFTWARE

There are dozens of free distributions of Linux. Try these sites to find them:

▸ www.linux.org
▸ distrowatch.com

In addition, these Linux "flavors" seem to be the most popular at the moment:

▸ Ubuntu – www.ubuntu.com
▸ Debian – www.debian.org
▸ Mandriva – www.mandriva.org
▸ Slackware – www.slackware.com

▸ Knoppix – www.knoppix.org
▸ Fedora – www.fedoraproject.org

You will want to download the version that works with your computer processor. For most PCs this is the "x86" version. If you have an older (non-Intel) Mac, this will be the "PPC" version. Some distributions are even modified for the AMD chipset. Be sure you know what you have before downloading a whole 700MB file. Or order it from OS Disc (www.osdisc.com) for only a couple bucks.

Many Linux distributions offer a "LiveCD." This is a version of the operating system and bundled tools all on a single disc. You can boot your computer off that disc and test the OS before you bother installing it. The Garbure project (www.garbure.org) offers a Knoppix LiveCD with animation tools bundled together. You may wish to try their "Ratatouille" distribution.

You can access these links directly from the Additional Content section of the accompanying DVD.

Windows, but, as with Linux, it takes some work to weed out which ones work well and which ones are a hindrance.

Even though few studios use Windows, this shouldn't be a deterrent—you don't need a new operating system to animate well. Keep using the tools you find most comfortable and familiar. In fact, software and hardware manufacturers have made a major push toward "multimedia" and "Web 2.0" (a silly name for very complicated websites that use databases and video), so it's likely that an out-of-the-box PC installed with Windows has free software perfectly suitable for professional results.

If not, then there are dozens of freeware and shareware solutions that will work well. Most of the major open-source projects attempt Windows binaries, so a great deal of that software will be available for you, too.

Macintosh

The Mac is solid, stable, and beloved by some, but it doesn't have as many software offerings as either Windows or Linux. A Macintosh computer does come preinstalled with many of the applications needed to make movies, however, and the trick is to use them to achieve the highest quality and best-looking end product.

Many of these free apps, however, are designed to produce dinky website movies and poorly made YouTube presentations. While video websites are brilliant for making certain your creations are *seen*, the Web doesn't demand much in terms of quality, and the presets on many software applications are set to a low-quality default that works for the Internet, but not so well for high-quality video.

So while the Mac may give you a great deal that you need, it's essential to learn how to use it!

Which Is Best?

Many a computer owner has engaged in the pathetic "flame war" over which operating system is the best. In particular, the Mac vs. PC debate has been the most heated.

The ultimate answer is simple: None of them are any good.

They are all prone to crash and are fallible in many frustrating ways. So rather than worry about which is the "best," it's better to just start working. The pursuit of the perfect computer can overshadow actually *doing* anything with it.

It's like the writer who quits his day job and spends all day staring at the word processor. He cannot work and decides it must be because the tools aren't there. He needs a new laptop and an Internet connection so his time at the coffee shop will be well spent. Soon he's in the coffee shop, where he needs a new cell phone so he can be contacted while he's writing. Except the coffee shop is distracting, too, and so is that cell phone. What's needed is a cabin in the woods, with nothing to disturb him, because he's a real writer, going to write some *writerly* writings.

Animators do this, too, worrying about the right clock speed, bus speed, hard drives, output, software, and whether they have a cool case for their machines. If you're a tinkerer, by all means, tinker away. But a writer writes, and a cartoonist makes cartoons.

KEY WINDOWS RESOURCES

Free and shareware Windows programs are so plentiful it is almost impossible to find anything. Try these resources to get started:

▶ www.opensourcewindows.org
▶ www.tucows.com
▶ www.download.com
▶ www.completelyfreesoftware.com

It may also work best to target the software you're looking for. Sharpen your search engine skills. Typing in "free windows stop-motion software" or "blender 3D windows" will get better results. Unfortunately, including the word *animation* will invariably bring up Web animation tools, most of which are disappointing for our work.

KEY MAC RESOURCES

As with Windows programs, search engine skills will probably give you more direct results than sifting through general free/shareware sites. But these are a few that may yield better results.

▶ guide.apple.com
▶ www.versiontracker.com/macosx/
▶ www.pure-mac.com

You can access these links directly from the Additional Content section of the accompanying DVD.

Creating Out of Thin Air

If you can visualize it, you can create it. You don't have to rely on expensive props or locations, and you don't have to worry about the sun being in the right position or whether the craft services van is serving your favorite donut. You control every aspect of a cartoon. So what are you going to make?

The act of coming up with ideas is sometimes called "ideation." Not everyone has the kind of mind that develops stories easily and quickly. Thus, there are lots of exercises designed to help generate the right kind of material—and the right frame of mind—needed to create exciting work.

Notebooks and Journals

Interesting things happen all the time, but because we have more pressing priorities—like catching the bus, taking a phone call, or changing lanes in traffic—most people forget the incidents and insights of the day. Carrying around a notebook or journal may seem cumbersome at first, but it's the only way to capture ideas as they strike.

Time spent standing in line at the post office, waiting for food, or queuing for the train could be spent writing, sketching, and observing the world around us. Watch the way that people act and move, notice how buildings are put together, and consider the texture of objects. Write it *all* down—it's not like anyone is going to check your work. Become accustomed to gathering observations that may later figure into your work.

Many writers keep an "idea file." Maybe this is just a

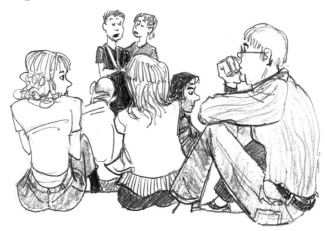

These unsuspecting folks became the subject of a sketch while waiting in line for a movie.

stack of papers in a folder, each of which may hold a germ of something greater—a character, a storyline, a terrific name, or whatever strikes a chord. Collect newspaper and magazine clippings, including the advertisements. If carry-

ing a notebook doesn't appeal, and scribbling on scraps of paper does, the idea file may be your best way to organize raw material.

History, myths, childhood, and family stories all make good material for the idea file. Don't worry about whether it would work as a cartoon—at this stage, it's too early to filter. Sometimes, the sudden juxtaposition of two pieces of unrelated trivia will spark a random connection that fans the flame of an interesting idea. Once you've accumulated a supply of raw data, organize and reorganize it to begin the process of mining for stories.

Surrealist Strategies

Surrealism was an art movement of the 1930s that emphasized the logic (or illogic) and texture of dreams. Surrealists were interested in creating without observing the boundaries of reason or propriety—they wanted to be free from any restraints whatsoever, especially the limits we place on our own thinking. Because they considered surrealism a philosophical movement, they developed their own strategies to liberate the imagination.

Above Here are four pieces derived from the same dream material.

Opposite Artist Jim Woodring (www.jimwoodring.com) works extensively with images found in his own dreams. This is an excerpt from his actual dream journal.

① The Dream Notebook

Freud's book *The Interpretation of Dreams* suggested that the strange combination of symbols in dreams originated in deep, dark emotions that could not be expressed during the waking hours. Just as the surrealists drew inspiration and imagery from their dreams, you have the same inexhaustible supply of imagery. Keep a notebook handy at your bedside, and immediately write down everything you can remember when you wake. Perhaps keep a small tape recorder at your bedside, and dictate the dreams so you don't lose anything. If writing doesn't suit you, draw quick sketches of the things you have "seen" in the mind's eye.

MAY 17 2008 ~ WENT TO BED IN AN UNUSUALLY LIGHT AND ALMOST EUPHORIC MOOD... A STICKY MOOD! WASN'T SLEEPY AND INTENDED TO LIE IN BED AND THINK, A RARE LUXURY NOWADAYS, BUT I WENT UNDER ALMOST IMMEDIATELY.

AFTER SOME GARBLED DREAMS INVOLVING BEING OUTRAGEOUSLY OVERCHARGED FOR TWO 4"X5" FILM POSITIVES (#3000!) I FOUND MYSELF IN THE LOBBY OF THE HOTEL WITH THE TWO STAIRCASES AND THE BIG EYEHOLE THING. WAS AWAKE IN THE DREAM AND TREMENDOUSLY EXCITED, AS IF I HAD BEEN TOLD I WOULD SOON SEE GOD FACE-TO-FACE.

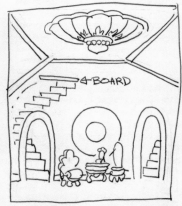

I CHOSE THE STAIRCASE ON THE LEFT AND WENT UP IT TO THE AREA BEHIND THE FACADE. I WAS INCREDIBLY EXCITED. THEN I FOUND MY PROGRESS BLOCKED BY A WOODEN BARRIER, THE PASSAGE WAS BOARDED UP.

I SAW THE UGLY SLAB OF INCH-THICK PLYWOOD IN GREAT DETAIL. I COULD SEE THE HAMMER DENTS AND NAIL HEADS EXACTLY AS IF THEY WERE REAL.

I WAS FRUSTRATED BUT ALSO RELIEVED, AS IF I DID NOT ACTUALLY WANT TO MAKE THIS DISCOVERY WHICH I HAVE SOOO SOUGHT AND WHICH HAS ELUDED ME IN GOD KNOWS HOW MANY THOUSANDS OF DREAMS. INSTEAD OF GOING BACK DOWN AND TRYING THE OTHER STAIRCASE I SAT DOWN WHERE I WAS TO ENJOY BEING ON THOSE STAIRS I LOVED SO MUCH AND SAW SO SELDOM

I REALIZED IT WOULD BE A MISTAKE TO TRY THE OTHER STAIRS; I HAD MADE MY CHOICE. THEN IT OCCURRED TO ME WITH A SHOCK THAT I ALWAYS, ALWAYS TOOK THE LEFT-HAND STAIRCASE WHENEVER I ENCOUNTERED THAT SETUP.

THEN I WONDERED IF I COULD CLIMB INTO THE BIG EYEHOLE-THING. I FELT A RUSH OF GUILT AND SHAME AT THE THOUGHT, AS IF I HAD BROKEN A SERIOUS TABOO; THEN A RELIGIOUS/SEXUAL ECSTACY BLOOMED IN ME.

THIS SENSATION EXPANDED INTO A HUGE, OVERWHELMING STATE OF CONSCIOUSNESS IN WHICH I REMEMBERED MANY, MANY PERMUTATIONS OF THE TWO STAIRCASES. SOME WERE FAMILIAR, SOME WERE NOT. MOST WERE NOT. THE ONES I COULD RECALL VISITING IN PAST DREAMS WERE AS WELL-KNOWN TO ME AS ROOMS

IN MY WAKING HOUSE: THE RUSSIAN ANTECHAMBER, THE LITTLE HOTEL, THE BIG HOTEL, THE THEATER, THE DILAPIDATED DREAMHOUSE IN THE FOOTHILLS, THE MAGNOLIA DREAMHOUSE, THE POOL DREAMHOUSE, THE SEX DREAMHOUSE, THE BOILER ROOM, THE WHITE HOUSE.

THE OTHERS WERE FAMILIAR WHEN I RECALLED THEM IN THAT STRANGE STATE BUT I DON'T REMEMBER THEM NOW.

I SAW CLEARLY THAT I HAD SOUGHT THAT CONFIGURATION WITHOUT SUCCESS ALL MY LIFE! AND IT SEEMED THE MOST IMPORTANT GOAL OF MY LIFE, THE PURPOSE OF LIFE.

I'VE OFTEN THOUGHT THESE STAIRS CORRESPOND TO THE IDA AND THE PINGALA, AND THE TABOO EYEHOLE THING AS THE SHUSHUMA (OR HOWEVER IT'S SPELLED).

AFTER I AWOKE AND HAD THOUGHT ABOUT IT FOR A BIT I REMEMBERED I HAD HAD ALMOST EXACTLY THE SAME DREAM —SEXUORELIGIOUS ECSTACY AND MEMORY PARADE AND ALL- IN THE 80'S WHEN I LIVED ON KIRKBY STREET IN GLENDALE.

❷ Cluster Writing

Cluster writing is a process of "automatic" writing, whereby the writer tries to set down on paper the first things that come to mind. To write with clusters, first you must decide on a single word to start.

Why not open a book at random to choose? Write that word in the center of the page, then around that word, write things it suggests.

Cluster writing takes your thought processes and gets them out on paper in a way you might not consider if you were consciously trying to write. The rational, left side of your brain is only engaged when trying to find connections between clusters. Until then, the right side, known for its impetuous nature, has free rein.

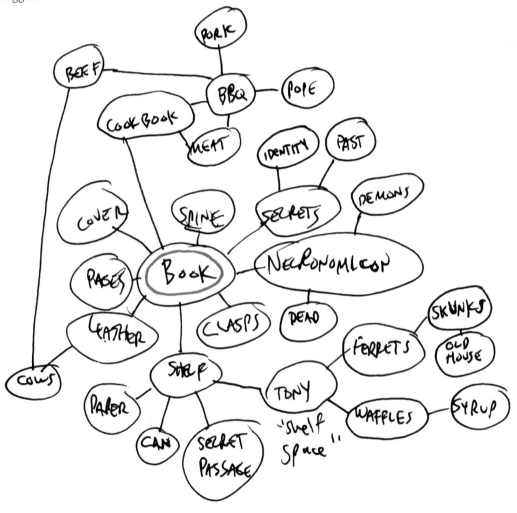

In this example of cluster writing, the word is *book*, chosen at random from a French "word a day" calendar. Around it are other words that *book* inspired: *cover, spine, Necronomicon,* etc. Next choose any one of *these* words and repeat the process. Thus, *shelf* leads to *paper, paint can, secret passage,* my friend Tony who used to complain about shelf space. Repeat as necessary, building clusters as far as they will go.

Extra sheets of paper can be taped to the edges to make more room. Soon patterns will emerge: Tony is a funny guy who cannot find shelf space to put his copy of the *Necronomicon,* the book of evil spells. He files it beside the cookbooks, and the evil spells invade the cookbook. Demonic pastries invade his apartment, intent on suffocating him in his sleep.

❸ Free Association, Random Images

The surrealists also placed a value on automatic writing—the process of writing whatever comes into your head without editing. Open a magazine and choose a picture at random. Write about it. Or just cut it out and start making a pile of appealing but perhaps disconnected images.

Or try typing random letters into the Google image search to see what comes up. One such effort revealed a picture of a stone robot, a guy holding a gun, a clownfish, fans wearing Uncle Sam outfits, and a cop at a vegetarian food store. It's a pretty slow wit that couldn't develop that into a pretty interesting cartoon.

Seemingly random images sometimes combine to form interesting ideas.

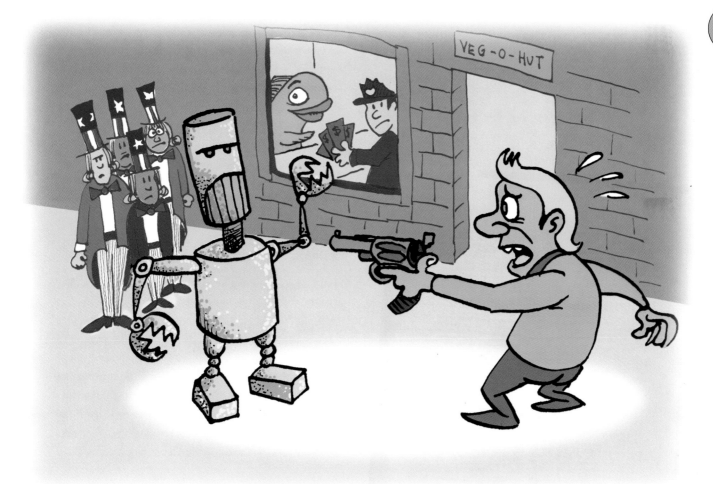

❹ Cut-Up Technique

William S. Burroughs was one of the twentieth century's most fascinating literary figures. Known for dozens of experimental novels, including *Naked Lunch* and *The Nova Express*, Burroughs was a fearless artist. He and his collaborator, Brion Gysin, developed the "cut-up" technique, by which you slice a page of text in half and mismatch the pieces. Burroughs would cut through several pieces of newspaper and try to match completely different stories from different pages. Burroughs did it with typewritten sheets of his own writing, and even his own novels, just to see what would result.

❺ The Tansey Wheel

Mark Tansey is a painter known for his dense compositions, monochromatic palette, visual puns, and playful juxtaposition of titles littered with terms from critical theory. Tansey generates ideas by using a strange device of his own invention—a three-part wheel inscribed with words and phrases.

Examples can be found with a quick Google search.

The outside ring is filled with subjects, the middle ring with predicates, and the inner ring with objects. Therefore, a spin of the wheel will yield an entire sentence. Tansey uses the resulting phrase as the title and starting point for a painting. You can make your own Tansey wheel representing your own interests and obsessions by cutting out and fitting a three-part set of concentric paper circles held together with a paper fastener.

❻ Guy Maddin's "Lost Films"

Filmmaker Guy Maddin is known for dark, melodramatic films that incorporate the style and feel of early silent movies with a postmodern sensibility. In his lectures, Maddin describes a writing method in which he chooses a film he has not seen and about which he knows very little. If he knows the plot or the story of the film, then it's unsuitable for this exercise. He then writes his own version, based solely on the title or perhaps random images or ideas connected to that film.

This method isn't likely to take you anywhere near the films that provided your starting point, and in the case of films that are actually lost—like Tod Browning's *London after Midnight* or Louise Brooks's early films—you'd never know.

❼ Dalí's "Paranoiac-Critical Method"

Salvador Dalí, the great Spanish painter, used this method to generate ideas. The "paranoid" part stems from the fact that a paranoid person often finds connections between unrelated events and people, suggesting, for example, that everyone is "out to get him." Dalí celebrated this irrational process and combined it with a deep and thorough analysis of the formal aspect of art. This is the "critical" part of the process. Thus, Dalí systematically inserted illogical juxtapositions into his compositions, creating double-images using color and negative spaces.

These pages were cut from a well-known source. Careful edits have been made to find the phrases that sound like English. A combination of words you've never seen before might start you thinking of a title, and sometimes a great title is all that's needed to get a story going.

Left Filmmaker Guy Maddin dreamt there was a lost German expressionist film called *The Blue Hands*. This became an important image—as well as a major plot point—for his film *Cowards Bend the Knee*. Photo copyright © 2002 Guy Madden

The result can be reminiscent of Rorschach inkblot tests, which psychologists use to test an individual's personality by gauging what the person sees in an abstract image on paper.

The paranoiac-critical method could be adapted to any creative process, using it to structure narratives that draw illogical connections between events, characters, and places, only conjoining them by formal filmmaking properties. Both Alan Renais' *Last Year at Marienbad* (1961) and Sion Sonno's *Suicide Circle* (2002) may have descended from this method. Each film has a dreamlike, wandering quality, filled with scenes that seem to follow somewhat logically but don't actually add up to anything like a mainstream narrative film.

Film and video are particularly good for this kind of experiment, since any two images placed next to each other will automatically generate a "story" for the viewers simply because the human brain has an unparalleled ability to seek patterns in random sets of data.

⑧ Magritte's Eight Methods of Bringing about the "Crisis of the Object"

Rene Magritte, another well-known surrealist painter, wrote about what he called "bringing about the crisis of the object." When you look at a Magritte painting, you feel as if the ordinary subjects he portrays—a pipe, a hat, an apple—have been made strange. They no longer have the commonplace, usual associations. This creates a "crisis" in the mind of the viewer. Magritte hopes to show you new ways to look at these objects by employing one of eight methods:

- **Isolation** – Taking an object out of its original context
- **Modification** – Changing the object slightly so that it becomes unfamiliar
- **Hybridization** – Combining two dissimilar objects, so that we recognize pieces of each but not the whole
- **Scale change** – Making objects appear at an unusual size
- **Accidental encounters** – Juxtaposing objects not normally seen together
- **Double-image puns** – Like Dalí's double images, using the subject of the painting to suggest a silhouette or structure not clearly delineated but perceptible nonetheless
- **Paradox** – Creating a contradiction within the frame, so that things that cannot exist are shown to exist. This could be an object that logically cancels itself out, as in Magritte's painting of a pipe with the legend "This is not a pipe" written beneath in French.
- **Double viewpoints** – Showing more than one view at the same time, such as mismatched perspective or simultaneous views of different objects side by side. Magritte painted a scene showing a building at night, yet the sky was broad daylight. Both day and night exist simultaneously in the same frame.

These eight methods, while employed almost mechanically—certainly methodically—by Magritte, nonetheless result in fascinating material. And all of the surrealist strategies may provide valuable inspiration to the home animator.

Drawing Games

Some activities develop ideas through drawings, rather than words. These may appeal even more because of the obvious nature of cartoons—they are made of funny pictures. Some exercises are solo endeavors, but often the best results can be had with a group of like-minded friends who don't mind scribbling and doodling with you. Invite a few over for an evening, and see what happens.

❶ The Exquisite Corpse

This is another surrealist game, but even small children can play it. Fold a piece of paper into thirds. The first player draws the head of a figure, ending at either the neck or shoulders. He leaves marks so that the next player may draw the torso—without looking at the head—on down to the waist. Without looking at the other segments, the last player draws the legs and feet. At the end, the "exquisite corpse" is revealed. Do three at a time, trading the papers around all at once.

❷ Jam Comics

In the 1960s, a group of underground cartoonists experimented with comic pages that were drawn by everyone. Each artist would draw a panel and pass it to the next artist. They likened this process to a musician's "jam"— a freeform composition with no rules and no apparent structure. Jam comics are wildly uneven, but this gives them their charm. The timing may be impeccable, or it may degenerate into a morass of scatological jokes. There's no way of knowing, and there's no use trying to rein it in.

❸ Decalcomania and Other Random Forms

The term *decalcomania* refers to the process of pressing pigments between surfaces and lifting them to create abstract shapes. Max Ernst, yet another surrealist, made paintings this way, pressing a board onto the wet paint and lifting it to create patterns he would then use in his compositions. Ernst also scraped off layers of paint to reveal new forms. You can splatter paint or scribble wildly to reveal shapes on the page and redraw the better ones. All of these techniques emphasize the creation of more-or-less random patterns that you organize into something you can use.

❹ The Drawing Challenge

Each participant needs a sketchbook and drawing utensil. In turn, each player issues a "Drawing Challenge"—a suggestion that all must tackle. They can be innocuously simple, like "big hat," or playful, as in "draw your next girlfriend," or bizarre and complicated, like "an ancient Chinese general is melancholy over his deceased hamster."

Another version, particularly good for the memory, is to go to a public place (alone or in a group) and choose a person at random. Get a good look at him, and retain him in your memory. Later, attempt to draw him. Compare your drawing with those of the others in your group. It's always amusing to see what everyone fixes on—eyes, nose, clothing, posture... the results should offer wildly different interpretations.

Above This detailed, almost fractal design was created by pressing viscous paint between two sheets of paper— an example of decalcomania.

Adaptation

Many times you base your new work on themes, ideas, and structures others have visited before. Adaptation is frequently overlooked as a viable strategy for new work, although it may be just as effective as original material. A new take on an old story may yield great results—and an existing piece can be adapted into another medium...such as animation.

Can you animate a poem? Can you animate scenes from one of Shakespeare's plays, using only cat heads? It's been done, so the answer is a resounding *yes*.

Consider short stories, music, myths, folk tales, paintings, and even other films. If the work is still subject to copyright, try to contact the authors directly rather than agents, managers, or publishers. Those people exist to guard the author from people like you, and they may demand exorbitant fees. An author or artist, on the other hand, may take delight in the fact that you appreciate the original work and may sympathize with your creative plans.

If you don't want to worry about living authors and the accompanying entanglements, choose works old enough to be in the public domain. "The Epic of Gilgamesh" is one of the oldest stories in any language, but the Quay Brothers' version (subtitled "This Unnameable Little Broom") is so full of their own preoccupations and interests that the film bears little resemblance to the original.

A wise man once said, "Everything has been done, but some people do it differently."

Copyright Issues

With adaptation comes the issue of copyright. The United States is a country gripped with fear over copyrights, royalties, licenses, and the idea of "intellectual property." Yet it's all smoke and mirrors—there are actually very clear notions about what is acceptable and unacceptable to use.

No one owns an idea, so there is no such thing as "intellectual property." IP issues have been generated by large corporations and their lawyers in an attempt to exploit their assets for as long as they can. As for "copyright," it's true that when you create a work, whether written, filmed, or drawn, there are laws to protect your right to profit from that work. But most often these issues become important when money is involved, or when someone's adaptation might damage the creator's own ability to make use of the original material. See the section in Chapter 13 for more information on copyright.

If someone makes a film based on a short story published last year, investing millions of dollars and featuring a stable of Hollywood stars, releasing it in thousands of theaters,

This pitch for "Epic of Gilgamesh Babies" was rejected by every major animation studio—even the lame ones.

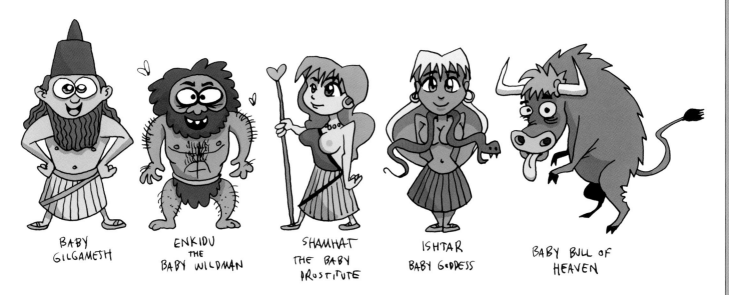

BABY
GILGAMESH

ENKIDU
THE
BABY WILDMAN

SHAMHAT
THE BABY
PROSTITUTE

ISHTAR
BABY GODDESS

BABY BULL OF
HEAVEN

making millions, then people will come out of the wood-work, certain they are entitled to some of the money. Legally and ethically, the writer *is* entitled to some of the profits—after all, it was his or her short story that was used.

Suppose you make a cartoon based on that same short story and show it around at small festivals. While fewer people will ever know or care, most will agree that it's still unethical. So the best bet is to contact the author and ask for his or her blessing or permission.

If they refuse, is your project shut down?

Not necessarily. Student work, in particular, doesn't require permission, since it is protected by the "fair use" clause in the U.S. Copyright Act. Paragraph 107 of this law sets out four considerations for fair use, one of which is "the purpose and character of the use, including whether such use is of a commercial nature or is for nonprofit educational purposes."

As a rule of thumb, always get permission for works you want to distribute widely, unless you're prepared for the eventual consequences.

The Danger of Self-Inventory

There's a trend today toward a kind of quotidian narcissism in art. Read any of the countless online comic strips and you'll follow the saga of the author, his or her friends, and the coffee shop at which they all hang out. The old adage exhorts you to "write what you know," but too many people have decided to share the excruciatingly minor details of their lives.

We have only ourselves to blame. American TV is filled with reality shows. Webcams and YouTube have led everyone to believe that he or she is a star and that everything they do is worth watching.

Generating material based on ordinary life can be disastrous. Most people simply aren't that interesting. Compelling stories establish a universal connection to the audience, so if you're going to use experiences from your

own life, distort and shape them appropriately. If you do use your own life as a starting point, be sure to tackle older issues, *never* ones in which you're currently involved. With older events, you're more likely to view them objectively.

Creative Gestation

After generating ideas, there are a few more steps before you can begin writing, and quite a distance to go before animating. You may have the essential germ necessary to make your piece, but you'll run out of steam if you don't plan it all the way through. The first idea you have is always a bad one—that's why it was easy.

How do you develop an idea?

First, mix everything up. Make elements bigger or smaller, switch character roles, or change direction. Dingy Duck, popular cartoon character, wants to buy the biggest car on the lot. Maybe it looks like a car, but it's actually a dishwasher. With wheels. Dingy Duck gets excited that he can drive and clean the dishes at the same time.

Maybe the car goes out looking for the right duck to buy.

Sometimes an idea just isn't ready. So let it sit for a while—maybe even months or years. Then one day, when you're driving, taking the train, or attempting to stay awake at a five-year-old's birthday party, it'll came barreling back, probably when you least expect. Chances are you'll move away from clichés and closer to your own voice.

Discuss the idea with associates. Great ideas take time and input from lots of sources. Tell your story to a patient friend or partner. First, you'll realize how embarrassed you are at all the bad parts. But the story will actually improve as you retell it.

Be sure to pick listeners who are sympathetic, but not *overly* so. It should be someone who's not afraid to tell you when an idea is positively awful, yet not someone who's going to be overly critical either.

Remain open-minded. If you get too precious and emotional about what you think is right, you'll never learn.

14

Writing and Analyzing

When scenarios were written in the silent film era, there was no "screenplay"—writers simply typed up the story. As films became more complicated, studio heads looked for ways to produce them faster and more efficiently. The screenplay format was developed not because it helped the writers, actors, or directors but because it was easy for producers to count page numbers and lines of dialogue to calculate the cost of the film and the schedule required to shoot it. It is an ugly, inelegant format, at best a cross between a play and a grocery list.

Early animators may not have used scripts at all and probably worked from sketches and notes, preferring to watch the piece take shape as they drew. As a result, the artists at Disney developed the technique of "writing" with storyboards.

These days it's common to use the screenplay format for cartoons produced at the studios. This is entirely wrong headed. Cartoons are about funny drawings, not clever dialogue. Most screenwriters rely heavily on what characters say, rather than what they do, especially if the screenwriters are only writing for animation because they hope to move on to careers in television or features.

Do not write animation scripts.

Story and structure do have a place in animation. A feature-length presentation, in particular, will require some kind of structure if you expect people to sit and

A sample of a screenplay page.

```
INT.  CENTER OF THE EARTH - LATER

Satan sits on a throne in the Lake of Fire, surrounded
by obsequious toadies and minions.

                    TOADIES
          Oh, Satan!  We love you!

                    SATAN
          Oh, really?  How much do you love me?

                    TOADIES
          A lot!

                    SATAN
          Just a lot?

                    TOADIES
          A VERY lot!

Satan smiles, his realistic vinyl-like skin crackling like
a bowl of breakfast cereal.  He chuckles, each spasm of his
diaphragm sending up enough flame from his lungs to sear
his nostril hairs.

                    SATAN
          Good.  I like it when you fawn on me.

                    TOADIES
          O Father of Lies!  O Evil One!  O Most
          Fiery Lord of Infernal Darkness!  O
          Wicked, Horned Goat!  O Naughty,
          Naughty One!

                    SATAN
          Hold it.  What's this "naughty one"
          business?  That's not one of my sacred
          names.
```

watch it for as much as two hours. Famous artist-driven films like Richard Williams's *The Thief and the Cobbler* or Paul Grimault's *La Bèrgere et le Ramoneur* are notorious for being beautiful but rambling—they wander from scene to scene, held together by a threadbare plot. Many viewers wish such movies, full of lush visuals and brilliant designs, had a more appealing narrative to carry them along. Even Disney's own *Fantasia* has its detractors because of the film's lack of an overarching story.

You probably won't face these issues, since you probably aren't going to make an entire feature. Few people have the tenacity, money, or determination at the outset. You will want to work out your story, but not be restricted by screenplay format, which was never designed for cartoons anyway.

The Myth of Formula

There's a terrible myth that suggests audiences only like stories told with a recognized, classical formula.

Screenwriting gurus have their own special systems, each hinting that if you follow the steps properly, then your work will be undeniably well liked.

Ridiculous.

The only fixed criterion is that entertainment remains *interesting*. Your audience deserves something fascinating for every moment of screen time.

The amateur tries to cram the structure of a feature into the small space of an animated short. With so little time you cannot worry about "act breaks" and "character arcs." Most people will—and do—watch just about anything for two or three minutes. This is the fundamental form of the music video, for example, and those are report-edly quite popular.

Below These are thumbnail storyboards, prepared very quickly to see if story concepts and ideas will work.

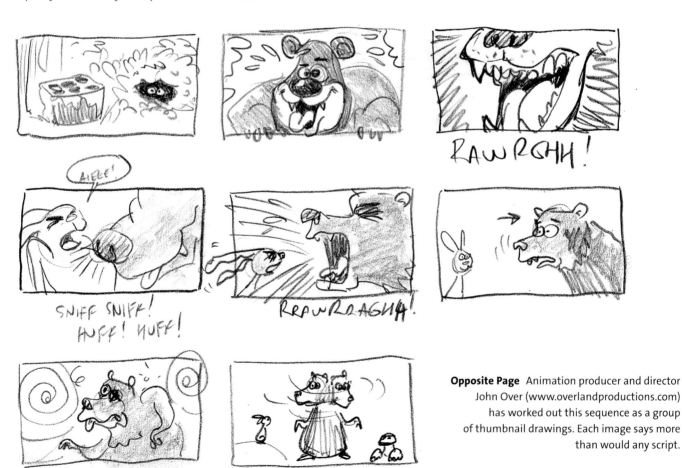

Opposite Page Animation producer and director John Over (www.overlandproductions.com) has worked out this sequence as a group of thumbnail drawings. Each image says more than would any script.

16

ACTION: Aston fidgets nervously with his hands.

ACTION: Miles enters carrying a long dagger.

ASTON: Is that it?!

MILES: It is indeed.

MILES: Your brother died on the other end of this.

ASTON: I can't believe that I'm holding it!

ASTON holds the blade up to the fire light.

Miles stands at a distance.

ASTON: This was the very instrument. It is larger than I had imagined.

MILES: If it were my brother that had gone by way of that...

MILES: ...I wouldn't touch the damned thing.

Miles walks away.

MILES: I can't figure why you'd want to.

An audience will accept an experimental structure, or even a bit of awkwardness, as long they don't become bored. Your job as an entertainer is to discover what you can do and where you can go without losing them. Because animation is so free—both from the restraints of physics and the logic of cause and effect—you have opportunities other film and video makers will not.

This is why your "writing" process is so different. When you "write" a cartoon, you're actually drawing it. Even if you're a 3D animator, and don't intend to do any actual drawing for your finished piece, you must work visually or your entire project will suffer.

Working visually means drawing, even if the drawings aren't great. In fact, they probably *shouldn't* be great—no one else is going to see them, so polish would be a waste of time. Try making small sketches that suggest only the action and expressions of your characters. Draw them on Post-it notes so you can arrange and rearrange them on a larger surface. Some writers use index cards, which offer a little more room. Some pin entire sequences to a corkboard for easy rearranging.

Scribble dialogue wherever you can. Cartoons are meant to be fun, so have fun in the process. Mix and match the pieces, starting with sequences that appeal to you most—the ones you can see in your head.

Learning to Read and Write Scripts

Screenplays are weird, because they're not really literature. The script isn't an end product; it's like the blueprint of a house. It *suggests* the form, and may have its own internal beauty, but it's not the work itself.

Because today's screenplays aren't written for actors or directors, but rather for readers and executives, reading

WORTH A LOOK

Naturally, you'll have your own opinions about who qualifies as an "animation master." Here's a short list of creators who are worth checking into if you haven't already determined your personal canon.

▶ Max and Dave Fleischer made dozens of surreal, bizarre Betty Boop cartoons before making a slew of great Popeye shorts. All these are restored and out on DVD.

▶ Richard Condie is a Canadian animator known for his brilliant short *The Big Snit*. Condie's work is harder to find but well worth catching.

▶ Warner Bros. had an amazing period of talent and creativity in the 1930s and '40s. Three names stand out amongst the many who worked there. Tex Avery, Bob Clampett, and Chuck Jones directed the best loved of these shorts. Each was a master of timing and draftsmanship in wildly different ways.

▶ The Quay Brothers' dark, creepy world of broken toys has been ruthlessly copied for many other animators' portfolios. Watch the originals and see what the others have been ripping off for years.

▶ Jan Švankmajer, the great Czech artist, was the Quays' mentor and director of dozens of shorts and features of his own. Švankmajer's work is also surreal and sometimes creepy, but very political, as well.

▶ John Kricfalusi is best known as the creator of *Ren and Stimpy* among other amusements. Not only does he make wild, funny, cartoony cartoons, but he publishes an entertaining and informative blog worth reading (johnkstuff.blogspot.com).

▶ Ladislaw Starewicz (sometimes Starevitch) is the granddaddy of all stop-motion animators. Long before anyone else, Starewicz was animating insects, objects, and elaborate puppets of his own design. Hard to find, but beautiful and even eerie.

▶ Famous turn-of-the-twentieth-century cartoonist Winsor McCay made some of America's first cartoons. Each was an elaborate labor of love, inked on successive cards and shot for McCay's public lectures.

▶ Bruce Bickford (www.bruce bickford.com) has made some of the most surreal, amazing clay animation available. Bickford also draws, and his epic works feature constantly changing figures and landscapes. Largely unknown but highly influential.

▶ Lots of people know Japanese cartoons these days, so the name of Hayao Miyazaki is not as obscure in America as it once was. His work is widely loved and respected, achieving a wide range of emotions and tones few others can manage.

screenplays—especially contemporary ones—can be a waste of time. Watching the films will teach you more about structure, and reading good novels will teach you more about storytelling.

There are two situations in which you may wish to prepare a standard screenplay. One is that you may transfer those scraps of dialogue to screenplay format for the sake of your voice talent. The other is to present your project to potential investors, studio heads, or accountants. Beyond learning the basic format—such as what margins to use — there isn't a whole lot that other screenplays can teach you. For information on format, refer to the appendices of this book. That one page is probably all you need to know.

Good vs. Bad Writing

How can you tell if your writing is good?

The truth is, you can never know—"good" is a pretty fluid concept. There are a few things you can do to hedge your bets, though.

Your material likely stinks if you base it on someone else's work. If you love the Fleischers too much and want to make a Fleischer cartoon, then no matter how adept you are, you will always be an imitator.

Duplicating the work of your own personal masters is an important part of learning your craft—it's a great way to discover how your idols solved their own creative issues. But leave that stuff in your drawer. When you show people your work, make it your own, not a sad copy.

And avoid the kind of entertainment that "name drops" other entertainment. Even if you're driven to make a fantasy cartoon with elves in it, having your character say "this reminds me of that dwarf in *The Lord of the Rings*," will only remind your audience that they'd rather watch *The Lord of the Rings* than sit through your film. After all, you're implying that even *you* prefer *The Lord of the Rings*.

What if your material is too melodramatic? Too sappy? Too violent? Too obscene?

These are all questions you need to answer on your own. Follow your instincts, and make the animated cartoon *you* want to see. If you're a racist Nazi skinhead, then make racist Nazi skinhead cartoons. Most people won't want to see them, but we live in a free country—for now—so exercise your rights. Someone may come up and punch you in

the nose for what you make—after all, there's no guarantee that everyone will like your work. But that's better than getting no reaction at all.

If your cartoon is so bland that no one can find anything to love—or hate—then you've wasted your time. Cartoons are made like this on the corporate level, and there's no reason for you to add to the already swollen body of uninspired pablum churned out for television and the cinema.

Animation Archaeology

What if you're not a writer but would like to become one?

There are dozens of books on how to write screenplays, and a few books on writing cartoons, but the emphasis on screenplay format renders them suspect at best. Few of these resources tell you much about writing short cartoons.

Analyzing the work of masters will help you develop your critical skills, as you note what does and doesn't work in existing films. You may uncover their secrets and apply them to your own production. Rent or buy examples of their best (and worst) works, and seek to determine:

- What elements made them unique?
- Did they do anything that *didn't* work and should be avoided?
- What techniques might you adapt for your own work?

There's no excuse not to do your own digging—especially when "research" means watching cartoons. In fact, there are even online resources that offer free downloads of public domain cartoons in decent formats. Most of these are decades old, yet they move and function better than many newer cartoons. Try www.archive.org or www.vintagetoon-cast.com to get started.

Scene Analysis

Films can be assessed in a multitude of ways. Any visual presentation, whether it be film, video, or the new media forms currently being developed, offers many aesthetic and technical considerations. Any given piece can have a terrible picture but great sound design. Another may have brilliant voice characterizations but terrible drawings. Or great drawings with stiff, awkward movement.

So what should you be looking for? How do you know what's "good" and what is not?

Start with work you admire—a favorite film, a short that makes you laugh the most, or a TV show that features characters to whom you respond. Then ask yourself, "Why is it so good?" To what are you responding? Start there and you'll begin to understand what your own interests are.

Narrative Elements

Not every film will actually have a narrative. There's absolutely nothing wrong with beautiful work that experiments with visual elements. Nick Park's *Creature Comforts* has only "documentary interviews," vaguely strung together.

In its simplest expression, a story is a series of cause-and-effect relationships through which an audience follows the actions of a particular character. For every story, there must be a character to whom things happen, a cause, and an effect.

This could be a story: "Dingy Duck fell down and broke his head." While not a particularly *compelling* story, it exhibits the three essentials: a character to follow (Dingy Duck), a catalyst that propels the narrative (fell down), and a consequence (and broke his head). More expansive stories exhibit the same basic elements, although more complex and presented in more scintillating ways.

Keep one thing in mind: There's no right or wrong way to tell a story. There are only interesting and not-so-interesting stories, and their success depends entirely on the style of the storyteller.

What is successful for you may not work for the next person. Ignore those who tell you that something cannot be done or that you must follow proscribed formulas. For every rule, there's someone who's successfully broken it.

That said, there are some commonly held dramatic elements and concepts.

❶ The Protagonist

Your protagonist is one of the most important elements of your story, and more than just the "main character." The good storyteller provides a character with whose hopes and fears the audience can identify. Fortunately, human beings are quick to identify with characters in general, and most audiences immediately latch onto the first character who appears on screen. Why? Because the audience *wants* to be entertained. They want to be delighted. And they know that doing so means taking whatever you give them and seeing where it will go.

This is a trust the audience has placed in you, so don't abuse it. You have to deliver the goods, or the audience will feel cheated.

Protagonists can be any type of creature or object, so long as they are interesting. "Interesting" is purely subjective; you have to follow your own instincts. What you think is interesting might be boring or clichéd to someone else.

You can't *make* people like a character. You may not have to. You may want to develop a character who isn't good, or likeable, but is, in fact, rotten, yet fascinating. Would anyone have remembered Dickens' *A Christmas Carol* if Scrooge had been lovable and friendly? How could Scrooge have transformed at the end of the story if he was already a nice guy?

Protagonist and antagonist—but which is which?

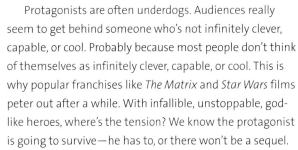

The protagonist can be mean, arrogant, stupid, clumsy, ugly, and even downright wicked. But regardless, he must exhibit *compelling* characteristics.

And those characteristics must be specific. Anytime you find yourself writing something like "Billy is a typical superhero," or "Josh is your average slacker dude," slap your own hand. Why should *anyone* be interested in someone who's "average" or "typical?" Much better to write "Cyrus, middle-aged with a bald spot and an increasing waist line, is vain, feeble, and incontinent. By day he is an ornithologist, specializing in pigeons. By night he dons a shabby costume and prances around town, thinking he's a superhero."

You've heard people complaining that a character in a film is "one-dimensional," "has no depth,'" or is "flat." This is just a clever way of saying that the character has few specific characteristics, and what traits he or she exhibits are commonplace and dull. Perhaps the character is "nice," or "always does the right thing," which is the same as "bland."

Bear in mind that characters are carefully crafted, stylized versions of reality, with the mundane parts removed and the exciting parts enhanced. The most "real" characters in films are as fake as all the rest, they've just been presented with such skill that you forget their falseness. And many characters are interesting due to internal contradictions, because *most people* are full of contradictions. We tend to respond to characters who exhibit internal conflict, as well.

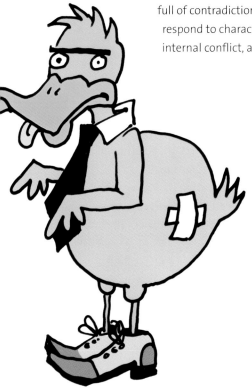

Protagonists are often underdogs. Audiences really seem to get behind someone who's not infinitely clever, capable, or cool. Probably because most people don't think of themselves as infinitely clever, capable, or cool. This is why popular franchises like *The Matrix* and *Star Wars* films peter out after a while. With infallible, unstoppable, god-like heroes, where's the tension? We know the protagonist is going to survive—he has to, or there won't be a sequel.

There are various theories—usually brandished by doctors of education—that small children need characters who are deliberately bland, with whom they can identify. The theory is that small children want blank canvases upon which they can project their own personalities. This is pure hogwash. The popularity of characters such as SpongeBob SquarePants, to name only one, repudiates this theory. People of *all* ages respond most to characters with strong, clear personalities.

❷ The Antagonist

We don't say "villain" anymore because the antagonist is, at the core, someone who opposes the protagonist. This could be someone who is perfectly "good" in a moral sense. This could be God himself, if we are telling the story of Job. It could be that both protagonist and antagonist are "good" but are on opposite sides of an issue. So the morality of each character is unimportant to our storytelling. The key is that when a protagonist has something he wants, it's far more interesting to put someone in his path to oppose him.

The most successful antagonists are also well crafted. It's not just one axis: "he's crazy," or "she's evil." It'll be a mixture of traits, good and bad. George Bernard Shaw once wrote that the most terrifying villain is one who is entirely convinced he is doing good. Hitler thought he was doing everyone a favor. Stalin thought he was on the right track. And Vlad the Impaler insisted that he was only kidding. Just as you would do with the protagonist, make the antagonist better than a cardboard cutout.

❸ The Catalyst

There wouldn't be a story without a catalyst. Consider this: "Once upon a time, there was a fowl named Dingy Duck. He was very mean and cranky. The End."

Not much there, huh?

Nothing propels us forward; no situation causes Dingy to do anything audiences might find interesting. He needs something to propel him—a catalyst.

The catalyst is just about anything that disrupts the normal routine of the character, whether good or bad fortune, because it always comes with complications that drive the story.

- Dingy Duck finds a million dollars.
- Dingy Duck is run over by a car.
- Dingy Duck cross-dresses and decides he likes it.
- Dingy Duck robs an old lady and accidentally kills her.

Each of these is rife with comic (or tragic) potential, depending on what the animator does with them. Catalysts work best when they are tailor-made to suit the personality of the protagonist. If Dingy Duck is a nervous young bird, then it makes sense to give him a catalyst like "Dingy Duck must address a stadium full of people about a subject he knows nothing about." If he were confident and capable, the results would be uneventful and dull.

But storytellers are generally a little sadistic. They're always giving audiences characters to identify with and then slamming those characters with hideous obstacles. The entertainment lies in watching how the protagonist handles the situation.

❹ Conflict and Resolution

A catalyst gets the ball rolling, but conflict is what keeps things going. A conflict between antagonist and protagonist is established, reaches a climactic point, and is resolved. There are many ways to do this. Here is the most common structure:

1. Establish the protagonist.
2. Introduce the catalyst (involve the protagonist in the story).
3. Reveal how the antagonist prevents the protagonist from achieving what he or she wants.
4. Show the protagonist and antagonist in conflict.
5. When it seems clear who is winning, reverse expectations.
6. Reveal the resolution of the conflict.

This is a template rather than a formula, because *formula* indicates a rigidity with which one must follow instructions precisely, or fail. A template allows the animator to develop the story freely, perhaps like this:

1. Dingy Duck is a half-crazed mallard whose diet consists entirely of nasty lumps of sulfur. (Establish protagonist)
2. One day he goes to the sulfur mine, but the vein he's been snacking on is tapped out. (Introduce catalyst)
3. He digs furiously, but there's nothing left. He sees trucks drive off with the last of the sulfur from the mine. At the wheel is his foe, Mangy Mouse. (Introduce antagonist)
4. Dingy Duck tries unsuccessfully to stop the truck and snag the sulfur. Several elaborate schemes fail, and he is beaten to a pulp, repeatedly.
5. On his last, half-hearted attempt, Mangy Mouse beats Dingy Duck so completely he has to go to the hospital. In the hospital there is a supply cabinet full of sulfur just two feet from Dingy's bed.
6. Dingy Duck hops up and down ecstatically as a buxom nurse tosses handfuls of sulfur into his open beak.

True, this cartoon might launch some parents' coalition after us if any children ever see it, but the result is still sound, and the structure is applicable to any number of topics or situations. Remember that you have the freedom to break the rules—even the most basic ones—when it suits you to do so and when a more interesting product will result.

My screenwriting professor, Frank Daniel, used to say that this template is like a well-marked highway in the country—you can follow it for an easy ride, but the real fun comes in when you go off-roading.

Study the work of your own personal masters.

- How do they introduce a protagonist? Even a well-known one, like Bugs Bunny or Popeye, gets an introduction in each cartoon.
- How is the catalyst shown? Not surprisingly, this will often be visual, rather than revealed in dialogue.
- Who is the antagonist? How is he or she introduced? Tex Avery might just stop the action and flash a sign saying, "This is the villain!" All's fair in animation—

and he achieved the important function of letting the audience know who to watch!

- Can you make a list of important developments in the cartoon? Who does what, and to whom? Who's on top?
- Finally, how does the cartoon resolve—is there a trick ending? Does it end with a bang? Maybe literally —lots of cartoons end when the cast blows themselves up with TNT.

You'll be surprised what you find. Cartoon structures are very loose, often organizing around visual climaxes rather than plot and dialogue. But more important, you will be uncovering someone else's storytelling secrets. This will either make you hate your masters or love them for their brilliance.

Either way, you're learning.

A happy ending

Graphic Elements

Story, plot, and character are good, but this is a visual medium. Examining other key elements will determine how the animator presents his material.

❶ Composition

Composition is the placement of images within the frame, as well as the use of the frame itself as a border for select-ing what is seen. As you do your research, note how the animator composes images and uses long shots and close-ups. How are the background elements and props used in conjunction with characters?

Watch a cartoon with the sound off to avoid being distracted by the story. Pause on a particularly striking frame, and draw your own thumbnail of it. Draw several. Take screen shots, and trace over them in a graphics program. This will allow you to walk a mile in the animator's shoes.

A series of thumbnail sketches showing the graphic organization of compositions. Guess where they're from.

❷ Color

Note the predominant colors used in scenes and for characters. What effects do they achieve? Is there a coordinated design at work? Consider the placement of primary and secondary colors. Some designers like to choose a primary color (red, yellow, or blue) for a specific character and then organize the rest of the colors around the complements or the secondaries. They may select a "cool" color scheme, composed of blues and purples, or a "warm" color scheme, with reds and yellows. And artists choose colors based on character interactions—the hero may be dressed in red, while the villain is in a complementary green.

Complementary colors lie directly across the color wheel from each other. Blue is the complement to orange, and yellow is the complement for violet. Mixing complements yields gray, and complements also clash the most—consider how green and red look next to each other, or purple and yellow. This may be an effect you want to achieve, or to avoid.

To confuse the issue, the three primary colors of *light* are red, green, and blue—your computer's graphics program may denote colors in terms of RGB. Even *more* confusing is that printers deal with colors as CMYK (cyan, magenta, yellow, and black). Indeed, the color wheel shown here is merely one of dozens of schemes used for organizing color. Artists continue to use this RYB model because of

its link to painting and the tradition of fine art. There's more about color in Chapter 8.

❸ Design

What motifs are used? Is there a unifying theme, such as Art Deco or cave drawings? Does the work look like cheap Saturday morning cartoons from the 1970s, or the Hanna-Barbera cartoons of the '60s? Break it down even further. Does the animator use lots of straight lines? Curved? How about circles, or triangles? Does the artist use bold, thick lines or thin, small ones? No lines at all? Chances are there's a philosophy unifying the art. Even with an "anything goes" collage style there will be evidence of the creator's decision-making process. If the images are all cutouts, from what sources were they cut?

Analysis may reveal that the film *isn't* well-designed.

❹ Camera Style

In much animation there is no "camera" per se, but there's still a presentation of views as if there were a camera. The "camera style" in animation is akin to composition, but it has more to do with how the frame *moves*. Are there pans or tracking shots? Zooms? Perhaps the frame is motionless and all action takes place within it. If so, what did the animator achieve by restricting the audience's POV? Was it purposely claustrophobic?

Red (Primary)
Orange (Secondary)
Yellow (Primary)
Green (Secondary)
Blue (Primary)
Violet (Purple) (Secondary)

Above The color wheel

PRIMARY AND SECONDARY COLORS

Red, yellow, and blue (RYB) are considered primary colors for pigments because they cannot be derived from mixing other colors. Secondary colors—orange, green, and violet (or purple) lie in between the primaries and are created by mixing the primaries.

Tertiary colors—red-orange, orange-yellow, and so on—come from degrees of mixing (a little more red, a little less blue, etc.).

❺ Editing Style

Is the editing fast paced? Or slow? Does the animator play everything out in one long shot with a moving camera or in a series of rapid shots? How does this affect the pacing or timing of the piece?

Quick cutting and relatively still characters can suggest movement, as it does in some anime. Television shows like *The Simpsons* achieve hilarious timing through editing alone.

Count the number of shots. How long is each shot?

❻ Sound Design

David Lynch has some of the most sophisticated sound design in film. His scratchy, creepy cartoon *Dumbland* is better designed and mixed than some Hollywood features. Listen on good headphones, or through a home theater system, so you can analyze the panning as well as other elements he's used.

When you listen to a cartoon, don't just pay attention to the music—close your eyes and listen to every element on the soundtrack. Do sounds originate from the speakers in the back? Is there a "placing" of sounds on the left or right? Where do they cause you to shift your attention, and what emotions do they inspire?

Some of the best animation comes from overseas. Hayao Miyazaki is one of the greatest Japanese animators, and *My Neighbor Totoro* is so well crafted that it can be watched without dub or subtitles, and the story remains clear. No matter how well Disney dubs Miyazaki's films, the voice actors Miyazaki hired fit his drawings and his animation the best. The tone, gestures, inflection, and sound quality of the original voices tell you much more about what the creator intended than do the dubs.

What Does It All Mean?

If a creator does something consistently, you've identified a key element of that person's style. If they place dissimilar elements in close proximity, then contrast is part of their style. If they have a consistent palette, this is the color style for the show. By studying the various styles and approaches, you'll come that much closer to forming your own.

Storyboarding

Creating storyboards for your animated cartoon is one of the most important steps you will take, requiring the most of your creative powers. These small, quick, gestural drawings indicate the actions you will animate. There's no set number required; no requisite size or shape. Draw as many sketches as are necessary to communicate what will occur, as if to someone who knows nothing about the film. It's a paper version of the final product (even if it's not on paper).

In the early days of animation each artist had his or her own methods. Many worked "straight ahead," starting from the first frame and ending when they decided the film was over. The storyboarding process as we know it began sometime in the 1930s, when animation directors at Disney began to pin sketches to the wall to work out story problems and to keep animators together on the same project.

Sell It or Kill It

Tedd Pierce and Michael Maltese, two of the funniest "writers" of the classic Warner Bros. era, weren't known for their draftsmanship, but each could—and did—draw. They whipped out thumbnail sketches and scribbles to show the actions and expressions of their characters.

Directors would then work with these "story men," acting out the roles, putting on funny voices, and generally testing the stories out on each other. To this day, many studios employ story departments for this purpose. You should try the same—you'll learn a lot about what does and doesn't work.

Television schedules are far tighter than features, though, and the TV storyboard artist often inherits problems from bad scripts. Some artists employ the "sell it or kill it" approach. To "sell it," they map out actions that will make a problematic scene work despite the way it's written. Or they may "kill" the gag by distracting the audience with something visual that's far better or funnier. With "sell it or kill it" you can end up with off-kilter, uneven boards—or you could save a terrible script.

Some crews only employ "writers" to supply general outlines for the episodes. The board artists work from half-

page outlines and are expected to invent all the dialogue as well as the action, staging, and "camera angles."

How Much Is Too Much?

Detailed storyboards prepared for live-action films often have color, shading, excellent perspective, and perfect characters. These are only prepared for people who aren't actually working on the project and are sometimes called "presentation" boards. If storyboards are going to be used as part of a sales pitch to get money for the production, potential investors want to see something finished. Scribbled drawings probably won't get them to write a check.

Nevertheless, board artists often fall under pressure to provide cleaned-up drawings and thoroughly designed backgrounds. Many television shows send storyboards to an overseas studio—often in China or India—for completion. There is often a language barrier involved, so the cleaner and more detailed the boards are, the greater the likelihood that the episode that comes back won't require expensive retakes.

If you're working solo, then you have to do it all. You won't have the same pressures, though, and your boards indicate as much or as little information as you would like. Even so, it's better to do your research before diving in. Establish what characters will look like before you need to draw them repeatedly. Know what backgrounds or colors you'll need for specific scenes. You can always redraw and rework your storyboards as the need arises.

Comics and Animation

Comics and animation are very different beasts. Do not mistake a comic book story for an adequate replacement for a storyboard. Thinking of them interchangeably will guarantee that your work will neither be good comics nor good storyboarding.

Comics use the frame as a timing device—how long you spend on a scene may depend on how many panels are devoted to it and how they're arranged on the page. Rhythm is developed from panel to panel by use of similar or contrasting graphic elements. Suspense can be created with the end of the page and the turn of another. Because the comics artist cannot control time, he or she must use the panel—and the space between panels—to control the flow for the reader.

The storyboard, on the other hand, is a sketch for movement you haven't yet produced. It's not meant to be read as a page but rather as if each panel represents the screen at a given instant. Comics and storyboards may share some characteristics—particularly when it comes to composition and the depiction of action—but the differences are enormous.

Even big-budget film directors assume that a comics version of a story is an adequate storyboard. And yet if you just transfer the comic to the screen, the film will suffer. Comics do what comics do best, and animation does what it does best.

Show, Don't Tell

Animation is about pictures, not clever dialogue, so your story should work perfectly well without dialogue. If someone watches your cartoon without sound they should still know what's happening. Try it with a classic cartoon you've never seen—you should get the gist of it. The adage is "Show it, don't tell it!"

When you start, you may not have *any* dialogue. This is perfectly fine—board out what you want to see, and dialogue may occur to you as you need it. But if you find yourself drawing Dingy Duck picking up a newspaper, and he's saying "Ha! I wonder what's in the paper today?" then think again. Your audience can already see what Dingy is doing—they don't need to be told.

The tough part is that you have to do all the "acting" for all the characters, as well. If you need a particularly funny pose or interesting expression, then practice making it yourself. As my drawing teacher, Diana Coco-Russell, used to say, "Feel the pose!" Once your body adopts the shape you're trying to draw, you'll better understand how the pose works, and your muscles will tell you how it feels.

Animation depends on stylized motions and forms. When we actually cry, we don't look like a cartoon character does when he weeps. The cartoon conveys the feeling of crying, rather than an accurate depiction of crying. You're trying to condense emotions into a few strong, readable lines.

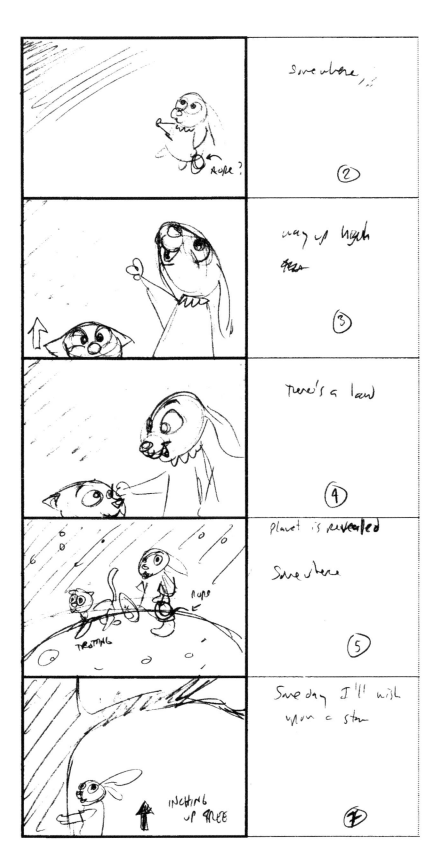

Storyboards used in *Over the Hiccups*, a stop-motion music video made for the experimental audio collective *Negativland*. These drawings are nothing more than crude scribbles, yet they convey the idea for the scene, capturing the proper expression or gestures. General notes about action and dialogue are placed beside each frame for reference.

The Additional Content section of the accompanying DVD contains useful forms for planning, including reduced-size storyboard panels, such as the 4:3 ratio for TV and standard definition video, the 16x9 HD ratio, and the 1.85 ration for theaters.

Composition

Entire volumes are written about composition, yet there are a few key concepts that are certain to improve your compositional skills. They're all borrowed from principles of Western art that are hundreds of years old. Many are used in live-action filmmaking, as well.

Learn the rules and then learn how to break them. Become confident in how they're applied and under what circumstances you stand to gain more by violating them.

The Rule of Thirds (the "Golden Mean")

Since the time of the Ancient Greeks, people have noticed that compositions look better when they contain a dividing line at the "Golden Mean," or the "Golden Ratio." Although technically at the 3/8 mark, many times we place the division at about a third.

[1] This diagram is just a standard 4:3 television frame, divided into thirds. But it's not the nine zones that are important; it's the lines themselves. When framing up a face, for example, you might place the eyes of the character on the upper third, like in this illustration [2].

A standing figure might be placed on a vertical third, like this. [3]

1

2

3

Horizons are placed on upper or lower thirds rather than halves. The halfway mark looks awkward to the eye, and the third seems more pleasing. **[4]**

Although it is called a "rule," the Rule of Thirds only *advises* how to compose an image and where to place important action. You do not need to follow it mechanically.

In a frame grab from Walt Holcombe's *The Courtship of Sniffy LaPants*, Sniffy's head is located on one of the key points and the robot on the right third. **[5]**

Notice that the robot leans in, giving the entire composition a lean to the left. This keeps the frame from looking too precise, and yet it still adheres to the "Golden Mean."

In a two-figure panel, even a background character can be placed in a strategic spot and exhibit the graphic "weight" necessary to achieve balance. **[6]**

Without that second character as a counterweight, the result would be an unbalanced composition. **[7]**

Bad frame? Not at all. Balanced and unbalanced compositions can both be effective, but they have different effects on the viewer. Balanced compositions tend to be more stable and provide less tension than the unbalanced ones. If increased tension is the effect you want to achieve, an unbalanced composition may be the key.

31

"I Love You, Rutherford B. Hayes, 19th President of the United States of America!"

4

6

5

7

Look Space, Headroom, and Tangents

Human beings prefer to look one another in the eye. A high angle on your characters causes us to look down on them—to take a superior position. A low angle makes a character seem powerful and imposing but discourages identification with that character. If you want your audience to follow a specific character, put them at that character's eye level and let them see the character's face and expressions clearly. [1]

Placing a character's face on one side of the frame or another naturally gives a character some kind of "look space"— a region into which that character seems to be looking. [2]

Placing the head on the other side allows the character no look space, and this can be uncomfortable for viewers, creating emotional tension within the frame. You may wish to use it in scenes where characters don't get along or when one is uncomfortable or nervous. [3]

You might also give a character some "headroom." Placing a head all the way at the top of the frame makes it look crowded and awkward. A little room above the head is much more pleasing. [4]

32

An extreme composition emphasizing headroom can be graphically appealing. **[5]**

And an extreme *lack* of headroom, to the extent of cutting off the head entirely, might yield a dramatic impact. **[6]**

But placing the head directly on the frame line—the edge of the image—creates a tangent between the character's outline and the frame. Tangents like this are notoriously "bad" because they interfere with the readability of the design. **[7]**

Similarly, if a character comes into direct contact with another part of the image it can be difficult to tell where the character begins and ends.

If the character touches the horizon line, both the figure and the horizon become unclear. If too much confusion exists, the audience may wonder what they're seeing.

Whereas if the figure is moved slightly, the confusion is removed. As in the illustrations **[8, 9 and 10]** on the next page.

5

6

7

33

8

11

9

12

10

13

Another problem may exist if the frame line cuts a figure at an awkward point. [11]

Moving the figure entirely into the frame will help, although if the character's feet touch the bottom of the frame line, there's still a distracting tangent. [12]

So the best solution may be to move the figure entirely into the frame. [13]

Just as you avoid cutting off limbs, you should avoid "meaningless" frames—arbitrarily placed compositions with no strong graphic organization. In this picture, [14] the cowboy is drawn with a nice diagonal, yet the dynamic power is lost because he is cut off at the knees and centrally placed—away from the Golden Mean. Though his body is in

a nice, dynamic diagonal, we lose the power of that direction because his relation to the frame is so badly constructed.

Simply enlarging the figure and moving him to the side of the frame adds look space and fills the screen with more action and expression. [15]

Likewise, while this burning skeleton is framed so that 90 percent of his body is contained, an annoying 10 percent is missing—the ankles and shoes. Ugh! He fills about half the frame, not falling along a pleasing third. [16]

Moving the skeleton to the right enhances the composition. Enlarging him emphasizes the diagonal of his blue coat and places his head on the one-third mark. Even though he has no look space, the result is much more dynamic. [17]

35

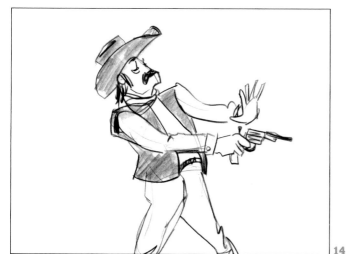

14

16

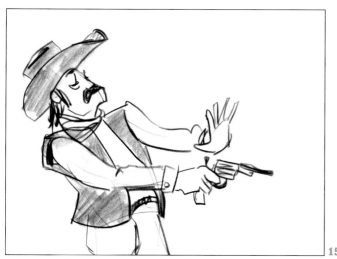

15

17

When film criticism developed in the 1950s and '60s, the Europeans identified what they called the "American shot," or, as the French put it, *le plan Americain*. This was a pejorative term; they were deriding Americans for cutting people off at the knees. And they were right; it's a clumsy, awkward framing—neither a full shot of the body nor a medium close-up. It's *still* in constant use in film and television today. Avoid *le plan Americain*; move the "camera" in closer or further out.

As an exercise, find some examples of the "American shot" in film or television. Capture frames with your computer graphics program and reframe them so they have better compositions. [18]

Diagonals

The most "active" composition uses a diagonal. The next active is the stable, but still somewhat tense, vertical. The horizontal is the most passive composition of all. So for the scene in which the insufferably cute kitty falls asleep in stupefying comfort, go for the horizontal.

If you want graphic tension, stage all your action on the diagonal, and contrast the directions from shot to shot.

There's no cute kitty sleeping in this composition. [1] This unfriendly hamster uses three contrasting diagonals, indicated by these hideously colored patches. [2]

18

Contrasts create the greatest amount of tension, so this frame is perfect for the dramatic climax of a scene. Yet an active composition doesn't necessarily mean you convey *action*.

The diagonal is here, in the positioning of the woman, but the placement of characters and the strong horizon give it a very different feel. **[3 and 4]**

This composition is dynamic, because of the diagonal, but it isn't a scene conveying action.

Staging

The term *staging* refers to how you place actors, props, and set pieces before the camera. A live-action director can develop the scene on set with the actors, but an animator must plan it all ahead of time. Rarely do animators want to wing it—a single failed sequence might mean hours of lost work.

Even so, animators have always struggled to discover novel ways to "put over" a gag. Bob Clampett and his unit at Warner Bros. pushed characters and situations far beyond what was comfortable, and Tex Avery drove the action faster and faster, timing gags in fewer and fewer frames.

Keep in mind that even the wildest experimenters began by training in the fundamentals. Picasso had classical training, and his genius was only possible because he conquered the basics. No one can teach you how to be a Master—it's a matter of experience, trial, and error.

BONUS! Check out the Staging Tutorial on the DVD.

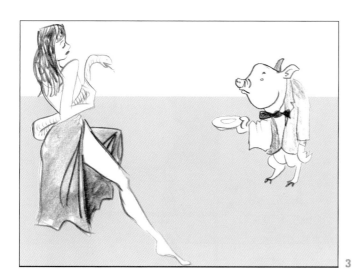

3

4

37

The 180° Rule
(The "Axis of Action")

It took the cinema almost thirty years to work out this particular principle, but it's been in use ever since. The 180° Rule is designed to keep spatial relationships between characters clear and understood.

Imagine that there exists between any two characters an invisible line—the "Axis of Action." To keep continuity between one shot and another, you need to make sure the "camera" is on one side or the other of that axis.

A and B are characters, seen from above (they're cartoon characters, hence the big noses). The dotted line shows the axis of action. The V shapes are camera placements, indicating direction and angle of view. If this were live action, you might place the camera at each of those positions, to offer a variety of shots to choose from in editing. But for a cartoon, it doesn't make sense to animate the entire scene from all those angles. You must plan your timing and your editing before you animate.

A common strategy used in two-person dialogue scenes is to start on a wider shot, showing both people. Then, as the conversation gets more intense, go closer and closer, becoming more intimate with the characters as they talk.

Cameras 1, 2, and 3 are on one side of the axis of action, and 4 is on the other side. Camera 4 is going to be the "wrong" camera, the one that's not going to match.

Camera 1 yields this shot—it's dull, but it's essential to establish character A on the left and B on the right. It imitates your point of view if you were standing right beside these people.

Camera 2 provides a shot of character B over A's shoulder. By making sure B is looking slightly to the left, you avoid confusion as to where A and B are standing. A is still to the left of B, just as he was in your first shot on camera 1.

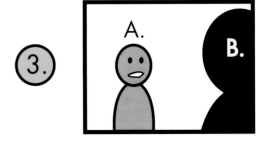

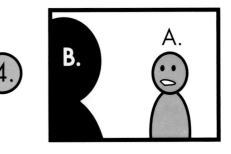

In shifting to camera 3, you'll get the "reverse shot" of character A as he talks to B. The character relationships are still clear: A and B are still on the same sides of the screen, and you know where they are in relation to each other. It's almost as if you were standing between the two characters, looking back and forth as you listen in on their conversation.

But with camera 4, the "wrong" camera, you've moved to the opposite side of the axis of action. This has the effect of making the characters switch sides. It seems unnatural because to achieve this view, you'd have to pop over to the other side. This is a bad idea because it may confuse the audience and call attention to the filmmaking, pulling the viewer out of the story.

Of course, the 180° Rule can be broken, and often with good effect. For example, a moving camera can always *cross* the axis of action.

The camera at position 5 can move along the dotted line to end up at position 6 without confusion, because the camera's motion reveals how the perspective has changed. The audience can watch as the new spatial relationship takes shape.

The same thing is true of certain kinds of blocking. *Blocking* refers to the movement of characters with respect to each other, separate from the camera movement. So if a character walks around another character within the shot, their spatial relationship will change. Once again, the audiences will see this as it develops and won't be confused.

You might deliberately break the 180°Rule. You could "cross the line" to create a disjunctive effect for the viewer. Live-action directors do this all the time. Consider a fight scene in which there are two characters on opposite sides of the screen. The character designs are vividly dissimilar, and they're wearing different colors. The fight begins. At a crucial moment, to build tension, you cross the line.

Are audiences confused by this?

Very often, they are not. Crossing the line can create graphic contrast. This is essential for filmmaking with high energy and emotion. Your viewers will be thinking about who will win the fight, not how many diagonals it has. But the graphic contrast will have a subtle psychological effect.

Learn how to use these concepts to improve your staging. The Rule of Thirds helps you create sharper compositions that place important action and characters in the spaces on screen that are most attractive and most effective. The 180° Rule helps you maintain spatial relationships between characters and creates greater visual tension when you need it. Yet these aren't the only answers to making beautiful cartoons. It's still up to you to design an attractive shot, and it's still your decision where to place your "camera."

At this stage, you may wish to read Chapter 10 to become familiar with editing. This will come in handy as we address the animatic—the next stage in your production.

Organizing Compositional Elements

With such rules we can keep our audience from being confused, but what about making beautiful images? One way artists create a sense of design in moving images is by controlling the graphic elements in meaningful ways.

You can choose to contrast the various graphic elements that make up a scene, or make them similar. You can organize color by contrasting colors from scene to scene. You can make the color consistent throughout—perhaps in a monochrome or limited palette.

These principles of contrast and affinity can apply to every aspect of your cartoon—including your sound design and editing.

❶ Movement

Movement—or the lack of movement—can also be controlled. Consider a scene in which one character is completely still while another flits about the room. This is contrast within the shot. Imagine a film in which a bumblebee darts off-screen, and his movement to the right is picked up by a character in a new scene coming in from that direction with similar, rapid movement. This is affinity of motion from one scene to the next. Animation lets you determine the exact speed and direction of all movements, so it's an easy—and effective—quality to manipulate for aesthetic effect.

The left image shows an affinity of color within the shot, while the one on the right shows a contrast of color (red, blue-green).

② Shape

One of the most basic ways to imply similarity or contrast is through shape. Is there an emphasis on round forms? Angles? Squares or cubes? Does each character in your piece contrast the others—are some blocky and square, while others graceful and lithe? Does your square and blocky character live in a suitably rectilinear house? Or in an ill-fitting and unsuitably round igloo? As with human beings, shape evokes a wide variety of reactions and emotions.

③ Size and Position of Objects

You can generate humor with a single picture that shows the size of characters standing together. You can generate tension by showing a diminutive protagonist facing an obstacle literally several times his height. You can place objects in the foreground for graphic effect. Everything on the screen should be where it is for a reason. And while some may be placed following the Rule of Thirds, others— for example, a row of identical objects that creates a visual rhythm—may be positioned *despite* the Golden Section.

④ Symmetry

It's a perfectly fine composition—if unbalanced—to place a character's head to one side of the screen, thus creating asymmetry. But if you designed your cartoon to have absolute symmetry, then the asymmetrical element may undermine your motif. Symmetry usually doesn't work well for character design, because the duplication often leads to boring poses.

Below Perhaps the best approach might be an asymmetrically posed character in a symmetrical world.

Above Animator Eileen O'Meara uses this graphic contrast of shapes and colors.

❺ Tonality

The eye tends to be drawn toward the part of the frame with the greatest contrast—usually the brightest spot in the field of view. But it's just as valid the other way around—staging the action in silhouette, for example. Deciding which are the lightest and darkest areas of your frame can also lead to unexpected but useful shapes—for example, the long lines of a shadow can be used to create dynamic diagonals across the frame.

❻ Continuity of Space

Many genres, especially low adventure and melodrama, use a wide variety of locations and cut frequently between them. Yet just as effectively, the action may take place all in the same space. Jacques Tati was a master of this technique. His live-action films often show a single space in which multiple stories take place. Your story might take place under a microscope, amongst the microbes, all in a single drop of water.

If you combine the best of your visual storytelling with clever, fun dialogue—or even no dialogue at all—you'll have something that uses the medium to its best capabilities. You could design a project that has no narrative whatsoever and relies only on aesthetics and graphic organization to deliver something that's delightful to the senses.

Abstract and experimental works can be more entertaining than shopworn clichés and tired characters. But either way, visual organization is vitally important to your work. It's what will distinguish your piece from a million others out there. It is what will make it *good*.

Or your action might take place on a tiny island that's only big enough for two people.

Recording Sound

Sound is perhaps the forgotten sense—we all hear things, but few of us are attentive to detail. Animators often spend so much time and energy making their pictures *move* that they forget about the sound. It's a common industry misconception that sound is something you drop in at the end, after the real work is done.

Nothing could be further from the truth. Sound is half of your presentation. Even a lousy picture with bad animation can be saved by great sound. Oddly enough, a great picture cannot save hideous sound. Perhaps the greatest difference between an independent project and what a big studio puts out is in the soundtrack. The studios make films that *sound* big, with full orchestral scores and fancy audio effects.

Rather than address your soundtrack at the last minute, begin planning now.

The soundtrack is more than music. It includes the voices, backgrounds and effects. even before you begin to animate, you'll record your actors' voices so you can develop expressions and action around the dialogue. You certainly can post-sync your actors—that is, record dialogue after the animation is finished. The Fleischer Studios did just that for years, even after prerecorded dialogue became easy and cheap. But working blind like that is tough for the animator—it's much better to have performances on which to hang your expressions. And it's tough for voice actors to match the mouth shapes that have already been drawn.

Because beginning animators often don't understand sound or recording techniques, they may rush the job, using substandard equipment in less-than-quiet environ-

ments. They stand around the microphone, shouting over the noise of the computer's internal fan, and end up with hollow, echoing voices that often cannot be understood.

Even worse, amateur animators compress the dialogue, trying to reduce the size of the file so their cartoons will download quickly. The results are tinny and unpleasant.

Sound Recording Checklist

A few simple precautions will make the difference between unlistenable amateurism and a dynamic soundtrack. Attend to these details and you're sure to record voices of much higher quality than those who don't possess the secret, valuable knowledge found in this book.

❶ Choose a Quiet Location

Nothing beats a proper sound recording booth, but few of us own one of those. Do your recording away from open windows and street noise, computer fans, and ticking clocks. This room should also be "dead," which is to say that you cannot hear any echo or reverberations. Try clapping your hands or snapping your fingers to hear the reverb. A "live" room can be deadened by simply hanging a blanket

on a wall to soak up the sound waves. Carpet on floors and non-parallel wall surfaces also help.

Many people record at home by building a makeshift sound booth out of furniture cushions. It's even possible to hide under a blanket with the microphone to deaden the sound. Terry Gilliam did all his recording for the Monty Python cartoons this way.

❷ Use Good Headphones

Never record *anything* without monitoring the sound as you record it. Make sure you're wearing a good pair of quality headphones. These will be over-the-ear types, *not* earbuds from an MP3 player. Invest in a decent pair—they should only run around $50 to $60 for something that will deliver superior quality.

Using a sound recorder without headphones is like using a camera without looking through the viewfinder. You might get something good, but it'll be a miracle.

❸ Get a Good Microphone

Try to use a high-quality mic, and don't let the performer touch it. It should be mounted on some kind of stand. Ignore what you've seen in dumb music videos—the best place for the microphone is slightly in front of the person who is speaking but not directly in front of the mouth. You'll need to move the mic around a bit to find the ideal position, since each performer has a different "sweet spot."

What is a good quality microphone? The answer is pretty straightforward: Good ones cost more money.

You can drop $10,000 on a microphone, and it really will sound superior.

Few animators have $10,000, though, so most have to make do with less. Peruse an audio equipment catalog or look online. Choose a midrange vocal mic that promises a flat response. This means that the microphone will relay sound information exactly as it comes in—it won't affect the sonic qualities of a voice and won't "color" the sound. Decent flat-response mics can be had for as little as $100, sometimes less.

Never use built-in computer microphones— they are notoriously inferior.

Here it is: the sweet spot.

- -

ELECTRONIC EQUIPMENT RESEARCH

If you're interested in sound equipment, you'll have to go outside your field a little. The best information can be had from sound engineers and recording enthusiasts. Try these online resources for information on mics and recording.

▶ www.tapeop.com—This site offers a free magazine for true recording enthusiasts. Most of the information concerns music production, but they have a DIY (do-it-yourself) ethic that is infectious and motivating.

▶ filmsound.org—This site has lots of great information organized in easy-to-understand categories. Lots of resources for beginners and advanced students alike.

▶ www.smpte.org—this is pure, unadulterated technical information from the engineers who invented it. Not for the faint of heart, but it is thoroughly accurate.

▶ recording.org—This is also a more music-oriented site, but its many forums cover a variety of topics. Try the "vocal booth" section for advice and recommendations.

You can access these links directly from the Additional Content section of the accompanying DVD.

Deciding which microphone to buy requires you to understand something about microphone technology. This way you can be sure that the instrument you select is doing what you want it to do. A *dynamic microphone* is made with a diaphragm connected to a coil of wire. This makes it less sensitive. And usually less expensive.

Condenser microphones require a power supply—usually a small battery—because they use capacitance to convert sound to electricity. They are usually much smaller. The mic in your computer or cell phone is a condenser. The common lavalier microphone clipped to the lapel of a TV news anchor is a condenser. However, lavs should be avoided for anything except live sound and other television applications. For recording voices or effects, they're practically useless because the constant rustling of clothing causes excess noise that's hard to control.

A larger condenser mic may work well for studio voiceovers or for going afield to gather sound effects. They're generally more sensitive than dynamic microphones, and more expensive.

Microphones are also designed to have directionality—the ability to pick up sound from one direction or another. This is known as the "pickup pattern."

The omnidirectional microphone is just as the name suggests—it picks up sound from all directions. If we were to look at the sensitivity field of an omni mic from the top, it would appear as a perfect circle surrounding the dot that represents the microphone, like this:

The omnidirectional pickup pattern

This is called the microphone's "polar pattern" or "pickup pattern" and is usually inscribed on high-quality gear. You can also find it in the microphone specs that are included when you buy the mic. If you're borrowing a mic and don't know what the specs are, take the time to research it first. Just typing the brand name and model number in an online search engine will probably yield a spec sheet.

Bidirectional, or "figure of eight," microphones pick up sound from two opposite directions.

The bidirectional pickup pattern

Although less common, they have lots of applications in music studios. Yet, most of those situations would be better served with two mics. They have very limited applications for voice recording.

The cardioid pattern is so named because it is heart-shaped.

The cardioid pickup pattern

This is one of the most common pickup patterns for general-use mics. It is directional in that it picks up sound from the front and actually *diminishes* sound from the back. Often this is accomplished through the microphone's physical structure. For example, the shotgun mic, has slits on the side of the barrel that cause the sound to be out of phase with itself as it enters the mic. This cancels frequencies from the sides and back.

The hypercardioid pickup pattern

Variations called the hypercardioid, supercardioid, and subcardioid all have differing degrees of directionality. Subcardioid isn't very directional and is somewhat rare. Hypercardioid, on the other hand, is *very* directional and exhibits a preferred pickup pattern for location dialogue on film shoots. It also works well for recording effects on location. The true shotgun mic can be seen at sporting events and presidential conferences. Also called an inference tube, it is an extremely long and expensive mic. Lots of people call hypercardioid mics—like the very common Sennheiser 416T—a "shotgun" mic, but this is inaccurate.

If you are gathering voices on location, as Nick Park did in *Creature Comforts*, you might take one of these microphones to record voices in the field.

Note that high-quality mics use XLR connectors. Most DV cameras and computers use mini-plugs. Be sure to check that your equipment all fits and works together before scheduling actors to record. Connectors that join the various standards are available at musical instrument stores and places like Radio Shack.

❹ Use a Pop-Stopper

When an actor speaks too close to a microphone, they can cause a "pop" sound when they pronounce any consonant that expels a lot of breath—like *p*, *s*, or even *f*. To combat this, you can buy a "pop-stopper," which is a device that places a screen in front of the performer's mouth. The screen minimizes the puff of air but preserves the sound of the actor's voice.

Alternately, you can make your own pop-stopper out of household materials. Cut a wire coat hanger and bend one end into a loop. Then stretch some old pantyhose across it. Bend the other end around the mic stand so that the loop of pantyhose is between the actor's mouth and the end of the mic. A little packing tape will help secure it to the mic stand.

Real pop-stoppers cost quite a bit, considering most are pretty much wire loops with pantyhose stretched across them. Expensive metal-grill ones actually do work the best.

An XLR jack from a high-quality microphone

A pop-stopper

⑤ Record Characters Separately

Unless you have two separate microphones, recording on separate channels of your audio recorder, *don't* have your performers record together. They will step on each other's lines, or one actor will dominate the microphone, making the other hard to hear. Meanwhile, you will sit in the corner, weeping softly at what you'll need to do to fix the soundtrack.

Recording the actors separately may result in flatter performances, however, and crucial timing may be lost. Since most audio recorders—and all computer audio software—can record two tracks simultaneously, you might build two makeshift sound booths or run separate microphones into two separate closets. As long as each actor has some sense of what the other is saying, they can still play off each other. It's not necessary that they be totally isolated—some leakage between mics is inevitable and isn't problematic.

Regardless, each should have his own mic and his own track.

Recording dialogue in stereo is unnecessary and will lead to *phase cancellation*. You can record environments and backgrounds with stereo, but most effects and voiceovers are done in mono. Since stereo is actually two signals (left and right), you might use two microphones to record two voice actors on the two tracks.

Phase Cancellation

Our ears are placed apart. Sound from the right side reaches the right ear first and the left ear milliseconds later. The brain uses this offset signal to determine where the sound is coming from. Stereo uses the same principle to imply the location of sounds by placing microphones apart from each other and recording two separate signals that correspond to our ears.

But when a signal reaches one microphone after another, these signals are said to be "out of phase." It's OK if we keep the two tracks separate all the way through the process—this will imply depth. But if the two tracks are mixed together, certain offset frequencies will cancel each

SOUND APPLICATIONS

Any search engine results may give you dozens of free software alternatives to use on your given choice of computer platform. Here are some open-source packages that can work for all models.

▸ audacity.sourceforge.net— Audacity is the most robust recorder and sound editor in the FOSS (free and open source software) world. It is also the easiest to use, with the fastest learning curve. Its only drawback is that you cannot "scrub" audio—which is the process of playing a file back very slowly by dragging the mouse over the audio region on-screen. Scrubbing is very useful for dialogue, as explained later.

▸ traverso-daw.org—Although harder to use than Audacity, Traverso has a few useful functions, such as the

ability to scrub audio. Designed to replace expensive DAWs (digital audio workstations), Traverso has many features only high-end software can give you.

▸ ardour.org—Ardour is also a DAW replacement software, somewhat older than Traverso. It is sophisticated, which means a steeper learning curve, but it has more functionality. Ardour also lets you scrub audio.

If you have extra money and would like to pay for software, there are a few solutions that stand out.

▸ www.digidesign.com—This is the home of Pro Tools, easily the most commonly used audio software in the professional world. Pro Tools requires a hardware component, but the introductory level mbox is certainly a good starting point. Digidesign is also known for being

expensive—although many say it's worth the price.

▸ www.sonycreativesoftware.com— Sony's ACID Pro is an extremely popular sound editing system for Windows machines.

You may also consider these popular solutions:

▸ www.adobe.com—This is for Adobe's Audition software.

▸ www.apple.com—The superintimidating Logic Pro may not be necessary unless you really know what you're doing, but the simple Garage Band could probably handle most of what you need to do.

▸ www.steinberg.net—This is the home of Cubase, also primarily a music application. You may also look at Nuendo, which is geared for film and TV more.

You can access these links directly from the Additional Content section of the accompanying DVD.

other out. This can make a recording sound thin or tinny and can lessen quality considerably.

Most voice recordings are in mono and are panned to the center, with an equal amount of sound coming from both left and right speakers. Long ago, sound designers tried panning people from left to right to match their position onscreen, but it just seemed too awkward and distracted audiences.

Some animators record a "scratch track"—temporary audio, like the audio version of a quick sketch. It's yet another way to test your ideas before committing to the expense of a full-fledged voice recording session. You can even perform the scratch track yourself, and if it turns out well, you can ask the actors to approximate it. See Chapter 11 and the section on ADR.

Understanding Digital Sound

In this new century digital audio is all around us, and you're going to have to learn something about it so you can make the best decisions for your production.

The obvious first choice is to record audio using your computer. There are dozens of free applications out there that can record high-quality audio—some may already be installed on your machine.

Technical Specifications of Digital Sound

Digital sound is created when a computer measures the pitch and level of any given sound thousands of times a second. These measurements are converted to numbers, and these are stored in the computer. When you play those numbers back, they are converted back into sound energy, and the original sound is restored.

Obviously, the quality of digital sound depends on making a great number of these measurements—the more you make, the better the approximation of the original. It also depends on the accuracy of your measurements—more accurate numbers mean better fidelity of the reproduced sound. So, digital sound is usually measured by two variables: the quantizing frequency in kHz (the number of

measurements taken per second) and the sample depth in bits (the accuracy of the measurements). Consult your user's manual to find the precise locations of these settings.

Quantizing Frequency

The quantizing frequency, also called the sampling frequency or the "Nyquist frequency," for the guy who determined this property, is determined by doubling the highest sound frequency the average person hears. Since human hearing is generally from about 20 Hz (lowest bass sound) to 20 kHz (highest pitched sound), the quantizing frequency for CD-quality sound needs to be above 40 kHz (twice the highest value of 20 kHz) in order to reproduce the range of human hearing.

The standard rate of 44.1 kHz was chosen for CDs because hard drives in the 1970s weren't fast enough to store the stream of numbers necessary for digital recordings. Researchers used modified video recorders instead. Because of the technical limitations of those machines, 44.1 kHz was chosen, and since it was far above the 40 kHz needed, it stuck.

Later, when film and video adopted digital sound, someone noticed that 44.1 didn't exactly divide evenly into 30 or 24, the frame rates of video and film. So 48 kHz was chosen so that we have an even 1,600 samples per frame of video, and 2,000 per film frame.

Then classical music recordists noticed that some instruments—like violins, for example—actually vibrate at super-high frequencies that are above the range of human hearing. But these supersonic vibrations also generate harmonics that occur in the ranges we can hear. A recording of a fine Stradivarius violin, for example, really does sound better with higher sampling frequencies that can digitize the ultra-sonic vibrations. Currently much music recording is done at 192 kHz, or four times the number of samples per second that video uses. Computer systems that record at 384 kHz are starting to appear.

Bit Depth

Bit depth is a measure of sound resolution. An 8-bit sound is one in which eight computer bits are used to store each sample. That's not a lot of information per sample. Just as a low-resolution JPEG has poor quality and cannot be magnified without showing distortion and artifacts, 8-bit sound

doesn't do the job. The lowest depth you can use for sound and still get realistic, true-sounding audio is 16-bit. Frequently, 24-bit audio is used in the studios. Lower resolution copies can always be generated from a high-quality master.

Always use the professional recording rate of at least 16-bit, 48 kHz. If you're using very high-end equipment you may want to beat those numbers. There may be the temptation to save space with lower resolution, but it's not worth the risk. Audio doesn't take nearly as much disc space as video. If space is an issue, purchase an additional hard drive.

Avoid 16-bit 44.1 kHz, the CD sample rate, since many video-editing programs will either reject it or up-sample it to 48kHz. Up-sampling can create strange artifacts during the conversion, like high-pitched whines. Don't ever record at low resolutions like 12- or 8-bit, or use 32 kHz or 22 kHz.

Audio Recorders

The compact flash recorder has become the industry standard for portable audio gear. It can record audio from an external microphone to a digital storage device like a memory card. These removable cards can be connected to your computer, just like the media that your digital camera uses. The sound files can be used in your editing and animation software as is, without conversion. This requires you to understand the compact flash recorder and set the sampling rate and bit depth. Consult your user manual, and make sure you know how to set both.

It's also possible to record on analog equipment—like reel-to-reel tape recorders or cassette decks. There are convincing arguments as to why analog equipment sounds "better" than digital equipment, but these arguments only apply to professional recording studios and top-of-the-line gear. The average cassette deck will sound infinitely muddier than an out-of-the-box laptop with a generic sound card.

Recording Sound with a DV Camera

Some people use a digital video camera to record sound—the quality is high enough if the camera settings are configured properly. After you record you must connect your

camera to the computer and use an editing application to capture the DV audio from tape to your hard drive. Although this takes a bit longer, the results are quite good. Before using a DV tape, you might want to "black" it by recording from beginning to end with the lens cap on. If you don't do this, you may have time code gaps between takes.

In addition to picture information, cameras record time code—a unique number identifying each frame of video and starting at 00:00:00 at the beginning of the tape. This helps you and the computer find the specific section you want, so you don't have to capture everything. If you stop the camera and then advance the tape forward—to a blank section of tape on which you've not recorded previously—that counter will start over again, at 00:00:00. So there will be TWO "zeroes" on that tape, and the computer will become confused as to which one you want when you are logging and capturing. Making a black recording allows you to use the tape without these gaps and keeps the time code numbers from repeating.

Make sure to turn off the "stereo" function on your camera. You want to avoid having two copies of your recording, one of which may be out of phase with the other. If your camera doesn't have the ability to disable stereo recording then just throw one of the tracks away when you capture to the disc.

Keep the Mic Away From the Camera

Your camera likely has a big motor in it to transport tape past the heads, so you'll hear whine and hum coming from the camera body. If the mic is affixed to the top of the camera body, those vibrations will pass up the arm of the mic and into the diaphragm. Most cameras have the facility to accept an external microphone, so use that connector (usually a mini-plug) to connect one. You may even wish to put the mic on a boom.

The Boom

Substitute a paint pole from the hardware store if you don't want to buy an expensive boom. The paint pole will be noisier, because your handling will travel up the boom and into the mic, but if you're careful, it should work fine.

❶ Adopt the Position of Orion

The ancients knew of the proper booming technique, even though microphones wouldn't be invented for a couple thousand years. As does the constellation Orion, stand with both hands up and feet spread apart slightly for maximum stability. You may also pretend you are Anubis, the jackal-headed God of Death (and Proper Booming)

❷ Boom on the "Inside" of Your Arm

Hold the boom so that your eyeline runs in front of the inside surface of your arm (the surface that's on the same side as your chest). It may seem like a minor issue, but craning your

NO **YES**

head behind your arm to see what's going on is uncomfortable, unstable, inflexible, and dangerous for your back.

❸ Remember the "Sweet Spot"

Just in front of an actor's face is often the best place to record dialogue, yet each actor has his or her own best spot for the microphone. Start in the generic spot and move it around to determine where the best location is.

❹ Reduce Handling Noise

Touching the mic creates thumps and creaks in the audio. Be careful to wrap cables against the boom so they don't slap against it when you move about. Create a loop of cable at the top of the boom, though, so the mic isn't pulled tight. The loop will reduce tensions on the cable that can be transmitted to the mic element. And finally, use your fingertips on the boom. Roll the boom between them to get directionality. Use a light touch.

❺ Air on the Diaphragm

Swinging the boom around causes that "wind" noise you get when air blows across the mic. A windscreen will prevent some of this, and an expensive covering called a zeppelin will prevent even more. Be careful, though; don't use a zeppelin if you don't have to. Some sound quality is lost when anything covers the microphone. And zeppelins are pretty costly, even to rent. They do look funny (and furry), though.

A zeppelin

Tips for Location Sound

Using a limiter function on your recorder will automatically reduce the gain on an incoming signal and keep it from distorting. Do not use it.

The limiter uses a compressor to automatically turn the recording level up and down whenever it thinks it should, increasing noise in quiet sections and dampening the quality of the source when it is loud. It's much more effective to set the incoming level manually with the record level control.

You may not have a record level control, in which case you pretty much have to wing it and see what you end up with. Do some experiments and listen to your recordings. You may need to vary your distance from the sound source to get a good quality audio. Rehearse a few times, and watch the meter.

The dynamic range of DV cameras is difficult to determine thanks to the substandard meters they give you. Make sure it stays somewhere around the middle and doesn't peak too high for too long.

A digital meter

Your digital meter may look similar to the one shown here. Notice that zero is at the top of the scale. For various reasons, digital audio is measured in what is called dBFS, or "decibels Full Scale." Zero is the top of the meter, and going above it means overloading the system. You have exceeded the computer's capacity to store information at that level. If you hit zero, the computer will record numerous dropouts at certain frequencies. This results in a harsh digital distortion.

This doesn't mean you should "ride" the levels, adjusting the level control constantly to stay under zero. Set the level so that the sound you want to record fits within the dynamic range.

Dynamic Range

Some sounds are too loud for your equipment, as described above. Some will be so small they cannot be registered by the mic. The range between the smallest sound measurable and the loudest sound possible is the "dynamic range" of the medium. When recording dialogue you may wish to keep the level well within the dynamic range—say around −20dB on the meter—so that your voices have enough "headroom."

VIDEO-EDITING SOFTWARE

Video-editing software is a lot more complex than audio software. As a result, there are many fewer FOSS solutions for you to explore.

▸ www.jahshaka.org—Jahshaka is a video editor, a compositor, and a visual effects studio.

▸ cinelerra.org—Cinelerra is a full-featured editing system designed to replace expensive professional systems. Unfortunately, it's a bit difficult to set up. Linux users will have the best time with it, but Windows and Mac users may need to do more work. Live CDs are available that allow you to download and try the system out by booting off a disc.

▸ www.kinodv.org—Kino is a DV-based editing system, but unfortunately it's only stable and usable on Linux systems.

Mac and Windows users have a few other options that are extremely useful. Windows machines come preinstalled with Windows Movie Maker (www.microsoft.com), and Macs have iMovie (www.apple.com). While each isn't a full-featured professional editing system, they have more than enough functionality to cut audio and video for your projects.

If these packages are too rudimentary for you, you can always spend some money for professional packages. These include Apple's Final Cut Pro, Adobe's Premiere (www.adobe.com), and Sony's Vegas (www.sonycreative software.com).

Of course, the grand-daddy of all editing software is Avid (www.avid.com). Avid is used in most postproduction houses, but it is expensive and prone to "break" when new operating system revisions are installed. Like Pro Tools, Avid is tolerated because it does so many other things well.

You can access these links directly from the Additional Content section of the accompanying DVD.

Yes, *headroom* was a term used to describe composition. But sound engineers use the term to describe the amount of dynamic range above the target level.

In the end, you want to make sure you record voices at a good, healthy, strong level—somewhere around the middle of the dynamic range or above—while not hitting zero or going too low.

Editing Dialogue

Once the dialogue is recorded you can cut it all together in your audio- or video-editing software. Both will allow you to work out the timing. Be sure to cut as much of the audio together as you can, with every pause and nuance you think you should experience on-screen. This doesn't need to be the final cut, so keep everything you might use later. Professional sound editors often cut dialogue on at least

two tracks per character. The diagram shows how two separate pieces of audio occupy two audio tracks—that is, the spaces on the timeline into which you can place sounds. As you can see, these are staggered, or "checker-boarded," so that there is maximum flexibility for editing each piece of sound. This will come into play in the final stages of sound editing, after the animation is done, and it's a good idea to do it while you're doing the initial cutting, as well.

Don't place all your sounds together next to each other in one track—it leaves you no flexibility and may end up sounding wrong. Most audio programs give you plenty of tracks to use, so fill them up.

Rerecording, or "looping," the dialogue is also called ADR (automated dialogue replacement). If your recorded dialogue isn't useable—due to noise, mistakes, bad technical specs—you can record ADR, even without a studio. ADR is covered more fully in Chapter 11.

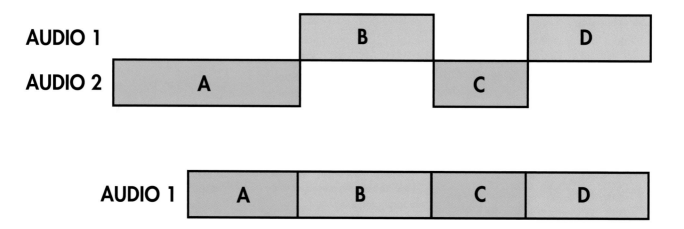

The top example is as it should be. The bottom editing is just plain wrong. Note how the sounds are butted up against each other so there is no room to work.

5 Layout

The layout process is the first step toward realizing what you have planned. Will there be a camera move in the scene? How big should the kitchen be to allow the characters to move properly? How will the background work, and what size will the characters be in relation to the background?

This layout drawing shows the "set" for the scene and the area in which the action will take place.

Without proper planning, you could end up slopping together endless cutaways of static characters shot against solid color backgrounds, hoping the dialogue will make things interesting.

Layout artists work with tons of reference material. It's at this stage that important details are considered, *before* the backgrounds go to the painters and the character animation is sent to the animation leads. It can be fun and rewarding finding all the right "props" and settings for your cartoon. Not only do you get to research real objects—a 1930s toaster, an 1890s blacksmith's hammer—but you can invent things as a result of your research. What *would* Leonardo da Vinci's toaster look like?

This steam-driven toaster was designed by James Watt in 1774. Sadly, the steam tended to make the bread soggy, and the device never caught on.

Now that so much animation is done with computers, the layout artist may be involved with determining how digital assets will be used in conjunction with traditional elements. For stop-motion animation, you need to decide the size of stages and props. If it's a mixed-media project (live-action and animation), you need to know how the various media will be acquired and used. Are backgrounds shot on video? Are live-action assets composited against green screens, so they can be married to drawings or stop-motion?

Action Safe

If you're outputting to video, you'll find that you cannot trust the edge of the frame. What looks to be the edge on a computer monitor may or may not be the edge when shown on a television. In fact, a great deal of information around the edges of the standard NTSC (National Television Standards Committee) video frame may *not* show up. This has prompted critics of the American television standard to claim that NTSC stands for "Never The Same Composition."

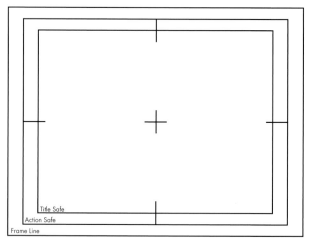

All essential elements of a film should remain within the "action-safe area."

Fortunately, we've determined the "action-safe area" of NTSC video—a space in the middle of the frame determined to be visible on the majority of television sets and monitors. HDTV has made some of this less problematic than it used to be, and users who are watching on portable devices like iPods or computers will see the entire frame, but you still have to plan for the problems of NTSC video.

It's probably best to respect this action-safe area and place all of your important action within it. Most editing software and some animation packages already have a "TV-safe" marking you can use.

A PDF of the Action-Safe grid is available in the Additional Contents section of the accompanying DVD.

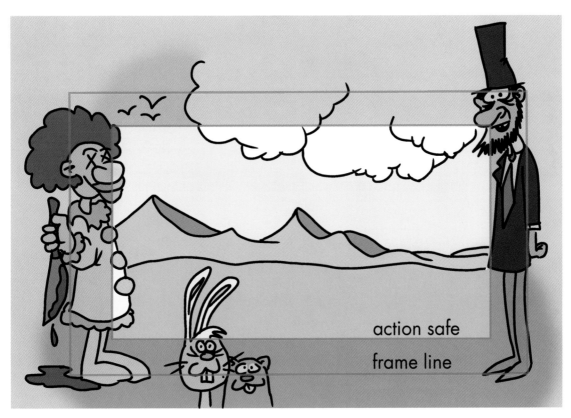

This picture fails, miserably.

Video Aspect Ratio

Standard-definition (SD) video has an aspect ratio of 4:3, or 1.33:1— for every four units across, the screen is three units in height. This "unit" can be any number—we can have an SDTV that is 40 inches across, and it will be 30 inches tall. This proportion is known as the aspect ratio of the medium. TV sizes are given in one dimension—the diagonal! So if a TV set is advertised as having a 50-inch screen, we can determine the height and width via the Pythagorean theorem.

$$x^2 + y^2 = z^2$$

Diagonal Measurement = 50"
Aspect Ratio = 4:3
thus: x=3a, y=4a
thus: $(3a)^2 + (4a)^2 = 50^2$
thus: $9a^2 + 16a^2 = 2500$
thus: $a^2 = 100$
thus: a = 10
Our measurements are 30" x 40" x 50"

This formula can be used to determine the height and width of a TV screen knowing only the diagonal measurement.

HDTV has made this more complicated. We still get the diagonal measurement for the TV set, but now we have different algebra since the HDTV screen has an aspect ratio of 16:9.

For most digital files the aspect ratio is expressed in terms of square pixels. A standard frame size for NTSC video would be 640 pixels by 480 pixels (which is actually 4 times 160 on the horizontal by 3 times 160 on the vertical). When digital video was invented, however, the engineers determined that the shape of a DV pixel would be *non-square*. This is, ostensibly, how they increased vertical resolution without adding more horizontal scan lines. But this means that DV pixels are actually little rectangles, one unit high and .9 units wide. Thus, the DV aspect ratio is usually expressed as 720 x 480 pixels.

If you use standard-definition DV as your output, editing software will squeeze a square-pixel image, making it look thin.

The Horrifying World of Video

At this juncture you may have noticed that 720 multiplied by .9 does not equal 640. In fact, it is 648. But the pixel nightmares are just beginning—the original digital video standard (called D1) specifies 720 x 540 pixels. 540 x .9 = 486. These numbers simply do not add up.

Prepare yourself, for you are now going to learn one of the *big* secrets of video: This system was never designed properly.

Over the years many committees and some insane geniuses have shaped the beast we know as video. It's been patched and repatched for more than fifty years, and each set of well-meaning, well-trained engineers have made a continual hash out of the whole enterprise. The sad fact is that all standard-definition video is calibrated so that the center of the image is maintained throughout the various cameras, recorders, monitors, and other devices. The *edges*, however, are highly flexible, and information on them may or may not be transmitted, captured, recorded, or seen.

When software engineers began working with video they all had heart attacks. The whole notion of centering things and then letting the edges fall off was ridiculous. To this day all those extra six or eight pixels just get dropped in favor of frame sizes that are easier to remember.

Did They Ever Fix It?

Yes, more or less. HDTV corrects many of the problems with NTSC, including a move back to square pixels. But HD sizes are tricky, too, owing to the wide variety of HD implementations. True, actual HD is a very simple, clear specification, but few devices are able to handle the sheer amount of data required for a full HD image. And Europeans have a completely different system for their digital TV.

A chart of TV formats and their equivalent sizes is provided in Appendix B and as a PDF in the Additional Content section of the accompanying DVD. Consult this chart when planning your cartoon for those ratios and sizes.

Choosing a Format

When planning for your ultimate format, always keep in mind that lower quality versions of your film can be made later. As of this writing, your big decision is going to be one of three formats:

1. Standard-definition (SD) output—usually DV
2. High-definition (HDTV) output
3. Film output: 2K or 4K resolution

The highest quality is film, but it's also the heaviest load on your computer and the most expensive to make. HDTV is a good bet for future media, and SD versions can be generated from it, including SD DVDs. Yet SD is good because it has a smaller footprint on your hard drive, and it's still the lingua franca of the American video world—not everyone has HD sets just yet.

In any event, you need to settle on a format so you can prepare digital art that works with your aspect ratio and your resolution. If you prepare art with a square pixel, it may look squeezed or stretched when you apply it to a vertical-pixel frame: 3DCG and stop-motion animators have the same problem with material they generate—square or non-square?

The best solution is to create art for a specific aspect ratio—4:3 or 16:9—and stick with it. Then make sure that the resolution is higher than you need it to be, but still within the ballpark of the output format. It's not necessary to make frames that are 4,000 pixels wide for a cartoon that will end up on DV where a frame is only 720 pixels wide. But if your frame is only 500 pixels wide, the quality will suffer when it's stretched out to fit a 1,080-pixel HD screen.

Scene Planning

The great majority of layout work is in planning the backgrounds. When a character walks down a street, it's often the layout artist who decides how long the street will be and where the character will be placed.

No matter your animation style or technology, you need to plan movement, choose backgrounds, and establish camera placements for the shots you want.

Camera Moves

Often animators design scenes to imitate the movement of a camera. To create a camera pan (moving from left to right), you move the background horizontally. But when you move a background horizontally, you'll have problems with vertical lines. If you intend to have a character pass a series of telephone poles, they can strobe annoyingly. Unless this is the effect you want—and it seldom is—you've got to avoid all vertical lines.

Even if there are supposed to be trees and streetlamps, you can work them into the background without creating strict verticals that create a strobing problem. Lean the verticals slightly—thus clearing up the irritating strobe and giving an additional feeling of movement. The Disney animators used to design their backgrounds so that any props or background objects would follow a graceful curve, therefore making a pan easier to read. [1]

Zooms are a different matter. Whenever you zoom in on artwork, you're magnifying it. If the artwork is at standard resolution and you zoom in, you'll lose resolution. Blowing up the artwork that much will cause you to see the pixels.

Computer art formats use DPI or "dots per inch" to measure resolution. DPI was originally determined for still images used in printing. So an image at 300 dpi isn't as sharp and detailed as one at 1200 dpi.

1

In the world of the moving image, the standard DPI is 72. This is a completely arbitrary number and has to do with someone's calculation that a TV screen would display a line of seventy-two dots within the space of an inch. This isn't necessarily the case on all monitors, and certainly not with many devices available today.

But if you adhere to 72 dpi, if you start on a wide shot of the enchanted castle and then zoom in to the door, the final door framing must be 72 dpi at 100 percent. This may mean that the wide shot is *thousands* of pixels wide. In the computer, this is much easier to do, since preparing digital artwork of that size is relatively easy. In older, handmade cartoons it was sometimes impossible to create artwork large enough, or to build a camera tall enough to accommodate such a tremendous zoom.

Perspective

Suppose the first shot of your cartoon shows Dingy Duck walking down the street. When you lay out the scene, decide on what image size and camera angle you're going to use—it'll probably be based on your storyboard. **[1]**

This shot needs to be drawn in perspective, to create the required sense of depth. Perspective is basically a bag of perceptual tricks to fool the eye into thinking that a two-dimensional image actually exists in a three-dimensional space.

The 2D artist who masters perspective will create interesting camera "angles" and backgrounds for his or her work. The 3D artist has the computer to help with perspec-

tive, but knowledge of the basics still provides the freedom to visualize complex camera angles and background structures without having to build them first.

❶ Basics

Parallel lines converge. Think of the typical example—the railroad track. The horizon line represents that distance at which the plane of the sky and the plane of the earth seem to meet. **[2 and 3]**

The point where those lines converge, the vanishing point, is a natural place for the eye to go. So, the clever artist places his vanishing point where he would like people to look.

An even cleverer artist may place his *characters* at that point of interest.

If railroad track lines converge, then so would other lines on other planes, such as roads, walls, and all objects within the field of vision. This is called *one-point perspective*.

However, if you drew a box as seen from its corner, the audience would be looking at the edge of the box, and there would be *two* sets of converging lines and two vanishing points. This is called *two-point perspective*.

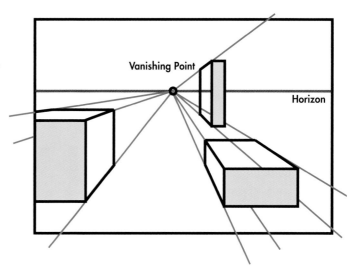

Vanishing Point

Horizon

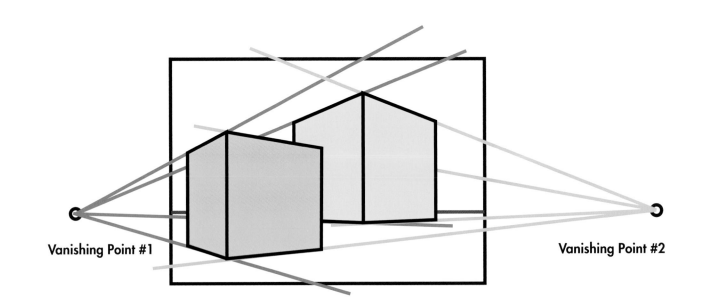

Vanishing Point #1

Vanishing Point #2

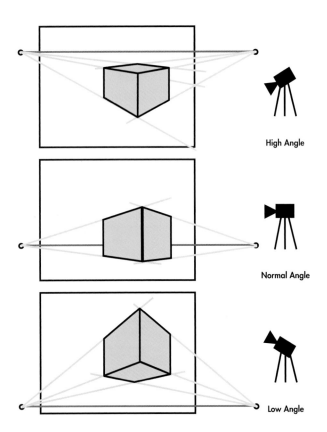

High Angle

Normal Angle

Low Angle

The camera angle affects the perspective of objects in the frame.

Two-point perspective is the most common perspective used in animation backgrounds. Not only is it easy to construct, but it gives a natural feeling of space that helps situate the characters within the background.

If we place action on one of the vanishing points, and place the vanishing points at a pleasing distance (not equidistant, which tends to be boring), then we can design any number of great backgrounds that work well with characters.

To construct two-point perspective, begin by determining the horizon line. Where is the camera level and therefore the eye level of the audience?

With perspective, you place the audience where you want them, and you affect how they feel about what they see. How do we draw these lines? Start with a simple grid to delineate ground space from sky.

1. To begin, mark off the bottom of the frame in even increments and draw lines converging to the vanishing point.

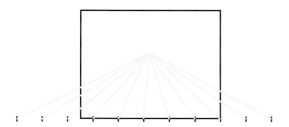

2. Draw a horizon.
3. Now draw a line from the center of the horizon line to the bottom of the page.
4. Next draw a diagonal line from either the left- or right-hand point where the horizon meets the edge of the page, ending at the opposite bottom corner. Where this line crosses that center vertical is where you will place your next horizontal.

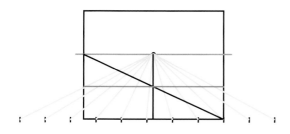

5. Draw a new line from the original point on the side of the frame, but this time draw it to the second horizontal instead of the bottom of the page. Where it crosses the center, you'll place you next horizontal.

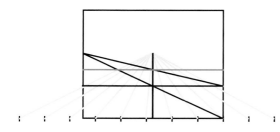

Continue in this way, and soon you'll have marked out perfect horizontals, spaced precisely apart, all the way to the vanishing point.

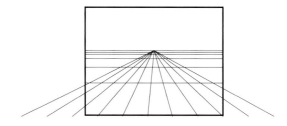

Here's another technique for creating evenly spaced lines in perspective. Think of the ground plane as a rectangle turned in space.

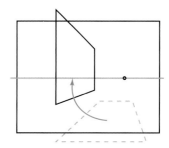

Draw an X by running a line from each corner of the rectangle. The point where the X crosses is the center of that rectangle. Mark it off as a vertical. That is the halfway point in perspective. Now that you've divided this space in two, consider each division as a new rectangle and repeat the process however many times you need.

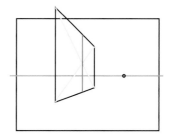

61

And if you want to add even more lines, try *three*-point perspective.

Vanishing Point #2

Vanishing Point #1 **Vanishing Point #3**

Here you're looking at an object corner-on, so all three dimensions of the object are governed by a set of converging lines. And with three-point perspective, all vanishing points are outside of the frame.

With these techniques, your drawing will be accurate, but perhaps a bit dull and even mechanical. Practice until you get the feel for the spacing—later you can guess where the lines are and create a background that has a human touch as well as it suggests proper spacing.

❷ Perspective Challenges

Occasionally working with perspective can lead to difficult geometry. For example, if you want to make an object appear grounded, rather than floating, make sure you place the bottom of the object below the horizon line. Objects placed above the horizon seem to hover in space.

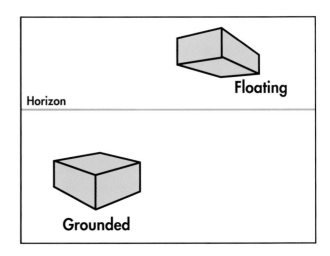

Floating

Horizon

Grounded

Three-point perspective is such an artificial system of construction that it is possible to distort figures completely. This is because perspective was invented to duplicate what human beings see in their "cone of vision," which is to say the field of view around the point on which you are focusing. This fellow shows us his cone of vision, which extends at a 60° angle from the center.

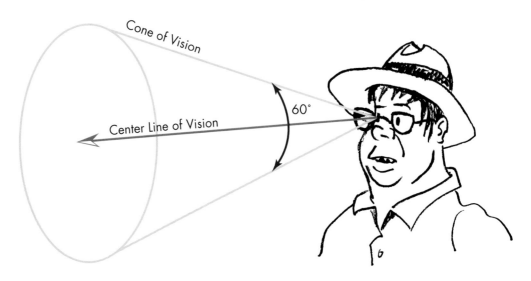

Cone of Vision

Center Line of Vision

60°

Outside the 60° angle of view, the perspective model doesn't hold up so well. You get distortion.

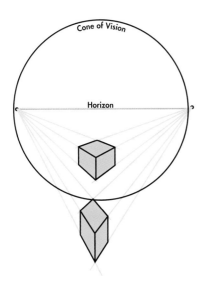

Try to keep three-point perspective drawings within a triangle created by the vanishing points, and you will never leave the cone of vision.

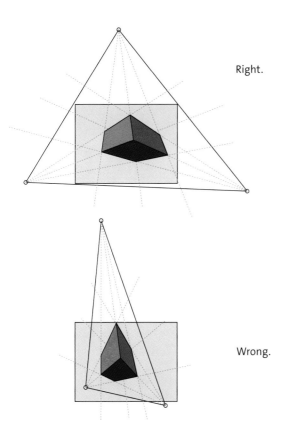

Right.

Wrong.

How about a circle drawn in perspective? Draw a perspective square first. Then you can fit the circle within it pretty easily.

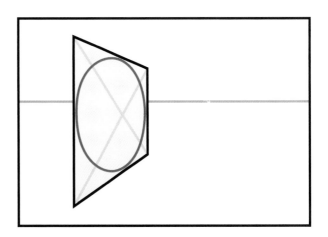

Placing characters in space is easier when you consider that same-size characters will hit the horizon line at the same spot. So if a character is in the background and the horizon line hits her at around eye level, it will continue to do so as she walks forward toward the camera, as seen in the example on the next page.

Once again, the best way to deal with perspective is to practice it, until it feels natural. Don't feel as if you need to construct all of your drawings by mathematical rules, or they'll be stiff. It's much better to decide on the framing and angles you like and then use the perspective to *improve* the drawing.

63

❸ Flat Space

Crazy perspectives can be fun, but boy, do they require a lot of extra work. A feature animation crew can get away with hundreds of setups, but what if you're the lone wolf who's trying to produce cartoons on a regular basis?

There's nothing that says you can't use flat backgrounds and staging, and sometimes these can be very effective. It's no less work for you in the planning, though. With a totally flat space, you're working with only two directions—left/right and up/down—so your blocking will be forced to work within these limitations.

Cut down the workload by avoiding excessive trucking, panning, and zooming. The more you move the camera, the more complicated things get, and the more artwork you have to prepare at more exacting standards. Save the tricky stuff for moments in your piece when it's necessary—like climactic scenes or moments of heightened emotion.

How Do You Know You're Done?

You should have artwork for every scene in your project. They may be pencil drawings of backgrounds you'll paint later, or they may be completed art ready for the final. They shouldn't be sketches or storyboards, though. You need to work out more detail than that. If the backgrounds aren't complete, how will you know how to animate your characters against them?

Scan it all in (unless it is already digital), and replace the storyboards in your timeline with finished layout drawings. Then watch it all at normal speed.

- Does it work?
- Are your camera moves and edits flowing in a way that seems natural?
- Is it dynamic when it needs to be, simple when it can be?

You'll know what works for you, and *now* is the time to redo it if it doesn't work. Every step of your process is worth checking in your timeline because, happily, you *can* check it constantly.

Character Design

Animators often use the term "character design" to refer to the aesthetic of a character's appearance on-screen. Fortunately, there are no hard-and-fast rules for this sort of thing. Although everyone seems to have his or her favorite tricks and techniques, there is no right or wrong.

However, the technical requirements of designing characters will make animation more or less difficult, so a balance must be achieved between the aesthetic and the practical.

Model Sheets

Frequently 2D animators draw what is called a "model sheet," which depicts characters from a variety of points of view, enabling the artist to understand how each character is put together and how to draw them from any angle. A model sheet often includes notes on the side, explaining specifics of the way the character is built. Related to this is a "turnaround," a set of drawings showing the character in various positions as it is turned around 360°.

For a cartoon character to have interesting, funny, or believable motion, the animator must convey shapes that possess mass, weight, and volume—something not all print cartoonists grasp when they try to animate. Although a flat character may have an appealing design, it may not be adapted well to animation. It may not look good from all angles.

On expensive feature animation projects, the artists may even create a "maquette," a small sculpture of the character, made so the artists can consider the character from all angles. Maquettes are usually made with polymer clay, like Sculpey. Try making one and you'll discover all the pros and cons of your design.

America's favorite model sheet.

3D Rigging

Your 3DCG models may look good, but you might not have them ready to animate. You have to "rig" the model for movement, usually with a simple skeleton.

The complexity of this rigging explains why there are people in the industry whose sole job it is to rig models that another team will use. Once the perfect "puppet" is created, animation becomes a much simpler job for the person moving the puppet.

Most 3D packages have systems and controls for rigging your 3D models. They may call them "bones," "joints," "parents," or even "skeletons." The most common term is "rigging," though, and your software manual should offer tutorials explaining the process in detail.

One very common way of referring to the way body parts are linked in 3D programs is to use the parent-and-child object concept. A parent object is one that passes its characteristics (movement, color, size, shape) down to child objects.

Think of your character as a kind of puppet. If an arm is moved, for example, the forearm, the wrist, the hand, and all the fingers move with it. The hands and fingers must be considered as "belonging to" the arm, yet capable of movement on their own.

So the arm might be the parent of the hand, and rotations of the arm will affect the movement of the hand. But the hand is the child of the arm, so the hand's rotation does not go back up the chain and does not affect the arm.

Because some objects are ranked above others, we have a hierarchical structure—one that might look like this:

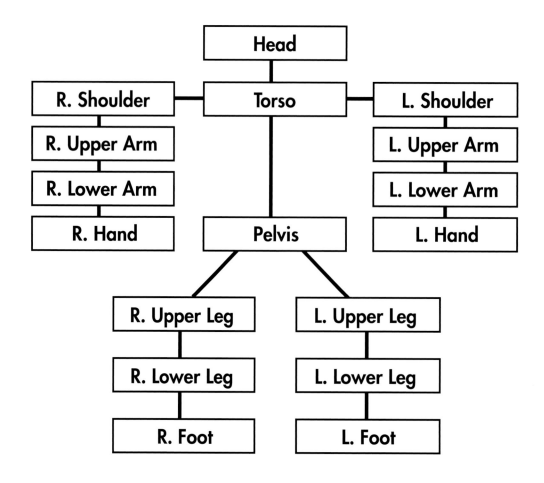

Stop-Motion Models

Stop-motion animation yields a challenge of an altogether different—and more physical—nature. Your models must be flexible enough to yield the movements you want to create, yet durable enough to withstand the hours of punishment you're going to give them.

There are as many different kinds of models as there are animators, but they generally fit into two broad categories: those with articulated armatures and those that use replacement parts. Clay animation can combine aspects of both very easily.

BONUS! Check out the Stop-Motion Tutorial on the DVD.

Armatures

Many stop-motion models begin with a kind of skeleton on which the figure is built. Clay models may have an armature beneath the surface to give the model consistent shape and stability.

The pros build their armatures out of metal, taking the time to machine them to specifications and designs. These armatures have stainless steel ball-and-socket joints and articulated hinge elbows and knees and may even be weighted so they balance properly. Machined armatures give fluid, precise movement and are, in general, a joy to work with. But they are prohibitively expensive—either you invest hundreds of dollars in each, or you buy all the tools and equipment to make your own.

Cheap armatures for less ambitious projects can be made easily, using wire. Try a thin gauge, like florist's wire. Do not use a coat hanger, which is far too stiff.

Add lumps of epoxy putty to the wire body to give it some mass and to isolate the parts where you want the armature to bend. Cover it with foam or other materials, add costumes and a head, and you're ready to go.

If you use several strands of wire for each limb and maybe as many as six for the torso, it will add flexibility and your model won't break as often while shooting.

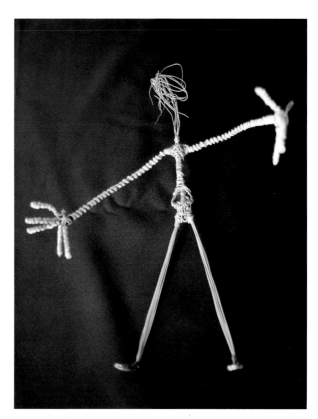

Armatures for a rudimentary character model using readily available materials

To secure these armatures to the surface on which you're working, place a common hex nut inside the foot loop with epoxy. Then insert a bolt through the bottom of your stage surface and screw it into your model to secure it in place.

Another cheaper but highly effective method is to build your armatures just as you would using metal, but employing wood instead. You can build wooden armatures at a fraction of the price, although they won't be as sturdy or move as elegantly as a properly machined skeleton.

All you need is a small hand drill, tiny nuts and bolts, and some popsicle sticks. Ball-and-socket joints are used for the shoulders and hips. These joints were purchased from smallparts.com.

With wood armatures, remember that the wood is thin and prone to break, so drill replacement parts that will be readily available during shooting. Wood may not work as well with clay, either, due to the force required to move clay over the fragile wooden skeleton.

- -

SOURCES FOR ARMATURES

If you've got money and don't want to spend time drilling small pieces of wood or metal, you can buy prebuilt armatures to your specifications.

▸ Armaverse—www.armaverse.com
▸ Animation Supplies.net—
www.animationsupplies.net/
shop/armatures.shtml
▸ Gryphyn—easyweb.easynet.co.uk/
edawe/index.htm

▸ Wuchan Kim—www.clay-mate.com
For DIY armatures, try these sites for materials
▸ Small Parts—www.smallparts.com
▸ Berkey Systems—
www.berkeysystem.com

You can access these links directly from the Additional Content section of the accompanying DVD.

Replacement-Part Stop-Motion Animation

Instead of moving one model, multiple models are made to represent each movement state. To create dialogue, for example, about a dozen identical heads—each having a specific mouth shape—are sculpted. When the scene is shot, these heads are switched out according to which mouth shapes are necessary to create convincing dialogue.

Replacement-part animation is extremely time-consuming, but it has a look like no other—it's as if the sculpture is somehow fluid. It's difficult and labor intensive, yet there's still something magical about real-world objects as opposed to computerized shapes.

Creating Mouth Shapes

First the original head is sculpted in a polymer clay—like Sculpey or Fimo, available at any craft or art store. These materials are used instead of oil-based modeling clay because you need a model that won't squish or squeeze during the casting. Most polymer clays are tough to work with until they're kneaded thoroughly, so be sure and work with it before sculpting. Polymer clay must be baked when you're finished modeling. Never bake oil-based clay.

You can use anything you like to sculpt the clay. Here are some favorite tools in my box:

These are also inexpensive and can be purchased at craft or art supply stores. You can also use chopsticks, toothpicks, barbecue skewers, dental tools, pencils, popsicle sticks, or, of course, your own hands. There are neither improper tools nor best tools; there are only what work for you.

This head is the basic unit and may be sculpted without a jaw at all to make the variations easier to produce. Where the head attaches to the body of your model, make sure it's "keyed" so that the hole or peg at the bottom of the head can only fit one way onto the model.

Next, create a mold that you'll use to make numerous copies. Although expensive, the best casting medium for this work is silicon mold compound, ordered from a plastics or art supply shop.

Select a container that will hold both your model and the sprue. The sprue is an extension of the head that will leave a channel in your mold.

Suspend the model over the container, and pour the silicon mold compound all around it, with part of the sprue poking out. Once the silicon hardens into your mold, you can cut the mold in half—very carefully—and remove the original head. Once you remove the original head, put the mold tightly back together, fill it with a casting material such as polyester resin or urethane, and you'll have an

This diagram shows the original head, sprue, and casting container.

Here the hole that will attach the head to the body is a simple square, which provides stability and consistency.

When preparing the head for a casting, include a sprue—seen here in yellow—which will leave an opening into which you'll pour the casting materials.

Once you've created your mold, you'll see the channel created by the sprue.

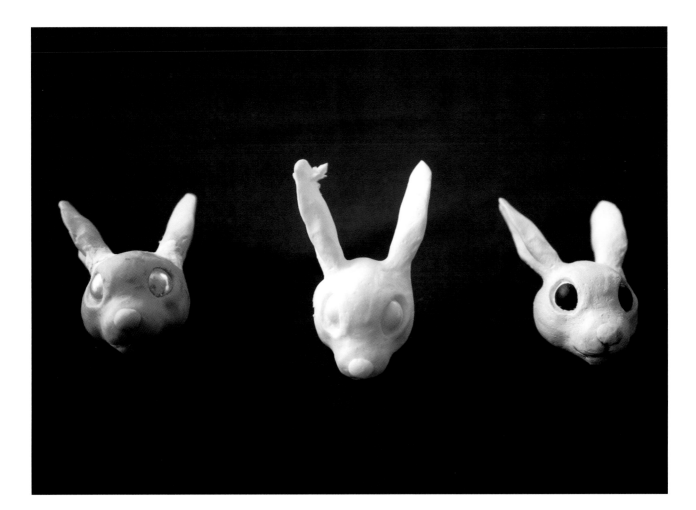

exact duplicate of the original head. Clean out your mold each time to avoid imperfections, then make more heads. Make extras.

Sculpt new jaws and lips onto each of the heads to make a variety of mouth shapes for dialogue. You can even create different eye shapes for a blink. When you paint your heads, paint them all at once so you don't have to match colors later on.

Which mouth shapes should you make? That depends. Read Chapter 7 on timing to decide how you'll do the dialogue, and then choose an optimum number of heads to make, and determine what mouth shapes they should have.

This photo shows the three different states of head manufacture. The head on the left is the original polymer clay model, and the one in the middle is a plastic cast of the original. When it first comes out of the mold, a plastic duplicate will have imperfections where the seam was in the mold, and you'll need to sand those away.

The one on the right is the completed, painted duplicate of the original head.

As you make variations, keep track of the heads, placing them in a box with labeled compartments so you don't confuse them. The "key" shape you included in the heads will keep them aligned between frames and prevent the heads from jittering or wiggling in the final shots.

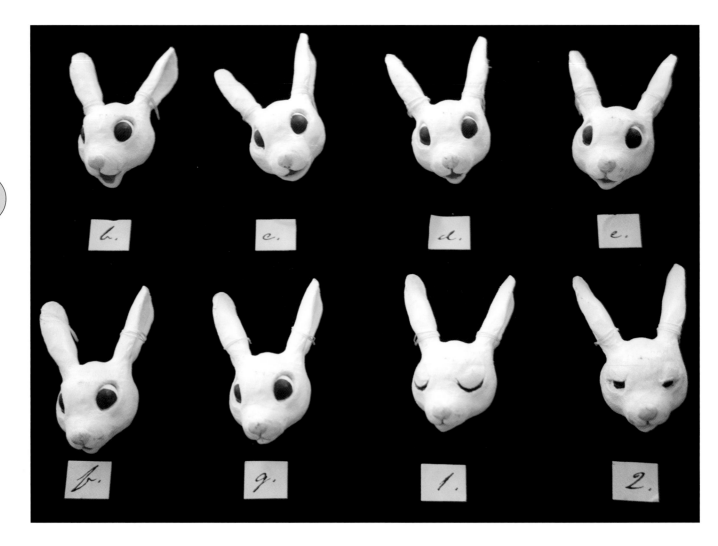

ADOBE FLASH

When most people think about computer animation today, one of the first words that comes to mind is *Flash*. This is because Flash is a very popular application for making animated content on Web pages. Although it's used in a number of TV shows, Flash is actually not a very good piece of software for animation.

Adobe engineers have worked hard to make the program adaptable and flexible for Web designers, but classically trained animators are a small percentage of their clientele, so further versions have become less suited to animated cartoons than for Web interactivity.

To use Flash well you have to employ a variety of workaround methods to get it to do what you want. In the last ten years of Flash animation some very clever people have adapted themselves and their work to the capabilities of the program, and high-quality, effective work has been done with it.

If you'd like to try Flash, download a thirty-day demo from www.adobe.com. But if you think you must learn Flash to make animated cartoons, then you are very much mistaken.

Limited Animation Characters in Flash

The following section describes an advanced technique for Flash users. It requires that you have some familiarity with the program and some experience in creating art and using symbols and timelines. If you don't have a copy of Flash, or you are a complete beginner with the program, you may want to skip this section for now. If you've used Flash, this section will show you how it can be employed to make higher-quality limited animation.

In the 1950s, in response to the high cost of making cartoons, TV animators developed "limited animation," a system whereby only certain parts of characters would move, reducing the time and resources spent drawing and painting. If a character spoke, only the mouth would move and the eyes would blink—the rest of the body would remain still.

Flash makes this particularly easy because the artwork can be stored as separate symbols, all of which can be composed of symbols themselves. You can create hierarchies of body parts that can all be connected to one another but still be edited singly, if necessary.

The real power of Flash as a program for limited animation is that each symbol can have multiple frames. So you could design a character's head symbol and include *inside it* all the symbols for the eyes. The eye symbols might have four frames just for the various states of a blink.

Thus the animator can place the head on a Flash timeline and, when a blink is necessary, change the eye symbol, thus:

- Create a keyframe.
- Double-click the eye shape symbol.
- On the Properties palette make sure Single Frame is the option selected.
- Type in the number of the desired eye shape.
- Go to the next frame of the timeline and set the next eye shape.

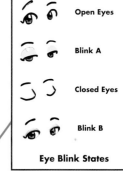

This diagram shows how symbols can be organized to create a limited-animation character in Flash.

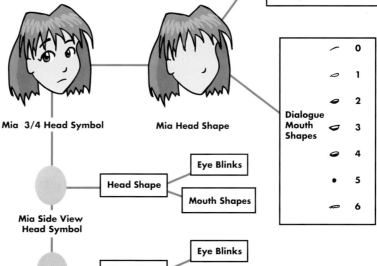

73

The Flash Properties dialog box showing the single-frame options

To design a character for limited animation, you must first decide what the hierarchies are. It helps to design this system so it's uniform for all your characters within a given show. Inconsistencies across characters will only result in confusion for the animators.

Start by drawing out the hierarchy of body parts. The lowest position is occupied by features—eyes and mouth shapes—with seven mouth shapes and seven blinking eye states. These are placed in order on a timeline, and the whole sequence is made into a movie symbol. The eye and mouth symbols are then placed on the head, and that is also made into a symbol.

Next, the head can be joined to a torso, along with limbs—which are similarly joined and made into symbols. Once all of the symbols have been created, the character is saved. For each scene we can load in the saved file and it can be pasted in for animation. When you want your character to speak, you will choose which of several already-made mouths will work.

For professional television work, making a complete character can be very complex. Not only will a character file include all the eye and mouth movements, but it will also include a character turnaround as well, each with all the corresponding eye and mouth movements already "rigged" to the appropriate symbols. When characters are happy or sad, there are variations for those, too.

Once all the poses have been designed, new poses can be added as a show progresses, and the new version of each character file may be given to the animators.

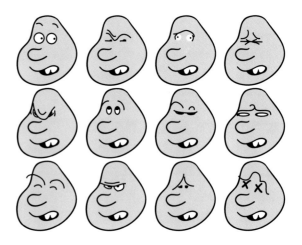

The really smart designers will create a Flash file that has all the character parts organized in the timeline according to a standard order. They might place the full-body turnaround on frames 1 through 9. Starting on frame 10 they might place the dialogue positions for every angle in the turnaround. Happy faces might start on frame 40, and at 45 would be the blinks. At 50 we might put sad faces, with the blink once again at 55. Gradually we build a regular system that any animator can use.

It's a long and tedious process setting up each new character—literally hours of design work for each one. But once it's been done, the animation process is remarkably streamlined.

7 Timing

Breakdown

In animation, the term *breakdown* doesn't refer to your mental state at any given moment, but rather to the process of breaking down the enormously complicated and sophisticated film you're about to make into smaller, bite-sized chunks of action.

As you start realizing your ideas, you have to contend with the fact that things tend to play out differently than you may have imagined. Perhaps your own lack of experience or resources will force you to change course. Sometimes happy accidents and other people's contributions make the work much better than you thought possible. The final project will be *related* to your initial vision, but it may be significantly altered by the process of bringing your cartoon out of your head and into the real world.

Novelists prepare outlines and divide their books into smaller chapters. Software programmers break down their tasks into routines and block diagrams, and painters work out their paintings from sketches and color studies. Similarly you'll break down your film or video into smaller pieces. In the process, you'll determine the timing.

The X-sheet

The X stands for "exposure," because X-sheets used to be instructions for the camera operator who would actually shoot the cartoon. X-sheets—sometimes called "dope sheets"—are vital planning tools for cartoons. You may be working with collaborators, so an X-sheet will help keep everyone literally on the same page. And the lone animator uses the X-sheet to keep all of the details and timings in one place.

Some beginning animators refuse to use the X-sheets. Not smart. The X-sheet gives you two distinct advantages:

- Your animation can be ten times as subtle, distinct, and exact when you map it all on paper first. Paper is better than memory.
- Animation is tedious at times. Whether posing clay or drawing pictures, you're using the right side of the brain so much that the analytical side is taking a nap. This means you will forget things you wanted to animate, and before long you won't remember what frame you're on. It's very comforting to know you can rely on the X-sheets, or improvise around them.

Most animators use one line for one frame of the film. This uses lots of sheets, but it keeps things pretty clear. The computer can be used to keep track of X-sheet information, but this can be problematic when you're using that same computer for animating. Switching between windows to see what frame you are on is a little more cumbersome than referring to a physical sheet of paper nearby. Stop-motion animators in particular tend to want a physical sheet for reference.

How do you fill out an X-sheet? Do you just guess? Not at all. There are many ways of determining how long actions should take.

PROD.	SEQ.	SCENE		SHEET

ACTION	DIAL	FRAME	4	3	2	1	EXTRA	CAMERA INSTRUCTIONS

An X-sheet. A template is available in the Additional Content section of the accompanying DVD.

Making an Animatic

Make a raw, temporary copy of your entire cartoon by scanning in all the storyboard thumbnail drawings and running them with your temp sound. You can continue to draw pictures and edit sound until you have a still-image version of the entire cartoon. This is called an "animatic," "story reel," or even "Leica reel," named after the camera they used at Disney in the 1930s. It's a pretty effective method of determining timing for actions and scenes before you begin to draw the final pictures.

It's a lot like storyboarding, except that the animatic will tell you *immediately* what is and isn't working for timing. Then you can be brutal, and cut anything that isn't brilliant. Conversely, feel free to add new things that will improve the piece. You may wish to consult Chapter 10, on editing, before producing the animatic.

Once the animatic is made, you can show it to others to elicit comments or criticism, or share it with your team. You can add rough animation, tests, and eventually the finished, colored, rendered artwork as you go. You can always view the most recent version, check it to make sure it still works, and get a feel for how much work remains.

Frame Rates

Before you produce the animatic, you still have a few decisions to make. You still need to know what frame rate you're working with. This next section is a very long answer to a very simple question, but these concepts are fundamentally important to knowing what you're doing.

Film and video use a different number of frames per second. The standard speed of motion picture sound film is twenty-four

frames per second. So, for each second of film time, twenty-four separate pictures flash across the screen. Video, on the other hand, was standardized at 30 fps.

Does this mean you need twenty-four or thirty different drawings for every second? Not necessarily.

You can animate "on twos," which means that you make one picture for every two frames. Can you animate on threes? Fours? Anything is possible, although if you're working in 3DCG there are very few cases where you would animate on twos or threes.

Disney is known for animating on ones—one drawing per frame—for the smoothest, best motion. The classic Warner Bros. cartoons were all animated on twos, and most TV animation is on twos. A lot of anime is made on a number of different frame rates, depending on the emotional mood of the scene. A humorous scene may be animated on threes or even fours, but an action scene or intense love scene might switch to ones.

As a result of the different frame rates of film and video, you can run into some confusion and technical trouble. Consult your software manual to make sure you understand where to set the frame rate for your projects.

Video

The thirty frames of NTSC video are split into "fields," and there are two to every frame.

Old television picture tubes had a scanning electron gun that shot a stream of charged particles onto a glass surface covered by phosphorescent material. This system was developed in the 1930s, when electron guns and TV screens weren't that great. Once the gun scanned from the top of the picture to bottom, the top half was already fading! The solution was to split each frame into two fields. The first field was composed of scan lines 2, 4, 6, 8... and so on. The second field had all the odd-numbered lines. Because these fields were made of interwoven lines, the frame was called *interlaced*, and this video scheme was called *60i* to denote the 60 interlaced fields.

HDTV and computers don't have to interlace. They keep the scan lines in order. This is called *progressive* and is denoted as *p*.

The benefit is obvious—no tricky fields. But whereas progressive frames give us undoubtedly better quality video, we're still stuck with the legacies of NTSC. All progressive-frame video that's shown on a standard-definition video monitor will have to be broken down into fields at some point. We can only enjoy progressive video on computers and expensive monitors.

HDTV specs vary, and there are a number of different configurations:

- 60i – Sixty fields of interlaced video. The SD rate. If you have a home DV camera, this is what it uses.
- 50i – Fifty fields of interlaced video. This is the scan rate of European TV, PAL, and SECAM.
- 30p – Thirty frames progressive video. The HDTV rate.
- 24p – Twenty-four frames progressive-scan video. If the size of the image is large enough, this video can be printed onto film with a very expensive laser. It must be at least 2K (2,048 pixels horizontal), but ideally 4K (4,096 pixels horizontal).
- 25p – Twenty-five progressive frames for use with PAL or SECAM cameras (must be converted to 50i for use on PAL TVs).

- 60p – Some high-end HDTV systems use sixty frames of progressive material. 1080p60 isn't as common as of this writing, but it is gaining ground.

Which is practical? There is no real answer, but there are some recommendations.

Beginners should strive for high quality, but not necessarily the most technically complicated. A DV-based project, using 720 x 480 sizes and a frame rate of 60i (on 30 fps) should result in a high-quality cartoon that's suitable not only for SDTV systems but for DVD presentation. This size and frame rate would be useable and watchable on the greatest number of systems.

The advanced user may wish to try his or her hand at one of the other formats. The full-size HD format is probably a good idea, because lower quality SD DVDs can be made from the higher quality file. If you believe you will present your material on HDTV or Blu-ray players, you should design with this in mind.

Film

Only those persons with lots of hard drive space and money should try to work at film sizes. You have to work with very large files—2K (2,048 x 1,556 for a 4:3 aspect ratio), and preferably 4K (4,096 x 3,112 for a 4:3). One frame of uncompressed 4K requires 36.5 MB on your hard drive, and one second is over 1GB.

Labs charge by the frame to transfer computer files to film, and the first transfer is never the best picture quality—you end up making a couple of them. This can cost literally thousands of dollars for a short film.

However, if you are good at raising money and expect that your piece will see theatrical distribution someday, you may plan for a 2K or 4K 24p project, knowing you can generate all the lower formats—including a brilliant-looking HD copy—once you are finished.

Telecine

Telecine is the process of making twenty-four film frames fit into thirty video frames without any conflict. It's best done at a facility that has equipment to perform a good film-to-video transfer. You cannot simply point a projector at a wall and shoot video of the projection if you want decent quality.

If you are producing any project that involves transferring film to video, mixing sources, or going from video back to film, you'll want to understand this next section.

Film-to-video transfer is possible because 24 and 30 have a common denominator of 6. As long as you match up four film frames to five video frames, the problem is solved. Since the video frames can actually be split into fields, four film frames must fit into ten video fields. Telecine is accomplished by duplicating information and mismatching the video fields when film is transferred to video.

The diagram shows how this is possible.

- Film frame A matches directly to both fields of video frame 1 but also video frame 2, field 1.
- Film frame B maps onto video frame 2, field 2, and video frame 3, field 1.
- Film frame C maps onto video frame 3, field 2, and directly to the entire video frame 4.
- Film frame D maps onto video frame 5.

This strange alternating pattern of mapping three fields and then two fields is what gives this process its other name, "3:2."

Pulldown

You may also run into issues with pulldown if you have recorded sound on a 30 fps medium—like a DV camera—but intend to animate at 24 fps.

Sometimes you'll hear people mention pulldown when referring to the 3:2 process. Software engineers often refer to pulldown when they are actually talking about the 3:2 process, and even some major applications have it wrong (like After Effects). But pulldown is a separate issue that affects sound when 24 fps material is converted to 30 fps.

NTSC color is the result of another completely brilliant—and totally mad—redesign. When the Europeans invented PAL, the old black-and-white sets could not receive the new color signals. The NTSC engineers fixed this by adding all the color for each field into a little packet of signals "wrapped" around the old black-and-white signal. Old sets would ignore the "colorburst" signal, but new color TVs could interpret it.

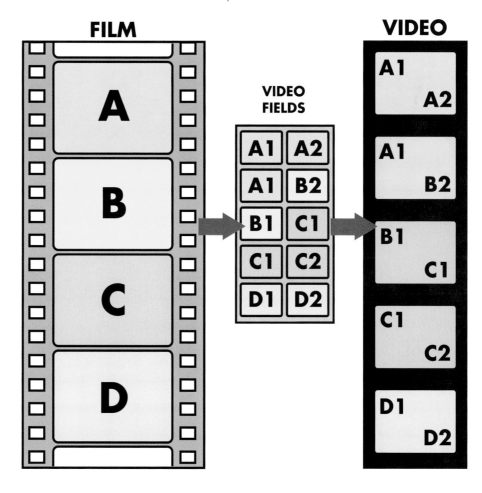

Only one trouble. The 30 fps was slowed down just a fraction, so the color signal could get wedged in. Now it was only 29.97 fps. In other words, the thirty frames took a little over one second of time.

But clearer heads prevailed. They realized that if you slow down the film speed so that it is equal to the video speed, things match up again. Film running at 23.98 fps will match up with 29.97 perfectly. In other words, in the same time it takes to play thirty frames of video (1.1 seconds) you must play twenty-four frames of film. So you "pull down" the speed of the film to match that of the slower video.

But what about the sound?

If sound is pulled down, it will run slower. This change is small (.1 percent—not enough to hear), but it could make a difference over time. In one second the sound is off by .03 frame, but in thirty seconds the sound is off by a whole frame. That's a significant drift, and it quickly becomes worse. Professional sound-mixing software lets you add or remove pulldown to match the medium with which you want to synchronize.

The Upshot

- If video is the final output, do everything in 29.97 fps (25 for European PAL systems). Record the sound on DV with no problems.

- If film is the final output, do everything in 24 fps, including recording your sound and placing it on a 24 fps timeline in your editing software. You can generate 30 fps versions for video later.

- If you record voices and other sound on 29.97-based media, like DV, be sure to save your audio as some kind of audio-only file type (WAV, AIFF, etc.) that has no time-base frame information (like 24 or 30).

- Be careful with 24 fps video. If video is the ultimate end, 24 fps video will just give you headaches. Remember that anything you watch on a TV screen will end up playing at 29.97 anyway.

Don't be fooled—24 fps video does not "look like film." If you animate on 24 fps and then convert the twenty-four frames to thirty video frames, then yes, your project will have the characteristic motion of the 3:2 process. But your work will still look like video for a lot of other reasons having to do with color and grain. These will be covered in Chapter 12.

24 fps vs. 30 fps

The long-time pros will tell you that all animation is done on 24, and that developing your sense of timing for 24 is essential. There's a lot of truth to this, though you can convert from 24 to 30 fairly easily. The math isn't hard—multiply everything by 5 and divide by 4.

Since all Hollywood films are encoded at 24 fps on DVD, and since the DVD players introduce the 3:2 and the pulldown to play back on NTSC 29.97 systems, animating at 24 fps will maintain quality if your piece is to be viewed on extremely high resolution monitors that will output 24.

Many animators prefer to think of timing with respect to music. Since the earliest days of cartoons, animators have been using musical beats as a measure for action. In fact, when action corresponds too closely to the music it is often called "mickey-mousing" for this exact reason.

Because a lot of cartoon action synchronizes with music, it may help to consider action in terms of musical beats. An animator may think of walking speed, or march time, at the rate of one stride = 12 fps and calculate from that. Quick actions may happen on eight frames (one stride of a run, for example) while slower actions (creeping around a corner) may be twenty or twenty-four frames per footfall.

Calculations with 30 are a bit more difficult using this method. If one stride = 15 fps then half that stride is 7.5 frames, and half again is 3.75 frames. This is a bit tough to animate to, whereas the further divisions of 24 (12, 6, 3 or 8, 4, 2) make it more versatile for breaking down actions using a single stride as a unit.

Timing the Action

With the animatic in good condition and our frame rate chosen, we can mark the X-sheets to show how long each scene will be. Now we must determine how long each action *within each scene* must be.

A stopwatch is extremely useful. Whether this is an old-fashioned wind-up device, a digital watch, or a computer clock, make sure it can count fractions of a second, since many fast actions take place in under a second.

You'll need to act out what your characters are doing and keep track of the time. Do several trials and average them. How long does it take to cross a room? How long to scratch your head? Of course you can always speed these actions up or slow them down, but it's good to have a general idea how long each one takes. For example:

- Yawn – 5 seconds
- Scratch head – 4 seconds
- Turn head – .5 second
- Get up from desk
 Push chair out – 2.2 seconds
 Stand up – 3.4 seconds

And don't forget a key component of movement—the *lack* of movement. Timing depends on not only what is done and how long it takes but how long between actions.

Only experience will tell if you are a skilled timer. "Good" or "bad" timing is your decision alone. Everyone has their own style, just as everyone has their own drawing style. Have you ever seen a cartoon that was terribly drawn but moved well? Or one that was terribly drawn, barely moved, but was still very funny? Chances are the timing was what made you laugh.

At Aardman Animation they play the edited dialogue and act the entire piece out in front of a video camera. When they've determined the timings and performances they like, they use this videotape as a reference for their animated characters. This is how they get subtle and detailed performances in their films.

BONUS!
Check out the Timing Tutorial on the DVD.

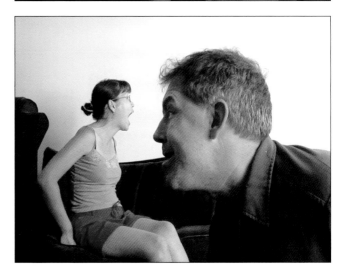

These people did not work at Aardman Animation, but they stole their technique for determining subtle expression timing.

PROD.	SEQ.	SCENE		SHEET

ACTION	DIAL	FRAME	4	3	2	1	EXTRA	CAMERA INSTRUCTIONS
opens mouth	A	215						
		217						
		219						
		221						
eats bug		223						
		225						
		227						
pose	W O	229						
		231						
pose	Vh	233						
		235						
		237						
pose		239						
		241						
throws up		243						
		245						
		297						
		299						
		251						
		253						

Marking the X-sheet

Back to the X-sheets. The first thing to do is to write in frame numbers. In the example on the opposite page, you'll see that the animator has marked these in the Frames column. You will use the column labeled Action to plan out your various character actions.

When you mark up an X-sheet for action, there are three different kinds of marks animators use.

- A straight line indicates a held pose or a still picture.
- A wiggly line indicates straight-ahead animation.
- A curved line indicates action from key pose to key pose.

Some animators use other angled lines to indicate other kinds of actions, but these three will suffice for about 90 percent of what you need to do.

The next column, marked DIAL ,is where the dialogue planning goes. When you read the track and determine what sounds of speech (phonemes) go on which frame, you will write them in here. The "A," "WO," and "Uh" listed on the sheet are phonemes.

For more on marking the X-sheet, check out the Timing Tutorial on the accompanying DVD.

Dialogue Timing

"Reading track" is the process of writing down the sounds of speech in your dialogue tracks and making notation for animation. You will be transcribing the sounds your voice actors have made (phonemes) into a list of symbols and letters on the X-sheet that you will follow when animating your characters.

There are dialogue timers whose sole job it is to read tracks and break them down for animators. There are studios where everyone has to read his or her own track. It's a valuable skill and one of the aspects of animation that can give your work real quality. The better you read the track, the closer your animation can be, and the better the overall effect.

There are various software solutions that promise to take the drudgery out of track reading, and some are better than others. Because of the processing involved in recognizing and categorizing phonemes, this software is often prohibitively expensive. Though results vary they may be good enough to accomplish what you need.

Reading track by hand is still the best possible way to get top-quality results. It is, however, tedious and requires you to listen to every inch of the dialogue very slowly and carefully so you can assign a mouth shape to each one.

Many animators today read the dialogue at the same time they are animating, rather than doing it as a preliminary planning step. This won't give you particularly inspired readings, but it's not the worst situation. If there are only a few mouth shapes, you may as well animate as you go. At most Flash- or After Effects–based studios they are required to do this as a cost-cutting measure, to avoid hiring a timer or a track reader at all.

READING TRACK AS YOU ANIMATE IN FLASH

Because sound files in Flash come in as streams that begin playing on specific frames, they can drift in and out of sync with each playback. While you animate you are seeing how your particular computer handles the data—not how the final file will play when converted to video. This means your audio can be off by several frames, and the errors may be inconsistent.

Flash animators need to do one of two things to guarantee that their dialogue will be in sync. Because Flash can scrub audio, the first method is to use Flash to scrub each track and mark it on an X-sheet. If you have the sound file labeled "stream" rather than "event," it should scrub just fine.

The second method is to animate as you go without preparing an X-sheet, but never rely on the preview function. Use the scrubbing to animate mouths and export video tests to double-check your sync. This is the method most Flash users employ while making television cartoons.

How It's Done

The first step to reading track is to prepare separate sound files for each character's dialogue. If your completed cartoon will be three minutes long, you will want to have a three-minute sound file with only character A's dialogue, then one for character B, and so on.

If you have a bunch of one-line characters, you may want to group them in one sound file, but otherwise you probably want to keep them separate. This will allow you to read the dialogue for each character one at a time. This is especially important if you have any overlapping dialogue, where two characters may speak at once or follow each other's lines very closely.

Below you see a portion of the X-sheet showing the column headers. The second column is marked DIAL, and it's where you will place the phonemes you read. The column marked Frames will be a running counter of the frame number where each sound occurs. If, two seconds into your cartoon, a character says "stop," then you will write in on the line marked 60 (two seconds at 30 fps) the first phoneme for the word *stop*, which is the *s* sound.

If you use software that is equipped with "audio scrubbing," you play audio files very slowly by dragging the mouse over the waveform that represents the sound. Doing so can help you pinpoint where one sound changes to the next—for example, determining the exact frame in which the *s* sound yields to the *t* sound in "stop."

BONUS!
Check out the Dialogue Tutorial on the DVD.

Approaches to Dialogue

Once you've read the track, it's time to decide how you're going to handle the task of animating dialogue. In order from least complicated to most, here are a few approaches.

Simple Lip-Flap

Some animators just open and close the mouth constantly for the duration of the given line. This is especially common in cheap animation for television. If a line lasts for two seconds, the animator will rapidly open and close the mouth for two seconds, not worrying about synchronizing with the sound.

The hamster has only three mouth positions, but if they are methodically repeated while dialogue is playing on the soundtrack, it creates an illusion of speech. This is often used in simple computer animation—in video games or on cell phones. Anime directors may use it sporadically throughout a cartoon, switching into lip-flap for an angry or upset character in a comic scene and then switching back to a closer sync technique when the emotional tone changes.

This simple lip-flap technique can be fun and dynamic, but when used all the time most audiences resent the cheap quality.

ACTION	DIAL	FRAME	4	3	2	1	EXTRA	CAMERA INSTRUCTIONS

X-sheet column headers.

84

The Filmation/H&B System

While developing techniques for limited animation, crews at the Filmation and Hanna-Barbera (H&B) studios realized they could reduce all the mouth shapes required for believable human speech to about seven major designs.

A timer, reading the audio track, would determine the mouth shapes that were necessary for each frame using a universal mouth chart. An animator would draw the character's head in a stationary position, and an assistant would draw each of the seven mouths for that head position. The cameraman would follow the timings set on the X-sheet. If the head moved, then another seven mouths were drawn. If an extra, eighth mouth were needed, like a character "antic" (a wide-open mouth or a special shape, for example), it was added to the sequence and noted on the X-sheet. This approach encouraged very static poses in 1970s and '80s TV animation and is part of its characteristic look.

The diagram below, taken from Walt Holcombe's *The Courtship of Sniffy LaPants*, demonstrates how the limited animation/Hanna-Barbera method works. Heads are drawn without the mouth portions, and the interchangeable mouths are drawn as separate art.

0. M, P, B
pause

1. T, S, N, J, K
L, G, D. H, Z
Zh, Ch

2. E

3. A

4. U, Uh, R

5. O, OO, W

6. F, V

Above This stylized chart shows the basic designs for the seven basic mouth shapes used in the Filmation/Hanna-Barbera system. You can also find this in the Additional Content section of the accompanying DVD.

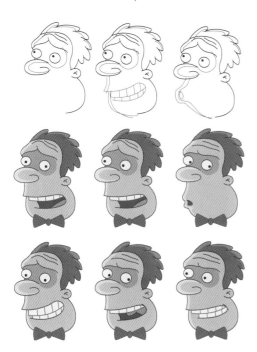

The result is a variety of heads Walt designed for his cartoon, in no particular order.

PROD.	SEQ.	SCENE		SHEET

ACTION	DIAL	FRAME	4	3	2	1	EXTRA	CAMERA INSTRUCTIONS
	—	0			0			
	I							
	C	2			1			
		4						
		6						
	OO				5			
		8						
	D	10			1			
	L	12						
	U	14			4			
		16						
		18						
		20						
	K	22			1			
	T	24			0			
		26						
		28						
	E	30			2			
	V	32			6			
	R	34			4 2			
	E	36						
	I	38			5			
	W							
	I							

This X-sheet shows a section marked for dialogue. In this case the line is "Good luck!" (There's no "c" because the "ck" sound is represented by the "k.") Notice that long stretches or pauses (frame 0 to frame 3, or frame 24 to 28) are "holds" on the first mouth shape—the closed mouth position. As soon as the character speaks, the frames are counted on ones for very close sync.

The dialogue shapes for the H&B system are noted on the column marked 2. This is a carryover from traditional animation, in which the X-sheet would denote which art went on which layer. In this case, the empty head with no mouths would go on level 1, and the new mouth shapes would go on level 2, as marked here. It's not a bad practice to get into, as most software has a similar way of dealing with layers of art.

Some mouth shapes are typically used for certain vocal sounds, so be sure you're assigning shapes that best approximate the sounds. The short *i* sound in the word *wish*, for example, is very different than the *i* used when someone says "I can." For the personal pronoun *i* you would need both the *ah* sound of mouth #3 followed closely by the *e* sound of mouth #2. Always be aware what sounds you are approximating and how the mouths match those sounds—*not* the spelling of words.

You'll find that sometimes it looks better to close the mouth even though the vocal performance does not indicate a closed mouth. Think of how a sock puppet works—if you were making the puppet speak with your hand, you might close that mouth on some phonemes to "sell" the illusion of speech, even though a real person's mouth would not close at that time.

Likewise, if you track dialogue too closely with a limited system, you can make the mouth look too busy. You don't need to jam in every mouth shape. Whatever software you're using, make sure you can preview your dialogue. You need practice lining up the mouths, and you need to check each line as you go.

You can use the H&B system with your own set of shapes. For a show I directed called *Mrs. Munger's Class*, we used a system of eleven mouths, with two and three inbetweens each. We ended up with almost two hundred mouth shapes as a result. 3DCG productions regularly use dozens of mouth shapes.

● ●

THE H&B METHOD IN AFTER EFFECTS

The H&B system was originally labeled A through F. This book has substituted numbers for two reasons. The first is to avoid calling a mouth position A when in fact the shape of the mouth has nothing to do with the mouth shape for the letter A or any of its sounds. The second is that numbering them from 0 to 6 allows you to use the H&B system in a very simple way with certain software packages, chiefly Adobe After Effects.

This section assumes you have working knowledge of the basics of After Effects, including how to set keyframes and how to work with timelines. If you need to know more, the application has extensive help files that will answer all your questions.

After Effects has the ability to accommodate the H&B method by using "time remapping," a way of playing frames from a source clip, but out of order. For example, if you want to start playing a clip from frame 20 instead of from the beginning, you can manually set a keyframe for 00:19. This is the twentieth frame of the clip, because the first frame is always 0.

The clip will play normally from that point onward, unless you add other keyframes. If, in a space of three seconds on the timeline, you type in a keyframe at 00:19 and one at 00:21, After Effects will play the twentieth, twenty-first, and twenty-second frame of the clip within three seconds. This means After Effects will have slowed down the clip considerably.

To use time remapping with the H&B system, you must make a seven-frame clip of all the mouth shapes in a row. Just as in our chart, the closed mouth, labeled 0, is our first, or "zeroth" frame. That would make the F mouth shape, frame 6, the seventh frame of the movie, since we start counting at 0. Once you make this clip (you can also make a timeline and nest it in another, if you are comfortable with that) you can enable time remapping and "force" the clip to show the mouth shape you want when the appropriate sound occurs.

Consider the diagram here. The phrase is still "Good luck!" The green squares show you the dialogue break-down—where each phoneme is located in the sound file. The faces at the top show the best approximation of those sounds using the H&B method.

The bottom row is a stylized version of the timeline, showing a keyframe at every point the mouth shape needs to change. If we click on those keyframes, we can set the clip to display whatever source frame we want; in this case be-tween 0 and 6—there are no more frames of our source clip (the mouth shapes) beyond that. We might go to frame 4 of the timeline, click the keyframe, and enter 1. The first mouth shape—the semiclosed mouth we want to use for the "guh" shape in "Good luck"—is displayed. Then we go to frame 8 of the timeline where the "OO" mouth is needed. We set the keyframe there to 5 for mouth shape 5 in our source clip.

The last thing we must do, after all these keyframes are set, is to make them all "hold" keyframes. Ordinarily, when you time-remap, the source clip will continue to play to the next frame and the next. Unless you hold the keyframe at 8 (the "OO" shape), the source clip will continue playing, so frame 9 of the timeline will show frame 6 of the source clip. Holding keyframes makes the source clip keep its position until a new keyframe is set.

This picture shows an actual After Effects timeline with time remapping enabled and the keyframes set for an entire dialogue sequence. "Round-Eye Front" is a seven-frame QuickTime movie of the mouth shapes. Notice that the keyframes all have the square right end that indicates they have been set to "hold."

Full Animation

At some studios—like Disney and Warner Bros.—anima-tors would draw each mouth shape exactly as it was needed. Since they would draw the whole figure, with its attitude and posture, according to what the specific needs were for each scene, they did not reuse anything. There are a lot more drawings required to achieve this technique, and it results in the best motion, the best look, the best "performance" of each character, and the best lip-sync.

There are absolutely no shortcuts, tips, or tricks with full animation. There's only "pencil mileage"—you must make millions of drawings and check them constantly. If you're dedicated to the art of animation and want to create truly captivating visuals in motion, this is the way to go.

Many animators mix styles constantly. Although Western animators scoff at the multiple frame rates and changing art styles used in anime, American animators throughout the 1940s and '50s animated on ones or twos as they saw fit. If you want to mix the full, lush animation of the old Disney with the clunky look of 1980s Filmation cartoons, then by all means, do it.

88

Preparing Artwork

By now you know what your characters are going to look like, and you may have designed some of the backgrounds during the layout phase. But now it's time to create all the high-quality art for your cartoon.

3DCG Preparation

3D animators must build detailed background models, which take almost as much work as designing characters. For the 3DCG animator this means many hours with your software of choice—and the manual.

It's a good thing you've planned well. Now you know that you can save time by designing only what needs to be seen. A beginner may model an entire cityscape, only to find that a street corner and a trash can will be the only things visible. Knowing all your setups ahead of time enables you to create assets knowing precisely how much detail you must prepare.

To that end, Hollywood big shots in all the major studios know that you save time by pre-rendering deep backgrounds as separate elements and adding the characters later. These backgrounds can sometimes be much less detailed than character models—even relying on textures to indicate detail rather than fully modeling complex surfaces.

An advantage 3DCG programs have is that once the models are created and posed, generating artwork at sufficiently high quality is easy—it just takes longer. Be sure to set your "camera" to the right aspect ratio for your project, and make sure the sizes match your output destination. If you think you may reframe elements later or even take them into another software package for compositing, you may want to render at a larger size.

Stop-Motion Preparation

The stop-motion animator must build large sculptures by hand. The same principles apply: Knowing your framings and setups will allow you to create sets and backgrounds that meet your requirements but don't require you to do too much work.

For stop-motion animation, you have to choose a real camera, not some virtual software approximation. Whereas plenty of good animation has been done on sub-standard equipment, you can save yourself a lot of time and trouble if you check out the specifications first.

Tim Burton's *Corpse Bride* was shot entirely with digital still cameras and posted with Apple's Final Cut Pro. Although you may not be able to afford a digital still camera with resolution good enough to print onto 35mm film at 4K, you can still get quality well above DV and into the HD range with consumer cameras. There even is software that will accept a "live" image from a digital still camera plugged right into the USB port.

Use a cable release on the camera, so there's no jostling, and you can be assured that your images will remain in register. Better yet, most software packages allow you to control the camera shutter through the computer keyboard.

2D Animation

The advantage to two-dimensional animation over 3DCG is that your work can have all the liveliness and spontaneity of the hand-drawn line. This is still difficult to achieve in 3D programs. The disadvantage is that you must draw a lot.

For hand-drawn animation, you'll need special materials, like the ones shown on the right. These may include an animation disc with a peg bar and illumination from the bottom. This allows you to draw on sheets of paper that are registered to each other (the peg bar provides this stability) while seeing a few of your other drawings underneath, courtesy of your underlighting. The appendices list some valuable resources for learning about traditional animation methods. Learning to draw cartoons by hand takes many years experience to do well, so start today—you're not getting any younger!

You can animate completely traditionally, drawing each frame on paper and checking them by flipping the drawings by hand—just as the Masters have done for decades. The computer can save you considerable time and money,

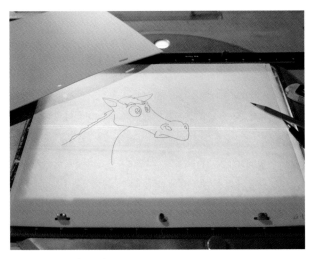

An animation board

however, in later stages where you will test, scan, color, and present the images.

These days many animators create art directly through the computer with a graphics tablet or a mouse. The advantage to this method is that you need not spend hours scanning and cleaning up drawings. Artwork made this way can look "cleaner," but it may look processed—even fake. If you are a beginner with the graphics tablet, make sure you set up the device so that you get a variable line width—if all of your lines are the same, your work will look mechanical. Try to get the machine to capture your gestures.

DIGITAL CAMERA SPECIFICATIONS

Digital cameras are everywhere. Can you use the one in your phone? Your webcam? The "still" function on your camcorder? The answer is at once yes and no. Yes, any image-capture equipment will work. The problem with cell phones and webcams is that the resolution is really low and the image quality is grainy and muddy. The lenses aren't great and the electronics connected to them introduce harsh image compression. You can do much better—and inexpensively, too.

Today's digital still cameras generally give you more than enough resolu-

tion. You only need a 640 x 480 image for standard-definition video, and practically every point-and-shoot pocket camera will shoot images many times higher than that. But more important, look at the manual or spec sheet for your camera.

If the camera shoots an image that is 3 megapixels, is that enough? A megapixel is a million pixels. Multiply the number of horizontal pixels by the vertical and you get the resolution of a still camera.

Film and video require less resolution than photos. What might make a grainy snapshot could be perfectly fine

for an HD video. A 3-megapixel camera will fill a 4 x 3 frame with an effective DPI of 250! Since we only need 72 DPI, this will be more than enough. It may be large enough for an HD cartoon, depending on your aspect ratio.

If you are shooting for a 35mm release print, however, you will have to acquire images at higher resolutions—for a 4K cinema project you would need a 12 megapixel camera.

There's more in this chapter about compression (such as JPEG) and how to work around it or with it. You want to choose a camera that gives you some control over these aspects.

These tests were made to show the variable lines possible with a graphics tablet.

Most artists like to work big with the graphics tablet. When you reduce your artwork it will look sharp, yet retain the variations and detail that show the human element in the work.

Pixel-Based Art

Art that's scanned, or drawn using a computer painting program like Adobe Photoshop, is pixel-based—composed of tiny dots on a grid, each one a different color. When viewed from a distance, these dots form a picture. Your graphics software has controls to set the number of dots per inch (DPI) used. Consult your manual to make sure you understand how your application controls this variable. As mentioned, the resolution of video and computer monitors is 72 dpi. This simply means that when artwork is

scanned in at 72 dpi and displayed on the screen, it will appear at 100% of the size of the original. Something scanned in at 300 dpi will appear four times as large, or roughly 72 x 2 x 2.

The resolution of pixel-based art is fixed. Whatever resolution your scan, your art will stay at that resolution. If you zoom in on the art, boxy, jaggy lines will appear where the pixels are being blown up. This is called "aliasing."

Do you want to zoom in to 400% of original size? Begin with 75 (rather than 72), since it's easier to figure. If 75 dpi is 100%, then 75 x 2 would be 200%. If you're going to zoom until your image is twice the size, then you need to scan your artwork at 75 x 2, or 150 dpi.

If you want to zoom to 400%, then 75 x 2 x 2 would be 300 dpi. And if you double it again, to 800%, 72 x 2 x 2 x 2 would require 600 dpi.

Original artwork at screen resolution size

From the box in the image on the left, the same artwork viewed at 1,000%, revealing the aliasing

For artwork you create digitally, just figure the size of the artwork based on your aspect ratio. For a DV project requiring a 200% zoom, start with artwork at least 1,440 pixels wide (720 X 2).

Black-and-White Artwork

If you draw on paper, tape a peg bar to your scanner. This will guarantee that your image files are all in registration. Scan your artwork as a grayscale file, *not* as a bitmap. For clear and clean printing, artists often use the bitmap scan setting at a very high resolution. This results in a nice crisp line on the page, but video likes the soft line of the grayscale. Thus, if you scan in as a bitmap at 72 dpi, you'll lose quality.

If you use a drawing tablet to draw right into your image program, you can place each character pose on one of multiple layers. You could use one image file to draw successive poses, one right on top of the other. If you change the opacity of the layers, you can see a few of them at once. Looking at transparent layers is sometimes called "onion-skinning."

This is a great way to work because you can see as many poses as you like. Eventually you'll need to separate those layers into individual files, but that can come later.

This figure shows "onion-skinning." Successive character poses have been drawn on top of one another in different image layers. Note the transparency of the other legs against the sharp, black outlines of the current pose.

Color

Most image-editing programs have color wheel interfaces for choosing color. This seems deceptively easy—in fact, there are a dozen different "systems" for dealing with color, all of which seem perfectly reasonable, and all of which boast specialized applications. These include RGB, HSB, Lab Color, Pantone, CMYK... which is the best, and how do you color your images?

Chapter 2 revealed that the primary colors of light are red, green, and blue, rather than the artist's palette of red, *yellow*, and blue. Furthermore, a single frame of an animated picture at DV resolution has 345,600 pixels (720 multiplied by 480), and each of these pixels must be described in terms of color—how much R, G, and B does it have?

One determining factor for pixel-based artwork is the bit depth.

But "Bit Depth" Was for Sound...

Since computers are binary machines, they keep track of everything in terms of bits. Picture and sound will both be described using bit depth. Just as the sound resolution depends on how many bits the computer can store per sample of sound, the image bit depth also determines the resolution of color in a digital picture. The greater the bit depth, the more colors can be expressed.

Computers can also display color information as "channels." A digital picture may have a separate channel each for red, green, and blue. If we like, we might show only the red channel of an image to see the red values of pixels. The red channel is a black-and-white image, with black pixels where there is no red and white pixels where there is maximum red. Gray areas would indicate percentages of red.

A formidable hamster

The hamster with only the red values visible

That hamster's feet show white in the red channel. This would indicate almost 100 percent red on the feet. Why aren't the feet totally red in the color image? Well, the feet *are* pink, so they do contain very high amounts of red. But since we turned off the green and blue channels to see this image, we aren't looking at all the color. When we measure the hamster's feet, we find that the values are R: 249, G: 194, and B: 211. Keeping in mind that 255, 255, 255 is white, this makes sense. The hamster's feet will be close to white, but more red will make them pink.

How many levels of gray do we have available to us? This will determine the number of total colors we have at our disposal. To understand this concept, let's pretend we've built a computer that uses a color bit depth of two. This means we are going to use only two bits to express all possible red values, ranging from absolute "black" (no red) to absolute "white" (all red). A bit depth of two gives our cheesy computer four values of red.

0 = 00	(0% red)
1 = 01	(33% red)
2 = 10	(66% red)
3 = 11	(100% red)

We also get four values of green and blue. We can mix and match the RGB values so we can store, access, and display sixty-four different colors total in our entire picture. What would these colors be? Let's choose one: R: 3, G: 2, B: 0. This means a color that has 100% red, 66% green, and 0% blue. Red and green light make a yellowish color in equal quantities, but here there is more red. Our color is orange.

Yet sixty-four isn't very many colors. We can't show a sunset with only one orange. If we want more colors, we are going to have to devote more bits to each color.

4 bits = 16 values/channel

5 bits = 32 values/channel

6 bits = 64 values/channel

7 bits = 128 values/channel

8 bits = 256 values/channel

Ultimately most software engineers found that eight bits per channel is both pleasing to the eye and the best approximation of the limits of NTSC video. In fact, it's actually *better* than NTSC video. There are colors that can be expressed by 8-bit RGB that cannot be expressed in the NTSC colorburst signal.

Color Space

With 8-bit RGB, we can access 16,777,216 colors. This range is called a "color space" because it is a numerical array having three values. When mathematicians graph a system with three values (the x, y, and z-axis), they show it as three-dimensional. We can graph out RGB in a similar way and it becomes a kind of color cube, with x, y, and z corresponding to R, G, and B. Sad little NTSC fits within the 8-bit RGB color cube with room to spare.

The diagram here is a different way of looking at color. It is a flat representation of color space—because that color cube is a little hard to show on a flat page. It's also different because it shows the relation of RGB to NTSC as well as the relation of both systems when compared to the sensitivity of the human eye.

The largest area of color represents human color perception. The white equilateral triangle shows the colors possible within the RGB color space, with an even number of colors from any part of the spectrum. White light lies at the center of the graph. NTSC—shown by the black triangle—exhibits consistently bad color reproduction along the green side of the graph, as well as difficulty with saturated reds. Yellow and blue seem fine, and cyan is weak. Note how pastel colors (toward the center) are fine in

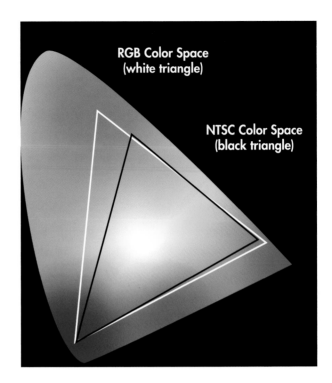

RGB Color Space (white triangle)

NTSC Color Space (black triangle)

NTSC, but bright colors never quite make it.

In some image editors you can actually work with a "color profile." Adobe Photoshop supports color profiles, which are settings that allow you to work in the color space of your choosing. If you are designing for film, you may wish to use a film color profile.

●●●

UNDERSTANDING LOGARITHMIC COLOR SPACE

Linear color space assumes that each step between absolute black (no color) and absolute white (100 percent color) is of equal amount, and gray tones are spaced evenly.

Logarithmic (log) color space uses a logarithm to determine the spacing instead of having equal stair steps between values. The logarithm is a way of writing exponents for certain kinds of calculations.

$x = b^y$

is equivalent to

$y = log_b (x)$

This results in very uneven—but ordered—spacings for the grays. Note how the middle range is stretched out with fewer values on the far left and many more on the right. This grayscale would apply to R, G, and B, meaning middle values of all colors would be better represented than the darkest values.

Why would any sane person bother with log color? Because the human eye responds to color loga-

rithmically. And so does film. Logarithms, difficult though they may be, are the best way to describe the way film works.

If you are designing a project for eventual film transfer, you should not worry about log color just yet. Working in it will only slow your system to a crawl. After everything is finished, the lab may ask you to prepare material as Cineon files, so you should originate all art in a bit-depth larger than what you need. Since Cineon is 10-bit and log color (as opposed to 8-bit RGB color) you must work in 16-bit color, knowing that you will translate it to Cineon at the end of the process.

If you work in the NTSC color space, you must check that none of your colors are "illegal." Although some cartoon creators should be jailed for their creations, this refers to the use of colors outside the boundaries of NTSC.

The FCC has licensed television stations to broadcast signals of specified wavelength. Colors outside the NTSC color scheme would overload the NTSC colorburst, thus causing a transmission that violates the license and potentially interferes with other broadcasters.

This overload will also lead to bad image quality, the way that too much sound causes distortion in a recording. If you have a regular NTSC TV

monitor connected to your editing system, you may be able to test your artwork on it to make sure the colors are "safe" for video. Some video editors have an onscreen version of a "vectorscope." This is a tool broadcast engineers use to check color on their systems and make sure it's legal. Real ones cost thousands of dollars, but the software versions work just as well for our purposes.

Top A vectorscope displaying NTSC color bars. Notice that the color signals match the vectorscope markings.

Bottom The approximation of a video signal with entirely too much red. The blob on the upper left side is farther from the center than the red limit, marked by the box R. The blob on the right side, while edging close to the blue limit, is legal.

Coloring Your Pixel-Based Artwork

If you work in a painterly style, you may have painted each frame in color from the start, but most cartoonists tend to draw a black outline with colored regions inside.

You will find it most useful to work in layers. Put your line art on one layer and the colors on separate layers so they can be edited easily. It helps to have the black line above the color and the composite mode—sometimes called "blending mode" or "transparency" by various software—set to "multiply." This makes the layer work like a sheet of clear plastic with markers drawn on it. Black areas will remain black, but color is translucent, and white areas are transparent. In this way you can leave the black outlines on top and color on the second layer.

The little fellow here...

...was colored in exactly this way.

Here you see an exploded view—you can tell the upper layer contains the black outlines of the drawing while the color is all on the layer below.

It's the same process many print cartoonists use to color their work.

Using Alpha Channels

In traditional animation, the black-and-white line drawing of the character was placed on top of a transparent cel—a sheet of clear acetate—and color paint was applied to the back. This result was opaque where the character was drawn and colored but transparent everywhere else, so the background would show through. You can get this same effect with the computer, but you have to determine what area of each drawing is transparent.

Just as you have red, green, and blue channels, you can create a channel that keeps track of transparency, called the alpha channel. Sometimes this is written RGBa. Just as you can isolate the red channel and see a black-and-white picture, where black equals no red and white equals 100% red, the alpha channel shows black where there is no image (100% transparency) and white where there is all image (0% transparency). Only some digital formats can support an alpha channel, so you have to make sure you are working with one that does.

Since alpha is an extra eight bits of information per pixel, this file format is often called "24-bit color," or even "Millions of Colors +." The plus sign is shorthand for the alpha channel. Consult your graphics program manual for specifics.

The best file formats to use for pixel-based animation are the Photoshop file format, (.psd), the Macintosh native file format PICT (.pct), and the cross-platform-friendly TARGA (.tga). There are other file formats—like TIFF—that support layers and alpha channels, but these are unwieldy for video. TIFF is a perfectly fine format, but it is used in print more than in TV and film.

Don't work in compressed image formats like JPEG. File formats like BMP and GIF will also give you headaches, as they do not support alpha channels. PNG is a fairly good-looking format, but it is also compressed and is designed for Internet graphics, not professional work.

Vector-Based Art

Vector-based artwork is made of mathematical equations that form points and lines to make drawings. Programs like Adobe Flash and Illustrator are vector-based. Vectors are not resolution dependent and may be increased or decreased to any size without loss of quality.

But vector art has two drawbacks. The first is that your drawings need many points and lots of work to look good. The second is that if you draw on paper and scan it in, you will have to trace over every drawing to produce the vectors—it's like drawing each image twice.

Control Handle

Point 1

Point 2 (selected)

An example of a Bezier curve

Keeping that in mind, the main reason to use vectors is that they go to film easily, as they can be *rasterized* (see below) up to any resolution, including the 2K–4K that cinema requires.

Bezier Curves

Vector art is made with "Bézier curves," named for the man who created them, Pierre Bézier, who used them to design cars. A Bézier curve is made with at least two points. These points have small control handles that influence the direction of the curve. The length of the control handle controls the strength of each point and the influence it has on the resulting curve.

With the addition of more control points, a Bézier curve can fit any form you wish to draw. But it requires patience to get good at a vector program. You must build art with a series of curves and flat shapes rather than lines. More than one artist has described working with Béziers as "drawing with rubber bands." 3DCG animators use Bézier points to draw shapes for extrusion as well as to define the motion path of objects. After Effects, too, uses Bézier curves for motion paths, masks, and the interaction of keyframes.

WORKING (RELUCTANTLY) WITH JPEG

JPEG stands for Joint Photographers Expert Group. They are the committee who developed the JPEG file-compression system and wrote its first implementations back in the 1980s. There is more about how compression works later in this chapter, so if you're interested in the technical details about how JPEG uses the *discrete cosign transform* function to compress images, you may wish to read the section on *codecs*.

Here is what JPEG compression looks like:

Now that you've seen it, you can be pretty sure you cannot have these blocky areas, often called "artifacts," in your final pictures.

But what about digital still cameras that only take JPEG frames? JPEG is so commonly used in cameras that you may not be able to avoid it. The answer is to acquire JPEG images at much larger sizes than you need. When you shrink the image, most graphics software will apply pixel interpolation processing on the image. This extra math takes the average of each pixel and its surrounding neighbors to come up with new values for the smaller image. "Bicubic interpolation" is a scheme that works best, averaging as many as sixteen surrounding pixels. This will iron out the defects.

Animating with Vectors

Most software has automatic vectorizing tools that will trace your pixel-based scans and convert them to vectors. But since this process is automatic, the quality of the traced scan is often questionable. You must spend time to tweak the Bezier points until you get the results you want from each drawing.

Beware of animating by altering the Bézier control points, accomplishing what Flash calls a "shape tween." The advantage is that you can set keyframes for movements and allow the program to fill in the motions. Unfortunately this looks terrible, as lines and shapes drift across the screen with cold, mathematical precision.

A similar complaint can be made for what Flash calls the "motion tween." A piece of artwork—an arm, for example—can be keyframed in different positions, and the software will accomplish the intervening moves. This is less problematic than the shape tween but still suffers from some of the same problems.

The best motion will always result from more drawings. Unless your style is purposely flat—like Terry Gilliam's *Monty Python* animation—you won't get a good look out of computer-created inbetweens. And even Gilliam did his own movements by hand, so they looked organic, rather than coldly precise.

98

1 Self-color lines drawn initially in red (left) and then made the same color as the shaded area they outline (right)

Never use vector art programs to work with pixel-based images. You end up with the worst of all possible worlds: poor control of poorly rendered graphics. The reason this software accepts pixel-based files is so that you can use them as templates. With vector art on another layer, you can create new, crisp, clean images.

One way of increasing the production value of your cartoon, and a great way to show off your mastery of form and color design, is to add highlights and modeling to your figures.

The outline of these shaded areas is called a "self-color" line because it's the same color as the shape. When drawing the self-color lines you may want to make them in a contrasting color at first—red, as shown here—so you can observe how the

shadow areas move in tests and previews. In Adobe Flash you can delete the enclosing self-color line completely, leaving only the colored shape within. [1]

Most vector programs have a freehand "brush" tool that works like a pixel-based brush. You can get a great hand-drawn look from this tool. Backgrounds should be drawn with the brush tool so you can get a variety of line width and styles. Rough in your animation with the brush tool. Then create a layer above it and trace over each frame for final "clean up" animation using straight-line tools. [2]

To make certain every image fits within the aspect ratio of your final format, you may wish to make a vector art version of the TV-safe chart found in the accompanying DVD's Additional Content section. Here's how to make one:

- Import the chart into your software.
- Scale it so that the outermost lines are exactly the size of your workspace.
- Trace the chart with the vector tools on another layer.
- Delete the scanned image.
- Save for future use.

This vector chart will take up very little memory. Make it the top layer and drop it onto every scene; make it transparent, so you can see what you're doing underneath.

Later, delete the chart, or hide it so it doesn't show in final scenes.

2 Gray shows the rough animation with the brush tool. Clean-up lines are shown in black.

Rasterizing

Rasterizing is the process of converting vector art into pixels. Remember that until you convert the vectors, they are simply mathematical equations to the computer. Rasterizing must be done eventually, or you'll never watch your cartoon on video or film.

Export your scenes using one of the uncompressed output formats that support alpha channels at full resolution and test the footage. If you intend to output at 4K you can do preview tests at lower resolutions, like DV.

Animation

Pencil Tests

To animate a hand-drawn film you can expect to use an enormous amount of paper. If you're shooting on twos, a single minute of animation can take as much as six hundred sheets of paper (twelve or fifteen drawings per second times sixty seconds). A few minutes of animation can get downright unwieldy.

Animators used to shoot the rough-penciled animation on film and check it to see what was working. Pencil testing will increase the speed at which you learn to animate by untold amounts. Many animators (including those at Miyazaki's Studio Ghibli in Japan) set up DV cameras over a peg bar so they are always ready to pencil test. Any software that is good for stop-motion will work to create rough tests of your movements.

You don't have to draw on paper to test your animation. Your editing system is always ready to take digital media and run them at any speed you would like.

The 2D digital animator needs to see multiple frames flipped in sequence. If you're drawing in a graphics program, and not an animation program, you may not be able to flip the drawings to see how they animate. It is essential that you take your files into an editing program and test the motion before finishing the art.

Straight Ahead vs. Pose to Pose

With the "straight ahead" method, an animator chooses a starting position and animates the next frame and the next—going straight ahead until the film is finished. It requires internal timing, control of form and volume, and an innate understanding of how many drawings to make.

Neophyte stop-motion animators may think they have to work straight ahead, but it's not necessarily so. Many animators work out their moves with stick-figure thumbnails or by doing rough tests with models. Likewise, 3DCG animators are likely to "pose out" their animation rather than work straight ahead.

With the "pose to pose" method an animator roughs out the movements by drawing the "key" poses first. You will want to consult a proper resource for the art and techniques of animation (there is a good list of resources in the appendices), but suffice it to say that these key drawings are usually the extreme poses of an animated sequence.

You can use your editing software to create a "pose test." Here you see fifteen key drawings from a lengthy scene. These were executed very quickly—no more than a minute was spent drawing each.

They can be scanned, labeled ("pose001," "pose002," etc.), imported into the editing software, and set for a specific number of frames (pose 1 may be two frames, pose 2 may be ten, and so on). This way they can be tested quickly and determine a "proof of concept" for the action. When you have a test that works, the sketches can be enlarged to form a basis for polished drawings.

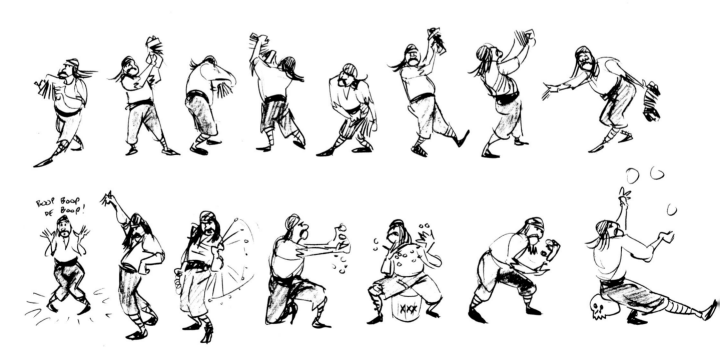

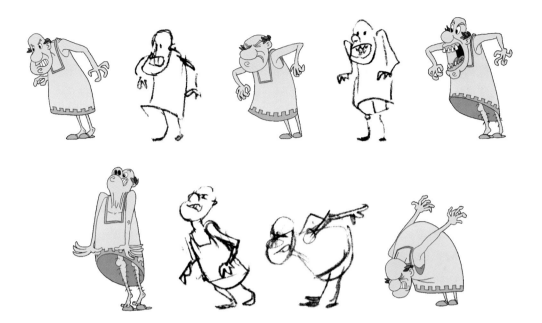

Or you may produce a sequence of keys interspersed with rough sketches to fill in the animation.

Using the keys as a foundation, the inbetweener sketches poses that make the movement more fluid. Notice that the first inbetween will have to be redrawn. The cylindrical shape that forms the Greek Philosopher's garment is seen from the top in the first two keys. But the first inbetween shows it flipping up, revealing the under-side—this will need to be corrected, since volumes and shapes must remain constant. On the bottom row the inbetweener is trying to work out the action by showing the Philosopher leading with his chest.

The number of drawings for a given action is determined by either the key animator or the timers. Since the main poses are determined by the lead animator, the assistants handle the brute task of linking them together. You'd think that it would be a simple matter of calculating distance and making drawings that fill the gaps. But to avoid motion that's stiff, robotic, and mechanical, poses must fit together properly and create a believable, moving object. This takes a lot of observation and practice.

The computer can calculate the exact center of any action and move the shapes, but it does so strictly mathe-matically. For this reason 3DCG animators are constantly redoing the computer's interpolated movements.

OPEN-SOURCE ANIMATION PROGRAMS

Commercial animation programs, like high-end 3D software, are intended to be sold to studios, not individuals, and are often prohibitively expensive. Try these free alternatives—sometimes a bit rougher than the commercial packages, but the price is right and the features are all there.

▸ Pencil – www.les-stooges.org/ pascal/pencil/—This has been writ-ten by animators for animators. It has one of the best user interfaces for hand-drawn animation in the computer. As of this writing, the only drawback is the exporting function, which does not support as many high-quality options as you need.

▸ KToon – ktoon.toonka.com— Adventurous Linux users may wish to try this package, which is similar to Pencil.

▸ Synfig – www.synfig.org— Can't afford Flash? Synfig is aimed at the vector artist but designed for animation, not Web banners. Mac implementation is slow.

▸ Blender – www.blender.org— Blender is an open-source 3DCG environment that can produce sophisticated, professional results. There are loads of free tutorials, content, plug-ins, and extras for Blender, plus great support for practically any platform.

You can access these links directly from the Additional Content section of the accompanying DVD.

Timing Charts

Long ago key animators devised a system for communicating to their inbetweeners how things should move. Let's say you'd like the action to start fast but slowly settle in on the final pose. This is actually a much more natural kind of movement and is called a "slow out." The animator would make a hash mark, like this:

This indicates that the motion, a head turn, should take 12 frames, or one-half second in 24-based time. To indicate that the head turn should start swiftly, but end slowly, he might make a hash mark like this:

This shows that the middle frame, frame 6, is actually further along the scale of movement. The assistant would read this as a slow out. It means that the end of the action requires more frames, resulting in slower movement on the screen. You can "slow in," too, or even have a slow in and out.

It helps to make these diagrams on your drawings—whether they're physical drawings or computer versions. You can always scrub out the charts later, when you get to the cleanup and coloring stages. Even if you're working solo, it may still help to plan the movement and the timing while you pose out the character.

Avoid Twinning

The human body is symmetrical. We have two arms, two legs, two eyes, and so forth. Likewise with animals, and many of our cartoon characters. Every time you have two identical details next to each other, you have "twins." To keep poses alive, not static, avoid twinning.

This extends to other details, as well. When making hair or feathers, it's always a good idea to keep them from being too regularly spaced and all the same size. Some cartoonists take this principle even further and apply it to the hands. Have you wondered why cartoon characters have three fingers instead of four? The loss of one finger makes it easier to pose a hand without twinning.

Symmetry can be deadly dull.

Silhouettes

A strong silhouette is one way that animators guarantee that no matter what the elements of design are, we can still understand what is going on. Consider the pose on the right. It's physically possible, but it's hard to read.

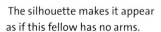

The silhouette makes it appear as if this fellow has no arms.

The beauty of animation lies in the ability to create something that's not based in reality. So we don't need a strict report of what a body can do but rather a stylization of what *imagined* figures can do. The animator is free to bend, move, squeeze, lift, or otherwise contort bodies until the desired effect is achieved.

 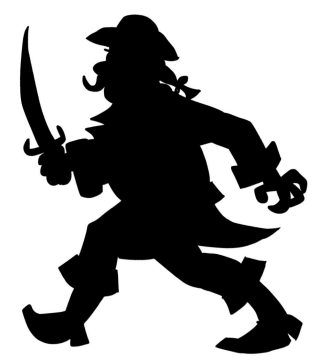

This figure's strange squatty pose is unusual but not at all hard to read.

Negative space can define the figure as much as the figure itself. Cluttering up your negative space can also lead to an unintelligible figure. Try to create dynamic negative spaces as well as positive ones.

This composition has a lot of negative space, but there is also important negative space information in the figure. Apparently afraid of that duck, this woman is curled up on herself. Notice the feet, which, because of that small triangle between them, demonstrate her attitude toward the fowl. Her aversion is made stronger with the leg bent and knee facing inward.

Overlapping Action

Traditional animators use what is called overlapping action to help define forms. Consider the floppy jowls of an old dog. **[1]**

When he turns his head, his nose gets there first, and the jowls and ears take a frame or two to catch up. When he stops, the jowls arrive just a frame *after* the nose. Overlapping action will make animation look more lifelike. Hair is the most obvious subject for overlapping action, but you can also see it in simple gestures, like an arm lift.

The arm seems to lead with the wrist, with both hand and lower arm trailing behind it. When the arm comes to rest, however, the wrist snaps into place a frame after the elbow and shoulder have settled. **[2]**

This is particularly useful for 3D animators, who are likely to set beginning and ending keys without considering these subtleties of action.

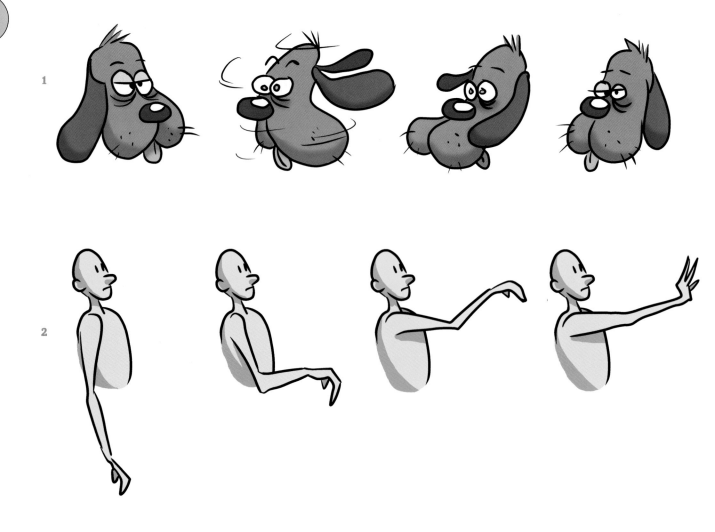

1

2

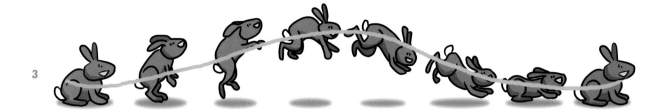

3

Arcs

Constructing your movement on an arc looks more natural. Arcs seem to "read" better than movement along straight lines. [3]

Output

Most computers cannot display full-size, full-motion, full-quality video, even at standard definition and only eight bits per channel. The bitstream for 8-bit video comes out to about 20MB/sec. And 1080 HD is 95MB/sec. Handling all that information, managing the operating system tasks, and keeping track of the application is just too much for most computers.

Nearly all computer video schemes rely on compressing the image. Compression is a useful tool, but be very careful. The general rule of thumb is this:

Never compress until the end.

If you're using QuickTime on your home computer, this will be easy. You simply select the codec labeled "none" or "uncompressed," and you'll export your files without compression. These will be your master copies, and all viewable versions will be generated from these.

Codecs

Codec stands for "compression/decompression." Computers compress full video into a smaller form suitable for transfer and then decompress it back into full video. Even though "none" and "uncompressed" obviously indicate that no compression or decompression is going on, software engineers have retained the use of the term *codec* to mean any video output scheme.

The problem with codecs is that they tend to lose information. Many look boxy, grainy, and can't even show 30 fps. You can see some of this effect if you watch Internet videos, many of which are encoded with the FLV (Flash for Video) codec.

Video compression comes in two flavors: "intraframe" and "interframe." Intraframe compression is a scheme by which every frame is compressed, and the picture information for each picture is compromised. Interframe compression, on the other hand, applies some fairly complicated math to the frames in succession and has to do with comparing one frame to another.

Intraframe Compression

JPEG is the most commonly used intraframe compression and should be avoided. It is used in all MPEG video codecs and may be found in your digital camera settings.

JPEG does three distinct things to an image: It reduces color space, it encodes data, and it reduces the resolution of the brightness variations. These three operations are important to understand, because variations of each of them will be used in other codecs.

Reducing color space is called "chroma subsampling," and here's how it works. Long ago someone noticed that the color information in a picture did not have to be at the same resolution as the black-and-white "luminance" information. Print cartoonists know that they scan in the line art at tremendously high DPI, but the color can be as low as 300 dpi (which in print terms is really low). Television engineers found the same thing when they invented color television.

So we can sample the luminance (called "Y" by engineers) at a certain resolution, and then only keep *some* of the color information, called Cr and Cb (for chroma red and chroma blue). Not only are the red and blue at a lower res-

olution than the luminance, but YCrCb sampling actually ignores the green and derives it mathematically from the other signals.

The second aspect of JPEG is the data encoding. JPEG analyzes 8 x 8 blocks of pixels and applies the "discrete cosine transform" (DCT) algorithm to them. The values for those sixty-four pixels are run through a formula that allows half the data to be thrown away. How they return the data is part of crazy math, involving a thing called "entropy encoding." Equally tricky math allows you to unencode the stuff and end up with the original.

The DCT crush isn't responsible for loss of image quality with JPEG—or with DV, which also uses it. The real loss of quality comes from the chroma subsampling and the reduction in brightness values.

Luminance quantizing takes advantage of the fact that the eye isn't good at determining the difference among brightness values on the high end of the scale. A simple equation is applied to all values from solid black to pure white. Bright values above a certain threshold, which would normally span a range of digits, are stored as a single digit. This reduces file space—and quality.

So JPEG is fine for Web images, small snapshots you want to send to friends, or images taken from your phone. But in animation work the aberrations and artifacts introduced by the compression can damage the quality.

Interframe Compression

Interframe (I-frame) compression is a system whereby certain frames are stored in their entirety—these are, unfortunately and confusingly, called "keyframes," as well. Other frames are stored partially, depending on how much change there is from one to the next. So in the same way that JPEG analyzes an 8 x 8 block of pixels and applies the DCT to it, MPEG analyzes an 8 x 8 block of pixels from one frame to the next and applies the DCT to the *change* between the frames.

How about this newscaster [1], who moves only his lips? MPEG first stores a complete frame as an "I-frame," or keyframe.

But a great deal of the image—the shaded portion— is redundant. [2]

So the next frame doesn't need to store any of that information—it's already in the I-frame. MPEG will store only the changes in the small area. The frames in between, called "P-frames" (for "predictive"—which means they need information from the adjacent frame) and "B-frames" (for "bidirectional predictive"—which means they need information from frames both before and after a keyframe) have only partial information.

This is totally undesirable for your beautiful cartoon, the movements of which you have labored long and hard to deliver in stunning, sharp, computer-rendered quality. Apply it only at the end for release formats.

1

2

Compositing

This is the process of combining separate video sources into one image. It can range from the simplest techniques—a split screen, for example—to the most complicated 3D camera tracking moves. It may be as straightforward as adding an animated character with an alpha channel to a background or adding the background in several layers and creating a multiplane effect.

The Multiplane Camera

The multiplane camera was invented in the 1930s by Disney genius Ub Iwerks, and it was perfected on such features as *Pinocchio* and *Bambi*. Several layers of artwork could be made to move at different rates to create a greater illusion of depth. The other layers might also be put out of focus, to suggest the depth characteristics of an actual photographic lens in deep space.

Pictured here is a four-part multiplane setup.

1. Clouds
2. Mountains, which, being closer, will move faster than the clouds
3. A run cycle of a character—which will not pan but will move in place
4. Foreground elements consisting of shrubs and grasses, which will pan at the fastest rate

A multiplane setup lets us duplicate a parallax effect by moving the layers at different speeds—just as we might see if we were driving by this scene in a car.

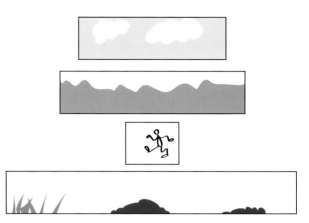

You need to run several layers of video simultaneously, as well as give each its own movement characteristics.

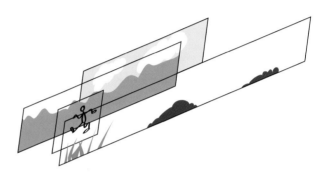

To create a "parallax" effect you need to run the different layers at different speeds.

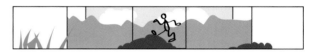

The layers all stacked together, as they would appear to the "camera".

COMPOSITING RESOURCES

These packages are the most popular and flexible ones for combining images:

▸ Adobe After Effects – www.adobe.com— The most popular option for Mac and Windows

▸ Autodesk Combustion – www.autodesk.com

▸ Nuke – www.thefoundry.co.uk— The former in-house compositing program at Digital Domain

▸ Jahshaka – jahshaka.org— Free, open-source video editor and compositor

Online forums are good sources of information about how specific products work and for user-written extras that might be useful.

In addition, many editing packages feature limited compositing capabilities. These include not only the high-end (Avid, Final Cut Pro) but the free software probably already on your computer (iMovie, Windows Movie Maker) and the open-source alternatives (Jahshaka, Cinelerra, Blender). Consult your user's manual for more details.

You can access these links directly from the Additional Content section of the accompanying DVD.

Zoom Effects

Let's say we want to move through the forest, past trees and shrubs, until we rest on the cottage home of the Annoying Elves of Fairyland. **[1]**

 We might use several layers, moving off to the side and out of the way of the camera at different speeds, using different amounts of blur to simulate depth of field. Instead of panning the artwork along the *X/Y* axis, however, you would follow the *z* axis to "zoom" in on artwork by increasing the size of the object you're approaching.

Make sure your resolution can handle it—vector art might be best for this technique. Also make sure to put a slight blur on layers that are close to the "camera" for extra depth cues.

Finished?

As soon as you finish a scene, be sure to place it in your animatic timeline. Watch your cartoon frequently—it's not only good to see how the project is turning out, but it's often very gratifying.

1

10 Editing

It's time to edit. But you've been editing long before this point, ever since pictures appeared on your animatic timeline. You've cut out things that were superfluous, changed the order of shots, and added elements necessary to make the cartoon work.

Even so, you may find your piece lacking. It may be rambling or incoherent in spots. How to fix it? There are a number of editing strategies that may help you whip your cartoon in shape—structures you can design around or ways you use your existing material.

Continuity Editing

Continuity editing is the art of telling a story through consecutive shots. Not all editing is continuity editing, as the next section will show. But much of editing is about connecting cause-and-effect relationships.

The continuity edit is meant to be invisible, so that cutting from one shot to the next isn't noticed by the audience. The eye and the brain are led from one important point to the next. Even if we know what our story is, and have timed it properly, we still have to edit the footage in such a way that it will work *smoothly*.

Continuity editing looks easy because we see it in films and TV all the time, yet it's actually very difficult to accomplish.

Match on Action

Suppose our cartoon includes a shot in which Dingy Duck is about to take one of those cartoon mallets and give Mangy Mouse a good smack on the noggin.

A lesser animator might do this:

1. Dingy Duck glances at the table and sees mallet.
2. Close-up, mallet: Dingy's hand reaches into the shot and grabs it.

This would be acceptable, but the timing is slow and doesn't really move things along. The editing creates a static quality by cutting to still frames without movement.

How else to handle it? Where to make that cut? You might think that you would match the hand position. [1]

1 The wrong way.

2 The right way.

This cut would create a stutter in the movement. The hand would seem to jump uncomfortably in the middle of the edit. This is bad, as it causes the audience to stop thinking about the fascinating adventures of Dingy Duck and start thinking about your incompetence as an animator.

The fix makes sense once you realize that the brain is actually quite good at predicting the future. We can read two shots cut together with less information than would seem necessary. Our fix is to cut the middle section out, like so:

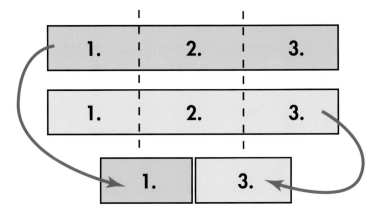

The brain registers the start of the movement and, knowing where the object should go based on how it has moved so far, anticipates the end of the move. When the cut is made, the brain expects the connection between hand and mallet and doesn't miss the middle frames. [2]

Eye Fix

Slavko Vorkapich, a Serbian filmmaker who worked in the 1930s and '40s, developed a technique he called "eye fix." You may have seen those old movie montages where a guy goes out for a night on the town. As he walks down the street, bright neon signs drift across the screen, dissolving from one to the next.

The "cocktails" sign comes down at an angle, drawing the eye to the lower left, where it's picked up by the "girlie" sign, which shifts from the lower left back up to the top left. Then the star sign comes in from the left, leading the eye all the way to the top right.

Vorkapich divided the screen into sections so that where one element leads your eyes the next should pick up. He used this principle to design beautiful film montages that still amaze. You, too, can create a chain of movements, shapes, or even areas of color from one shot to the next.

And in animation all graphic elements are under your control, so you can do as much or as little of this you would like.

"L" Cuts

Another technique used to make editing more transparent is the use of overlapping dialogue, or "L" cuts.

The amateur will edit by going to the person who is speaking for the duration of their dialogue. This sets up an awkward timing: "Cut. Line. Cut. Line. Cut. Line..."

Professional editors might cut away from a character in the middle of his speech to catch the reaction of another character. We might play entire lines off the wrong person, just so we can focus on someone's expressions as he listens. The dialogue might even trail into the next scene. It might begin before the previous line has ended. These variations set up rhythms of cutting that are much more sophisticated.

Because of the way these cuts look on the timeline, they sometimes resemble the shape of an L, hence the name.

Don't just overlap dialogue because you feel like it—use it to achieve a specific effect. In live action it's often used for technical reasons—the speaker looked funny, or the editor had to cut two takes together and used a cutaway shot to hide any discrepancies. You can use it to direct the viewer's attention to characters and reactions that are more important than what is being said.

Alternatives to Continuity Editing

Continuity editing establishes that events are taking place in real time in the same space. But the great thing about the moving image is that we're not limited by such trifles as this so-called time and space. We can cut as much as we like, and audiences will follow along. Alternative strategies are no less readable than continuity editing—in fact, many of them are familiar to you already.

Instead of having spatial relationships as the cornerstone of our editing, temporal relationships can be the basis. A flashback or a flash-forward is making use of malleable, flexible time to tell a story. You might expand the moment, drawing out the moment for emotional effect. You might also have an ellipsis of time—"cutting to the chase" as it were.

Jump Cut

A "jump cut" is a discontinuity in time. It happens when you remove the middle section from a single, live-action take.

When you play the results, it seems as though the subject has jumped slightly, yielding a purposely startling or disorienting effect.

Consider the overplayed "shopping montage" in films, where a character goes on a shopping spree and is seen trying on clothes in front of a mirror while bad songs from the 1980s play in the background. There is a jump cut with every new outfit.

Shooting in Separations

If you cut back and forth between two locations or two subjects that are separated by time and/or space, you can make whatever cuts you like. An audience will link the material, making thematic connections even if there aren't any on the surface.

The simplest example of this is the "glance-object" cut for which Hitchcock is so famous. The first shot is of a person looking, the second is of the object the person sees, regardless of how far away it is. This unifies both subject and object by drawing the connection between an action and the object of that action. No two shots must "match" each other; they only need to be interesting compositions and carry the audience along. This technique is called "shooting in separations."

Consider separations a technique, but don't rely on it. When done poorly, it can disorient the audience, giving them no clear idea of where they are or what's going on.

Rhythmic Editing

Editing can also be about rhythm, even if there's no music to suggest it. Sometimes an editor cuts a number of shots of exactly the same length—one second, for example—simply because it sets up a visual rhythm. This rhythm can come from the cutting or from movement within the shots.

Frustration of Continuity

Sometimes you break—or "frustrate"—all the rules simply because it works.

You might insert a shot because it comments on the action or characters. This is called a "non-diegetic insert." Let's say Dingy Duck is pleading with Mangy Mouse to give him an ice cream sundae that's fifty feet tall.

"No," says the petulant rodent, "We know what will happen if I let you have it."

Cut to Dingy Duck, lying comatose in his own vomit. Then cut back to the salivating duck, still pleading for the sundae.

It wasn't a flashback or flash-forward. It wasn't part of the story—it showed what Mangy Mouse *thinks* will happen. It is discontinuous but follows thematic elements established in the piece, so it works just fine.

Also along these lines is "false continuity editing." You can cut completely different sources of footage together so they seem to make sense. If you spliced a public domain educational film—like the ones found at www.archive.org —with your own cartoon footage, you could make it look as if your character was responding to the old film.

Titles and Credits

As an instructor, I often see students turn in "finished" work without titles or credits. Even if the filmmakers wish to remain safely anonymous, a complete project should have all the trimmings. At the other end of the spectrum are students who put in three minutes of credits thanking themselves fourteen times to the tune of that hip-hop song they love so much. At least those directors are thinking about the whole presentation and have respect for their own work.

When creating titles and credits, consider the "title-safe" area, even if you're designing for film. Make them an appropriate size. Any type below 12 points needs to be tested on a variety of machines for readability. Although your completed cartoon may play on computers, one of your main distribution channels will be DVD.

Whom Do I Credit?

Everyone who helped. "How do you credit them?" is a better question. Here's a general breakdown of production credits for animated films.

Executive producers are people who raise money for the project. They hire everyone else. They are the "bosses," but they may or may not exercise creative control.

Producers concern themselves with the day-to-day activities of the project. Although the executive has raised the money, the producer prepares a budget and oversees how that money is spent. **Associate producers, assistant producers**, and others are all mysteries. These people could be carrying the entire production on their shoulders, or they could be people who simply got the title included in their contracts.

The **director** decides all aesthetic and technical matters, often with a team of department heads working directly beneath him or her. On a TV series the director is hired to oversee individual episodes. The show's creator, who is often the head writer and usually credited as a producer, acts as a kind of über-director.

After that, people get credited for what they actually did—**animators, lead** (key) **animators, assistants** (inbetweeners), **background artists, editors, sound designers**, and so on. What used to be called "ink and paint" is still called that, even though there's no actual ink or paint being used.

Music credits usually follow this format:

(Song Title)	"My Love Is a Waffle Left in the Rain"
(Written by)	Written by Gug Fuddley and Duane "Tex" Mephistopheles
(Publisher)	Published by Hatful of Chipmunk Music
(Performed by)	Performed by Satan's Cheerleaders of Doom
(Courtesy of)	Courtesy of More on Music Corp.

Often at the end of a motion picture there's text that begins "Any resemblance to persons living or dead..." It's a legal disclaimer designed to protect against defamation of character lawsuits. You can add it if you like, and it may help, especially if your characters have names that are easily confused with real people.

Finally, a copyright notice is a good idea. For more information about copyright, see the appropriately numbered Chapter 13.

Sound Design

Sound is half of your presentation. In fact, a poorly made film with a great soundtrack beats a well-made film with a bad soundtrack.

It's estimated that 80 to 90 percent of a Hollywood feature is rerecorded from scratch. The original dialogue recorded on set is thrown away and the soundtrack is painstakingly recreated. This is how seriously the pros take sound. It will be less work for you, since you have already recorded good dialogue, but there's still much to do. The key to making your cartoon work for a twenty-first-century audience lies in how you use sound to create environments and drive dramatic and humorous situations.

Basics of Sound Design

My mentor, Tomlinson Holman, creator of THX, used to define "sound design" as "the right sound at the right place at the right time." This sounds like Zen nonsense until you consider it thoroughly.

A designer uses sound for specific reasons. The pros choose the exact *thing* they want to hear and find the exact *moment* in the film to play it—at the exact *sound level*. Just as a picture is designed meticulously, so is sound.

Your sound ideas should have begun in the story-board stage. You may even have a number of gags in your cartoon that rely on sound, but to design sound you must understand how it works.

Physical Properties

The same way visuals have physical properties—line, color, shape, and tone—sound has physical characteristics that we can measure.

Frequency is the pitch of the sound—high, low, or middle. An instrument will measure the frequency as the speed at which the sound-producing element is vibrating. The faster the vibrations, the higher the pitch of the sound. Thus a sound at 440 Hz is actually vibrating back and forth 440 times per second.

You can use sound frequency to organize sounds in a scene. Perhaps different locations have different pitches—from high crickets chirping outside, for example, to the low hum of an air conditioner. It's a good idea to keep pitch in mind

when designing sounds around dialogue—loud sounds in the same range may cover dialogue and make it impossible to understand.

Harmonics are sounds that are multiples of the fundamental frequency, and chords are made of harmonic frequencies. The fundamental frequency is the dominant pitch of a sound. If you listen to an air conditioner or a microwave, you can hum along with it and match the pitch of that machine. That is its fundamental frequency. You can add sounds to your track that have pleasant harmonic relationships—or you can design them to clash and create dissonances.

Distortion is actually a set of harmonics, as well, but instead of giving us the pleasing sound of a chord or a musical arrangement, distortion gives the original sound a harsher quality. As you know, this distortion can be used to good effect. Besides giving the impression of a sound that's too loud, it's been used in music for the last forty to fifty years as a characteristic of electric guitars.

Level is what sound designers call volume. Sound level is as much a technical quality as an aesthetic one. You need to control level so that you don't overload your equipment or your final medium—to avoid having unwanted distortion on your dialogue, for example. But you must also consider how loud certain sounds are in relation to each other so you can build moods and effects.

Panning is the direction of sound. Computers can handle stereo digital sound so well and at such clarity that a well-defined stereo mix is essential. This includes moving sounds from left channel to right channel or placing them within the stereo field. If you have a 5.1 channel system available to you, you can even place sounds in the surround speakers. There's more about this in Chapter 12.

Design Principles

There are non-quantifiable properties of sound that can also be organized. The following are some fairly artificial—but workable—strategies that might help your soundtrack. Each is described as a pair of opposites.

Think of your design as fitting somewhere on the continuum, neither one nor the other but leaning toward one side or the other.

Focus vs. Democratic

Film critic Andre Bazin wrote about what he called "democratic vision." For Bazin the best films are ones in which the director fills a frame with detail and characters, so that the audience gets to choose where they want to focus their attention.

The opposite style is one in which the filmmaker directs your attention specifically to the things he wants you to see. Hitchcock is known for this style, and it's very common in television, where the storytelling tends to be very linear, even simplified.

You can design sound in much the same way. The "democratic" approach is to fill the scene with many sounds and let the audience concentrate on what they'd like. A cocktail party, traffic jam, or a political rally might benefit from this kind of design.

The "focus" approach is to direct the audience's ear by playing exactly what you want them to hear, dropping the level of the other sounds. This single, dominant focus corresponds (or contrasts) with what the audience sees.

Objective vs. Subjective

When we say a sound is objective, we mean that it is literal, not figurative or metaphoric. What if you were to animate a scene of Dingy Duck racing off into the horizon dragging a dog, its jaws fastened to his tail?

You might cut in the sound of an F-14 fighter jet, to imply the speed of his exit. That would be subjective sound.

Cartoons regularly utilize outrageously wrong, subjective sounds that feel right. To what degree your sound is objective is up to you. Most presentations use a little of both and reserve the subjective effects for moments when subjectivity is to be heightened: the moment before a major triumph or a terrific gaffe.

Conversely you might play the whole cartoon subjectively but switch to cold objectivity at the moment when a character requires maximum clarity.

Contrast is a powerful tool.

Denotative vs. Connotative

Denotative is an academic term used to describe sounds that act as direct referents to the source objects. Sound designers would say, "See a dog, hear a dog." Denotative sound is almost always used to heighten your sense of realism in a scene and can be used with both subjective and objective approaches.

The sound of a tea kettle coming to a boil as a character gets more and more angry is denotative—a tea kettle does whistle, after all. But it is also subjective—the whistling is intensified to coincide with character's growing anger. Connotative sound relates to the emotions and sensations generated by certain sounds. The picture may show a character stalking the ruins of a bombed-out building, but the soundtrack may play a scratchy old radio, being tuned in and out. There's no radio on-screen, but the lonely, distant sound of the transmission may fit the mood and may even suggest the time or place for the scene.

Diegetic vs. Non-Diegetic

Diegesis is Greek, and it means the world of the story. Diegetic sound arises from the story and situations—for example, dialogue, explosions, and even Dingy Duck making a fighter jet sound as he runs with a dog attached to his posterior.

Non-diegetic refers to things not originating from the story. Non-diegetic sound comes from the filmmaker and is directed at the audience. Music is the best example.

Characters in your film do not hear the score—those sounds are for the people who are *watching* the cartoon.

Occasionally a sound designer will work in a switch from diegetic sound to non-diegetic. A common use is evident when a character puts on headphones and the tiny sound from his music player becomes a full-blown soundtrack.

Conventional vs. Experimental

There's a fine line between how sound can be used conventionally and how it can support a cliché—an overused stylistic image or scene. Conventions aren't always bad—sometimes they help you tell the story. The trick is to know when you're using a convention wisely, and when you're indulging in imitation or cliché.

Alternately, you may wish to use sound in completely experimental ways. You could abruptly start and stop music whenever you like, as the filmmaker Jean-Luc Godard does in his live-action films. You could play a soundtrack that contrasts the picture entirely. You could play sound backward or at the wrong speeds. You can digitally manipulate the sound so that it is unlistenable, or perhaps ambient and dreamy.

It's easy to experiment with digital equipment. Try the most unlikely sounds and see what happens. If the experiment fails, you can always go back to the conventions.

Selecting Sound Elements

Sound designers like to tell stories about how they made certain effects: twisting celery for broken necks, crumpling a reel of discarded recording tape for fire, or hitting a leather pouch filled with corn starch to make the sound of footsteps in the snow.

Selecting and creating sound effects is half the work—and half the the fun. Go through your edited version (formerly your animatic) and make a list of all the sounds you'll need. This is called "sound spotting," and it's the basis for your sound design. Work out the details on paper, and then go gather your elements.

Juxtaposition

Editing will place sounds next to each other and provide contrasts or affinities. How you place them is the next level of organization.

If you cut two elements together, that's sequential organization—the order in which you cut them and the timing between them is what creates specific effects.

You can also play elements simultaneously, so they are heard all at once. When Ben Burtt cut in lion roars and bear growls over explosions in the original *Star Wars* it was a revelation. The theory was that the viewer's subconscious somehow picked up on the organic, animal sounds in the explosions and caused a kind of visceral reaction.

You can juxtapose elements slowly over time. A cross-fade is a slow cut between elements in which you gradually change the quality of sound over long stretches of time. It might not even be noticed by the viewer. Soothing sounds might slowly change into louder, rhythmic ones, building a sense of tension. Sound works in a less conscious way than picture. It creates emotions, moods, and environments very effectively.

Sound Editing

Soundtracks are organized into major categories, then into further subdivisions. Sounds aren't just dropped randomly onto whatever tracks are handy.

Dialogue gets its own tracks, music gets its own, effects get their own, and sometimes they're divided further, into hard effects (where the sync must be perfect) and soft effects (where the sync can be less precise). You would never put dialogue onto a music track—you would make a new dialogue track.

Here's how most people organize tracks:

Dialogue

Voiceover or narration is usually kept separate from other dialogue. If there's production dialogue, these are called *X tracks*. A documentary-style show like Nick Park's *Creature Comforts* would have X tracks, recorded on location and edited together. The others are simply labeled Dialogue A, Dialogue B, etc. You can even name them by character, if that's easiest.

Effects

Also noted as FX, these are often grouped by whether they are loud or soft, foreground or background. Sometimes they are noted as AFX and BFX, in which case they might distinguish a long, continuous sound—the A track might be a car engine, for example—from specific onscreen actions—the sound of the windshield wipers.

Foley

Foley tracks are technically FX tracks, but they are made differently. Whereas the FX tracks are cut effects, and may originate in your recordings or library sounds, Foley is sound made specifically in sync with your picture. More on Foley later in this chapter.

Music

Sometimes abbreviated as MX, both diegetic and non-diegetic music is placed here. If the music has been manipulated to sound like a radio or speaker phone, it might go on a separate track.

Ambience

Note the spelling: This word is pronounced "AM-bee-ents", not "AHM-bee-AHNS". The latter is what you get in a nice restaurant.

Ambiences are often called "backgrounds," although that can be confusing for animators, since "background" really refers to the art placed behind the characters. Ambiences are the sounds you use to create environments and moods—distant rain, machinery, low rumble, children on the playground.

When the pros run out of room—and they sometimes do—they make a "premix" of similar tracks. You might go into your final mix with a dialogue premix, an effects premix, or even a music premix if the music tracks are complicated. Foley is very often premixed, as it might be recorded on a dozen or more separate tracks.

This is somewhat difficult for the beginner, as you have to consider how the balance of elements will sound in the final mix. A dialogue premix is sometimes useful, though, as it gives you the chance to make the dialogue of a similar level and consistency.

Dialogue

You've cut the dialogue well enough to animate to it, but now you must clean it up to produce the best possible sound mix. Be sure to listen closely, in your best environment. Headphones are OK as long as they're the closed-ear variety and not earbuds.

The pros usually break dialogue down by character and "checkerboard" the tracks. In live-action films this dialogue will be checker-boarded every time the editor uses a new take. In animation, it is sometimes done after every line. Now we'll see why we did it.

Even though you've probably worked hard to reduce noise in your recording, there may be some residual noise or, as some engineers call it, "air" sound. Sometimes this is hiss from the mic or recording technology. Sometimes it's just the natural background of air molecules striking the microphone. It's there when the mic is on, and it's obvious when it cuts out. When you hear the absolute silence in between segments of dialogue it draws attention to the poor quality of the mix. So it's important to fix this by editing the dialogue so there's no hiss or extra noise.

Strangely, this has nothing to do with actually removing the hiss or noise. You can try digital noise and hiss reducers, but for the most part they'll introduce digital artifacts such as ones you might hear in bad cell phone conversations.

You must cut the dialogue track so the audience is unaware of the problem. Listeners won't even hear the hiss if the track is consistent. Whereas the human sensory system is attracted to contrasts, it is very likely to skip over consistency. If you smooth out the dialogue so that it has a constant hiss instead of an intermittent one, the brain will stop "hearing" that hiss altogether.

Be careful, though. There's a persistent myth that filmmakers can just drop a big carpet of noise over all the dialogue tracks and mask out the imperfections. Yes, a loud enough hiss or ambience probably will drown out the cuts—along with half of your dialogue and all of the subtlety. It will fill your track with unnecessary noise, and when you hear your project on a good sound system, you'll be cringing.

To handle this problem correctly, you will *add* the ends and beginnings of takes until all the gaps have been filled.

The figure below shows a representation of an editing timeline, with the audio tracks checker-boarded. We put the audio from picture A on audio track 1, and the audio from picture B on track 2. We'll fix this edit after we understand a few basic concepts.

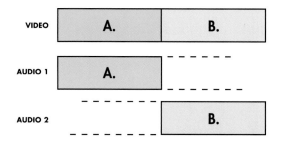

Sometimes there are two different sets of noise—one from each mic session. If you recorded all characters at once, you should have no problem matching the noise. But if you have takes from different sessions—especially recorded at different places—you may find that the noise doesn't match. The best way to hide these cuts relies on a process called *masking*, and sometimes by *backward masking*.

Backward masking had its heyday in the 1980s when fundamentalist preachers desperately tried to prove that rock albums tricked youngsters into a life of sin and depravity. But the term doesn't actually refer to backward messages that seduce listeners. Masking merely refers to using louder sounds to cover up smaller ones. When the loud sound comes slightly before the small sound, the brain doesn't even register the small sound, even though the equipment does.

This is a perceptual phenomenon, part of what we call "psychoacoustics" (the study of how the brain perceives sound). We can use it to hide our mistakes.

So what is backward masking? It's actually much weirder than devil messages. A loud sound that occurs just *after* a softer sound will also mask the softer sound. It's as if the loud sound goes back in time and erases the soft one that preceded it. So if you cannot mask a sound by regular masking, you can use backward masking to hide your edits.

Dialogue is full of "plosive" sounds—sounds like those of the letters *P* and *T* and *S*—hard and harsh enough that they can hide your cuts. Here's a diagram of an actor saying "my stars!" Not only do we note the sounds phonetically ("MA-E" instead of "MY"), but we mark the plosives.

121

The beginning of any line is usually loud enough to mask incoming or outgoing sounds, but the *M* sound is usually not enough to hide an edit. The hissing *S* and hard *T* definitely provide good points for edits.

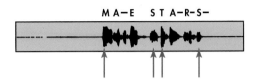

Now that you know what points make for a good masked edit, let's go back to the timeline.

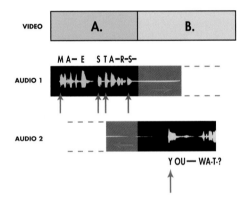

Possible editing points for dialogue masking are marked with red arrows.

Here's our checker-boarded audio, but this time with the line "my stars!" filled in as well as the line on audio track 2: "You... WHAT?"

Notice that the full audio take is shown grayed out. Notice that the top track, Audio 1, could be extended to the right, in the direction of the blue arrow. Likewise, Audio 2 could be extended to the left in the direction of the other blue arrow.

If we extend Audio 1 to the right until the red arrow at the beginning of the line "You...!" then the loud sound of the incoming "You" ought to mask the end of Audio 1. Likewise, the beginning of Audio 2 should be masked by the hard plosive of the *T* sound in "stars!"

Easy enough, but what if you want to mask an edit, yet there's not enough non-dialogue sound after the line to bridge the gap?

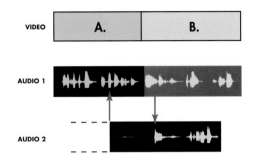

As you see, there's enough space on Audio 2 to extend it and mask the edit on a plosive from Audio 1. But Audio 1 does not have enough "silence" to extend to the plosive on Audio 2. You can see in the grayed-out area that there is another line there.

To fix that, we use sound from the beginning or end of the take and splice it in instead. As long as it's from the same mic placement and recording, it should work well.

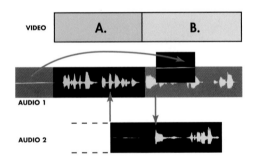

If there is a tiny pop or click at the edit line we can use a small cross-fade—only a few frames' worth at the most—to hide any discrepancies. Here the cross-fade is shown as an X figure, the way most audio software displays it.

Do not cross-fade dissimilar tracks. This will just make the difference between tracks even more noticeable as you draw out the transition from one to the next. It would be better to have pops and dead air than to make a fade that really emphasizes the issue.

Effects

There are a number of sound libraries published by reputable companies that can be used for cut effects, but these are all rather expensive. Some have rights associated with them, as well. If you have access to one of these, and you understand the licensing agreements, they are incredibly useful and can save you time recording nonspecific sound effects. Often you can even find these at the public library.

Do not under any circumstances use library sound effects that you downloaded from the Internet. They're likely to be low-quality versions someone put up at MP3 resolution or worse. The quality of your presentation will suffer, and when you finally hear your cartoon on good speakers in a proper venue, you'll be burning with shame to hear the hiss, noise, digital artifacts, and other misery that comes with these easily found but poor-quality recordings.

As an output format, MP3 is highly compressed, at a ratio of about 10:1. It's a clever scheme also built on psychoacoustic principles. The MP3 algorithm removes all frequencies that you probably don't hear anyway, because they're masked.

Just as you would never use JPEG or WMV for serious video work, you cannot use MP3 for serious audio work. The best way to get sound effects is to record them yourself. It's a whole lot easier than you think, and all you need is a pair of good over-the-ear headphones (not earbuds), a half-decent microphone (which can be bought for as little as $100), and a recorder. Remember, you can even use a digital video camera.

Foley and ADR

Unlike the effects tracks, Foley and ADR (automated dialogue replacement) must be done in sync with a completed, final edit of the picture. This is often called "picture lock," because the edit is considered a final version. In actuality, many people edit beyond picture lock, but it creates problems for all your sound tracks. Any edit you make in the picture track will create edits on every sound track you have placed on the timeline.

A sync recording requires you to play the picture material at the same time as you are recording any new lines

and/or sound effects. This can be done with easily available equipment. The first thing to do for ADR is to isolate each line you want rerecorded as a separate clip in your editing system. You need to be able to play this original line over and over about five hundred times, and your actor needs to hear it while he speaks his own lines. Most editing systems will let you set up a loop.

Improvise a "recording studio" the same as you did to record dialogue, only this time run the headphones from the editing system to your actor. Follow all precautions and preparations that you would for recording any sound, per Chapter 4, and use an external recorder (DV camera, DAT, a separate laptop that's *not* running the editing software, etc.)

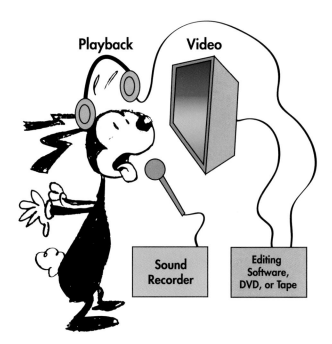

Finally, have your actor duplicate the exact performance he or she hears. You'll be surprised how fast it goes.

ADR may have to be edited just like other dialogue, and if you mix it with X tracks or previously recorded lines, be prepared to work extensively with those tracks to get a good mix. You may even consider a dialogue premix to sort it all out.

For Foley you'll do the same thing, only now your Foley walkers—so called because footsteps are among the most common effects—will have to see what's going on in the picture to be able to make sounds that sync with it. Foley is rarely dead-on. The pros will always get it right—that's why

they're professional Foley walkers—but most likely you will end up cutting and resyncing some Foley.

Foley works best for sounds like rustling clothes, handling of props, footsteps, paper rustling, door slams, fighting, and other close-miked and controlled sounds.

As you record, make sure you mic the Foley close up, which results in a good signal and a very "present" sound. Be careful not to mic it *too* close, as that can make the Foley seem fake. This is why it's important to listen with headphones while you record and while you watch the picture. It doesn't mean you record Foley at the level you want to hear it in the final mix. Always record at a strong level. The sound shouldn't distort, but it should occupy the middle section of the dynamic range, tending toward the top.

Music

Music is the most powerful element of a soundtrack because it tells us how we should feel. As a result, it is abused—especially in amateur filmmaking. The biggest mistake is to add only music to your work, without incorporating other sounds. Consider music an element of the total work but not the *only* element.

The pros use about thirty seconds of music before they add something else, like dialogue or action. They save the music for *exactly* the right moment, when they feel they can get the best emotional response. Music played by itself, without any other sound, has a kind of distancing effect. It pulls an audience out of the film—as if a glass wall exists between the audience and the characters. If you want to involve your audience more, you'll cut in ambiences, effects, and Foley—all of which ground an audience in the "reality" of your world.

Try this experiment. Take a sequence of any film and play different music to it. Try to change styles drastically and watch how the scene plays. Try the sound from another movie or TV show—even the radio. You'll notice some interesting things going on.

One is "magic sync," the phenomenon by which actions onscreen seem to work perfectly with the music. You've heard about that old stoner's game where you play the film *The Wizard of Oz* and Pink Floyd's album *Dark Side of the Moon* at the same time. The burnouts will tell you that it syncs up perfectly and claim that Floyd must have planned

it all along. Rubbish, of course—this is magic sync. The brain has an unparalleled ability to make sense out of random patterns, and material as evocative as these two sources is bound to create connections for some people. Music also suggests narrative connections you never planned. Lyrics seem to describe whoever is on-screen. When paired with music, the neutral expression on an actor's face seems to convey a variety of emotions: sad, happy, sneaky, gullible, hopeful, depressed, unlucky...

Ambience

Ambiences are the easiest to edit, the simplest to record, and some of the most effective sounds you can use. Since each is tied to a specific environment, you can blanket scenes with an ambience that provides a certain mood, as well as a distinctive sound. Ambiences make places seem more alive. The sound of each environment has an effect on how the audience reacts to the scene—is it distant and hollow?

Cozy and close?

Industrial?

Pastoral?

Stereo ambiences create a depth to the soundtrack that is immediately felt by the audience, whether they know it or not. The best way to record them is with two separate microphones, placed some distance apart. The wider the distance, the wider the perception of the space when the sound is played back.

Some people use a binaural setup for ambiences. When you record with a pair of small microphones set at the exact distance of human ears and play it back, the illusion of 3D stereo is remarkable. The pros use what is called a *Kunstkopf*, a mannequin head with specially designed ear canals and tiny microphones placed at optimum distance. There are binaural mics available that seem like earbud headphones but which actually deliver acceptable quality recordings.

Sound libraries often have good ambiences, but since they are so easy to make, and since you can really shape the sound of your film with specific ambiences of your own design, why not record your own?

If everything works, and you have picture and sound, it's time to put on the last bit of polish. You're still a few steps away from screening your cartoon for audiences, though.

Sound Mix

Although you've edited the sound, you still need to mix it. This can be expensive and time-consuming if you pay to have it done at a professional mixing facility. Don't turn over the reins to just anyone. You need to make *all* of the key aesthetic decisions, whether you are operating the controls or someone else is.

If you mix the sound yourself, you probably won't be working in a standard sound-mixing environment, and the computer you're using to edit may have those tiny little computer speakers. Those are a generally bad idea—great for beeps and MP3s, but not good to monitor your sound mix. If this is your situation, then listen and mix with good, over-the-ear headphones.

You might use a home theater system with your computer. Utilizing the right software, you can cut your project in 5.1 stereo, but while this is ambitious, it presents its own pitfalls. Your home has its own acoustics, so the mix you get in your living room may not be the same as what you hear in other venues. A mix stage is calibrated so that you can be relatively certain what you hear there is what you will hear on other calibrated systems. But since it's all variable—and dependant on things like make and model of speaker, size of room, and quality of components—you can never be sure.

If you can make test copies of the cartoon with the final mix and try them out on a variety of systems, you'll likely discover other things you can fix.

For now we'll concentrate on the simplest mix possible—a two-track stereo (left and right) mix that will work on 99 percent of computers, theatrical sound systems, and home theaters.

Mix Notes

One of the most useful tools you can employ during a sound mix is an equalizer. On a big mix stage this might be a physical device, but it's more likely that you'll use a plug-in for your audio software.

An equalizer can shape a sound by increasing or decreasing component frequencies. You can decrease low frequencies ("roll off the bass") to reduce tubby, boomy noises, for example. Reducing high frequencies can make a track sound less tinny or sharp. The best way to learn how to use equalizers is to apply them and listen to the tracks. You'll hear the differences immediately.

If your film has dialogue in it, then intelligibility will be of a primary concern. Frequencies centered on 4 kHz are called the "presence range" of dialogue. Increasing these frequencies even slightly can help with understanding, as can reducing the boomy frequencies under 100 Hz and in

the midrange of 250 Hz.

ADR and original dialogue tracks must also be mixed so that they fit in the environment you're showing on-screen. Are the characters outdoors, yet there's some echo to their voices? Generally outside sounds have very little bottom or high end. To make it sound natural, try eliminating all frequencies under 250 Hz and above 6 or 7 kHz.

But for inside voices, consider keeping those frequencies and adding some reverb, depending on the location. Obviously a cavern needs a long reverb, but even small indoor spaces can benefit from adding "early reflections"—the sound made by voices bouncing against a nearby wall.

These days digital reverbs can sound pretty good. Some make use of a function called "impulse response," which engineers have developed to recreate the reverb characteristics from specific locations. You can add an impulse response to your own voice and hear what you'd sound like if you were singing in the Royal Albert Hall.

One characteristic of a really awful mix is bad Foley. Amateurs will either forget to put Foley in at all or mix it so loudly that the sound overwhelms the image. Keep effects and Foley down so they seem to originate with the objects on screen, too. Of course, you can exaggerate them for comic effect, but make sure *you* are in control of the process.

Watch out for fatigue. Ears can get really tired, and you may start to think that something sounds great even if it's actually terrible. Take breaks, have others listen, and let the "final" mix sit overnight before listening again.

Stereo, 5.1, 7.1, and Others

The original stereo experiments were done in the 1930s, but it took almost forty years before stereo became common in motion pictures. Now stereo is everywhere, and 5.1 is the standard in movies and home systems.

The "5" in 5.1 stereo is for the left, center, right, left surround, and right surround channels. The surround speakers are the ones placed on the sides of the auditorium and in the back. The effect is that of being immersed in sound—it can come from front, left, right, or behind us. Furthermore, a sound effect that originates in the surrounds and moves toward the screen has a great effect, as if something from in the back of the theater and traveled to the front.

The ".1" in 5.1 refers to the subwoofer channel. The subwoofer is a specialized speaker for low-range frequencies. The frequency range of this channel is one-tenth that of a normal channel, hence the clever name 5.1. It actually takes six channels of audio, six outputs, and at least six speakers.

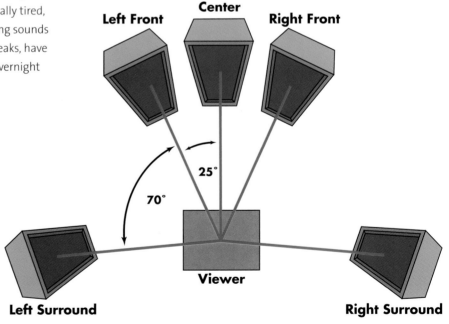

Proper speaker placement for a 5.1 monitoring environment.

Mixing with a subwoofer is very fun, since the low and subsonic frequencies can really pack a punch. Bass and drum tracks often have ultralow frequencies added to make them sound better on the subwoofers in dance clubs. Because the frequencies are so low, audiences tend to *feel* the vibrations more than they perceive the sound with their ears. Subwoofer adds a very physical sensation to the mix—it's why some jerks drive around with their car trunks filled with subwoofers, blaring their music. Fun for them, but it irritates the cat.

As of this writing, most people don't have access to 7.1 systems, but it is gaining popularity. It's essentially the same as 5.1, with the addition of a pair of speakers, left rear and right rear. Now the mixer can pan a sound all the way around the room, from any of seven locations. This requires eight channels of audio.

After the Mix

Often the final mix is output to what are called "stems"—partial audio tracks that are used to make release versions. For example, you may output what is called a DME, for dialogue, music, and effects. The M and E stems can be sent as they are to a foreign distributor, so there's only need to translate (or dub) the D stem.

Sometimes the 5.1 mix is matrixed into an LtRt (left total, right total) signal. Dolby Digital, also called AC3 Encoding, is exactly such a system—playable as a left-right stereo signal by non-5.1 equipment but easily decoded when 5.1 is available. Dolby is licensed for use in quite a few software packages, so it may be available to you. Some DVD authoring packages include it. Although it uses a compression scheme, it's considered the best sounding, and is used by the majority of big-budget Hollywood films in their prints and on DVD.

You'll match your sound mix to the finished picture, either in the editing software or perhaps in a DVD authoring program. These different mixes are called "print masters" in the industry, and they may include the following:

5.1 English digital stereo (for theatrical release)

2 channel LtRt (total) matrixed stereo master (for DVD)

5.1 M&E (out to foreign theaters for dubbing)

2 channel M&E (foreign TV)

Maybe some actual foreign-language versions: French, Spanish, etc.

Color Timing/Grading

In live action, cinematographers often work hard to ensure that vibrant colors and contrast ranges are present in the final print. This process of tuning up the color and establishing a look for the film is called color timing, or color grading. This may also be referred to as a digital grade, because the process has moved to the computer.

Just as you made a final sound mix to deliver a perfect soundtrack, you may want to color grade and deliver a perfect picture track.

Do you want to skew the colors of your film toward the sepia and golden tones? Should it be colder, and bluer? Did you want it to look like old, scratched-up film? Would everything look better if it were all desaturated?

Computer software can deliver any look you want with just a few clicks. It might take a while to apply that look to every frame, but many packages—free and otherwise—can control colors and contrast with great precision. Apple's *Color* software is probably the best consumer color-grading software available, but most editing software has filters you can use to control the look of your piece. Be sure to consult your manual to find out what your specific package can accomplish.

"Film Look"

Lots of directors want the old "film look" in their pictures. You can use digital tools to achieve this effect pretty easily. Color film from ye olden times was made with dyes that faded over the years, so old film usually has strong reds but fairly weak greens and blues. You can make a film look as if it's from years ago just by pinking it up. [1]

This can be accomplished by using a three-way color-correction filter. Many editing systems have them, such as Final Cut Pro, Avid, Premiere, After Effects, Sony Vegas, and Blender.

The center dots are controls for the hue, and sliders control the luminosity. The three circles control the dark tones, middle tones, and light tones of the scene. Moving the controls will show you immediately what effect you are getting, so practice and experiment.

Your picture is divided into blacks (shadows), midrange grays, and whites (or highlights). Each of these can be adjusted according to saturation and color, allowing you total control over the color balance in the shot. You can also control contrast of the image, sometimes called the gamma.

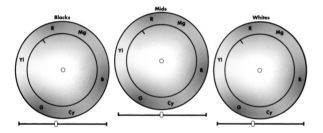

1

Why not add film grain? There are many grain filters out there, but film grain is essentially black-and-white noise that's multiplied onto the original image. You can use editing software to create your own. Start by making several (try ten or twelve) still images of picture noise. Most image editors have a "noise" plug-in. A Gaussian noise filter is great, if you have one available. Blur it slightly, put it on another video layer, and multiply it. Loop it. [2]

You could use an actual scan from an old, beat-up film leader. Try one of the leaders you find in the films at www.archive.org. Be careful not to use a section that has an obvious loop point, though.

Very old film has a slight flicker to it as well. If you change the gamma of your piece very slightly, from frame to frame, it can simulate crummy projection or a bad print. Add a little more blurring to finish the effect. Perhaps add "scratches" to the film. [3]

2

3

Picture noise. Most image editors have a plug-in to create this random spread of dots. The bottom has a slight blur to make the simulated film grain softer.

You can try a "bleach bypass" as well, which is a look that is used in many action films today. **[1]** It's characterized by a very high contrast range but muted, desaturated colors.

You can go for a sepia-tone look by desaturating and colorizing the footage to look brownish. **[2]**

Or you can even go for strict black and white if it suits you, although you probably should have thought of that when you were inking and painting! **[3]**

Final Film and Distribution Copies

The highest quality version of the picture with the highest quality sound will be considered your master. If you can make a single file—like a QuickTime movie at full size with no compression and full-range uncompressed sound—then you should archive it.

It might be good to burn it to a DVD—or several, if it's too large. Store it on more than one hard drive, just in case. You've worked too hard to lose your master, so make backups.

From this very-high-quality copy you will make the various distribution copies you will send to others.

Internet

This section includes a veritable alphabet soup of acronyms. If you understand basic Internet technology, you'll have no problem recognizing them. If not, please refer to the glossary at the back of this book.

For Internet distribution, you should probably output a 320 x 240 version from an SD file. This would be different for an HD image, probably around 485 x 270. Make sure it's a full-motion copy, meaning it has the full frame rate— don't skimp and output the piece at 15 fps or 10 fps thinking you'll save on the download. The resulting jittering file will only be a disappointment, even in the generally low-quality world of Internet video. Use a good-looking codec, probably some kind of MP4.

"MP4" is a shortened form of "MPEG-4." The specification consists of over a dozen parts, each describing an implementation of codecs and data types that govern practically every digital device known to mankind. As a result, not everything calling itself MP4 subscribes to all the parts of the MP4 standard. DiVX (commonly used for swapping movie files), XViD (the open-source version of DiVX), 3iVX (another version of DiVX), and the QuickTime 6 MP4 all subscribe to part 2 of the MP4 specification (regular video compression), while H.264, QuickTime 7, and Blu-ray subscribe to part 10 of the specification (advanced video compression.)

Microsoft's version of MP4 has rather tight DRM, or digital rights management, built in. Therefore, you should try not to use it. Besides the fact that it's a lesser implementation of the standard, supporting DRM is problematic, and your files may not be playable on certain devices.

MP4 is nowhere near as nice looking as a DVD, much less the full glory of your master source files. But since YouTube, MySpace, and other online distribution sites transcode your file into the unwieldy and problematic FLV (Flash for Video) format, you have to make a decision about balancing file size and picture quality. A good MP4 with H.264 compression seems to give those sites the best quality and size.

If you post your file to your own website, it's probably a good idea to make the link downloadable. You might try exporting a version that works especially with iPods or phones. You're posting the file to the Internet, so hopefully people will download it—you want them to grab it and share it with friends, to fuel your online popularity.

If you don't want to let the piece go out for free, then don't post it anywhere.

Tape

Most editing software has an option to go out to tape. This requires a video interface—like a camera. Any video-editing system that's designed to work with DV will connect to a camera through the FireWire port, so that DV tape copies can be made.

Tape-based systems are on the way out, and the newer equipment uses hard drives and flash cards to capture and store data. DV seems to be going to the wayside as HD formats become cheaper and cheaper. For now, your most likely distribution format will be the DVD.

DVD

Authoring a DVD is simple if you have the right software. The free applications available on home computing systems work extremely well. Windows XP doesn't come with a DVD creator built in, but solutions are fairly easy to find (see sidebar) and Vista has DVD Maker. There are a few open-source solutions for Windows that offer the same robust features and ease of use you can find in the commercial software, so these may be worth considering.

Picture Encoding

One of the weird things about DVD is that you encode the picture and sound separately, but then you must "mux" the two together—storing the data in some interleaved fashion. Undoing this process is called "demuxing."

The first step is to translate the picture part of the movie to an MPEG-2 file. MPEG-2 is what is called a "lossy" codec. A fair amount of the original data is lost in compres-sion, but the resulting images are close enough. MPEG-2 also uses intraframe compression, described in Chapter 9.

It's likely that any MPEG-2 encoder will have fairly complicated settings that allow the user to determine the spacing and order of the I-frames and B-frames as well as the level of quality. The best encoders let you apply the settings scene by scene to optimize each scene of your film. This is what the professional DVD authors do, but since you likely have a small film, and plenty of space on a DVD, you may as well use the highest quality settings and leave it at that.

A word of caution about SD DVDs: Though the DVD specification calls for bitrates up to 10 Mbps—megabits per second—this will probably choke most consumer players. Most experts will advise you to use an average rate of 7 Mbps or even lower for best results. Below 5 Mbps things start to get chunky, so you should probably keep it above that rate. Using a variable bit rate, or VBR, and a two-pass algorithm, which goes through the data twice to make sure the best bitrate is used per section, will result in better

DVD AUTHORING SOFTWARE

There are very few DVD authoring packages, either paid or free, that work with multiple platforms. You are more likely to find solutions that fit your particular brand of computer.

▸ Apple's iDVD (www.apple.com) comes installed on Macs. It is simple and effective for basic DVD projects.

▸ DVD Studio Pro is Apple's high-end tool for DVD authoring.

▸ Sonic Solutions (www.sonic.com) makes a variety of Windows-based DVD tools ranging from the high-end DVD Creator to the less complex MyDVD.

▸ Windows Vista (www.microsoft.com) has the built-in DVD Maker program that compares to simple tools like iDVD.

▸ Nero Easy Media Creator (www.nero.com), Ulead DVD MovieFactory (www.ulead.com), and Roxio Easy Media Creator (www.roxio.com) are all Windows-based tools that run at a median price, but each offer different capabilities and tools.

Free and open-source solutions sometimes lack features you may wish to use. They often do not support region coding or Macrovision, chiefly because of the license fees necessary to use those technologies.

▸ DVDStyler (www.dvdstyler.de) for Windows and Linux

▸ DVDFlick (www.dvdflick.net) for Windows

▸ CD Burner XP (cdburnerxp.se) for Windows

▸ Burn (burn-osx.sourceforge.net) for Macintosh

▸ Q-DVD Author (qdvdauthor. sourceforge.net) for Linux

In addition, these video tools may be useful to you:

▸ TMPGenc (www.tmpgenc.net) is a popular video encoder for Windows and Linux. It encodes AVI files to MPEG-2 for DVD at significantly higher quality than many authoring programs.

▸ ffmpeg (ffmpeg.mplayerhq.hu) and ffmpegX (homepage.mac.com/ major4) do much the same for Linux and Mac, respectively.

For all the DVD and video help you could ever want—including tutorials and explanations—visit www.video-help.com.

You can access these links directly from the Additional Content section of the accompanying DVD.

quality results, but it will take longer to encode. Be sure to consult your user manual for detailed information on how to set these values.

Blu-ray discs are a bit more problematic. The MPEG-2 files for Blu-ray are much larger than for standard-definition DVDs, but Blu-ray also has support for MP4 files encoded with the H.264 compression. Blu-ray authoring is, as of this writing, still iffy, with computer drives and software capable of burning a Blu-ray disc, but not all Blu-ray players supporting the disc that is burned. You may need to research this carefully before jumping in, as software and hardware change every day.

Sound Encoding

DVD sound may be a straight PCM file or compressed as an AC3 file. PCM, or "pulse code modulation," audio is an uncompressed stream of audio data, usually the same as a simple WAV or AIFF file right from your computer. PCM takes more room than Dolby's AC3, but it's not compressed. AC3, on the other hand, supports the LtRt format— which means you can encode Dolby 5.1 sound in two channels of audio. If you have a 5.1 mix, you pretty much need to use AC3.

If you have only two channels of audio, you may consider skipping the AC3 encoding and just putting straight PCM audio on the disc. For short pieces, this is optimal.

Whatever you do, do not mix PCM and AC3 tracks in a DVD. You might think you can use PCM for the feature but AC3 for the menus or for special features. These formats play at different levels, causing sudden and uncomfortable changes in the volume during playback. Choose one format and stick to it.

Making DVDs

Once you have your audio and video components, you can drop these into your DVD creation program and burn a disc. If you're sending out copies for festivals or as a presentation reel, make the disc self-launching, so that your cartoon starts immediately. You may want to design custom menus and other features, and you'll want to design your DVD menu to include your name and contact information. DVD authoring applications will export your finished project to a series of VOB (video object) files. These are burned onto a DVD-R using the UDF (Universal Disc Format).

DVD CONVERSION CHECKLIST

Your software will vary as to the particulars, but this is a short checklist of the procedures you'll need to go through to create a DVD.

▶ Begin with finished picture and sound.

▶ Encode your picture to MPEG-2. This can be done through a stand-alone encoder, although many authoring packages will accept your uncompressed video files and do the encoding for you when the DVD is compiled.

▶ If necessary, encode the audio file as an AC3.

▶ Create menus in your image-editing program. Think about adding sound to the menus.

▶ If you have special features, gather these together as well. All video clips must be encoded, and all soundtracks must be either PCM or AC3, depending on your design.

▶ Your DVD authoring software will allow you to connect the pieces. Think about whether the DVD starts with a menu or with the feature itself. Make sure that when the video clip is finished, the authoring program knows to connect back to the main menu. Most programs will let you test the DVD in software only, without burning an actual disc.

▶ When the DVD seems to be right, you must compile it. This is the step where all data is encoded to VOBs in a folder marked "VIDEO_TS." Your software may compile and burn all at once.

▶ The VIDEO_TS folder must be burned to a DVD using the UDF format. Some burners will call this "DVD Format" so it is even clearer.

▶ Check the finished burn on as many systems as you possibly can. Check for navigation as well as sound and picture quality. Try it on computers, too.

▶ Manufacture your disc—either by burning copies yourself or contacting a pressing plant.

Although your computer can read UDF perfectly well, it's a different file system than a computer normally uses. This file system was adopted by DVDs back in 1996 and is still standard. Blu-ray uses an upgraded form of the same filing system. This makes the DVD a little different than a standard computer data disc.

You can take your burned single-layer DVD (called a DVD5, even though it only contains 4.7 GB of data) to a manufacturer and have copies made from the DVD-R. Be sure to first ask your manufacturer if they accept DVD-R. Some places will want this data transferred to a tape drive, like an Exebyte or AIT. Alternately you can give the manufacturer a hard drive with a disc image of your DVD on it.

Consider purchasing an inexpensive laptop drive with only a few dozen gigabytes on it, just for that purpose.

DVD manufacturing is a complicated and crazy process—many things can go wrong. If you have an extremely long video program—maybe a whole collection of shorts from you and other animators—you may consider a dual-layer DVD, which has two DVD-5 layers stacked on top of one another. Dual-layer DVD (also called DVD-9, even though it holds 8.4 GB), while easy to author and easy to burn on computers, is difficult to manufacture.

If, for some reason, you want to make a dual-layer disc, consult the manufacturer very early on. You may need to have your data checked by a third party for consistency.

Exhibition

Online Venues

In the professional world, online entertainment is viewed as less respectable than other venues, largely because the Internet has no filtering process. Many people assume that online material—especially the free variety—is something of lesser value.

On the other hand, exhibiting shorts online allows a great number of people to see them—potentially millions of views for work that would only reach a few dozen if the films were distributed by traditional methods.

But on the other hand (our third one), uploading your animated shorts to online venues allows other people to profit from your work without you receiving a penny. These sites sell advertising, and the ads popping up around your cartoon are making money for someone else. And since your work is lumped in with all the other crappy cartoons—plus cats in microwaves, celebrities making fools of themselves, and other greats—you may not even stand out.

The point is that by waiting to be "discovered," you'll only grow older.

Anyone who is "looking for talent" is looking to *exploit* talent. They want to own your work, if possible, without giving you a fair share of what it returns. No one is interested in nurturing creative talent unless they can make money off of it.

But, as a wise man once said, "It is better to light a candle than curse the darkness." There are many smarter things you *can* do, and one of them is not to rely entirely on online venues. The advantages of posting a low-resolution copy somewhere on the Internet far outweigh the disadvantages. Try to pick one or two sites with the greatest possibility of exposure. Consider making your own website and posting links there as well.

There is no "best" place to post online, just as there is no worst. Explore these sites yourself and choose ones that seem to cater to the audience you want to attract.

Non-Online Venues

Film festivals charge around $25 to $40 for the privilege of accepting a DVD copy of your film, which shall never be returned. If the festival is any good, you stand a good chance of receiving nothing for your entry fee when you are not chosen. If the festival is lousy, then you may get in, but you may be in such dreadful company that no one cares.

Once again, the cynical reality must be embraced, but there are smart ways to handle it. Whereas many film festivals really are bogus, a number of them are legitimate. If your film plays at Cannes, for example, or Toronto, or the Venice film festivals, then you'll be receiving job offers so fast you cannot keep up with them. But it's notoriously hard to place in these—if they even have an appropriate category! You cannot blindly apply to every event or you'll run out of money.

You need a logical approach.

First type *film festivals* into a search engine. The site www.filmfestivals.com actually has extensive lists of all film festivals, including entry dates, prices, and links to the festival sites. From there it simply depends you.

Decide how much money you're willing and able to spend on festivals and enter some of the most prestigious

festivals on the chance that you'll get in. Shoot for the top, but hedge your bets by entering smaller ones in which you might place—making sure to avoid the *extremely* low-quality, cheesy festivals.

Give priority to festivals where films are being bought and sold. If yours places in the competition, it will be seen by people who are looking to spend money.

Screenings

Too few people organize screenings of their work. This can be as simple as having friends over for a viewing or as complicated as renting a hall for an evening. A screening party or DVD-release event will draw attention to your work—perhaps even press.

If you bring people out for an evening, then you must offer a whole evening's worth of entertainment. Consider building up some kind of program, either with more of your work or the work of other cartoonists you know.

If you charge admission, that admission may have to pay for the hall plus any incidental expenses you incur along the way. If you have to hire personnel—usher, ticket taker, security guard, caterer—you have to figure in those things, too. There may be permits or insurance costs. You probably won't sell out the house—you must be realistic. But a screening event may be a good place to sell the DVD or perhaps some T-shirts. A ticket price may not be necessary if you can recoup losses in other ways.

In short, expect to lose money on a screening. It's a difficult way to make money, and that may not be the point. They're great fun, and if you know of any "important" people you'd like to impress, invite them along.

Contracts and Negotiations

Let us say someone wants to do business with you. Your first reaction may be to get a lawyer. These cost money, and you can't really afford to hire one every time there's a simple contract negotiation. Unless you have a friend or relative who is in the legal profession, you're going to have to learn a few things yourself.

The first thing to realize with contracts, law, and business is that very little of it is actually regulated in any way. If there isn't a strict law against a particular practice, a contract can stipulate anything, and if you sign it, you've agreed to honor it. Likewise, people manage their way in and out of contracts all the time.

Ultimately, it's best not to sign a contract that's bad, rather than to sign it and expect to get out of it. More likely than not, the party who can break the contract is the one who has the most money and power, and this probably isn't you.

If someone wants to buy your work, a buyer will contact you. Their legal department will make up a ridiculous contract asking for everything and giving you as little as possible. It's up to you to read the document thoroughly and to strike out anything you don't like about it, rewrite sections you feel need to be rewritten, and send it back. They will do the same, and it will go back and forth until you've negotiated what's fair for both parties.

The other party may become irritated with you for prolonging the process. They may even cancel the deal. This is a good sign that you have avoided something potentially harmful.

This is not about gamesmanship. Don't ask for changes just to see if you can get away with it. That's just being a jerk. Ask about things that confuse you or that don't gibe with what you know about similar deals. If people think you are being difficult, they won't want to deal with you. Remember that even though it's "just business," personality still figures into it.

Copyright

Since 1976, copyright need only be claimed by the creator to be in effect. You don't need to fill out any forms or send anything to the government. Of course you can file with the U.S. Copyright Office, but it's not necessary. The practice of sending yourself a copy of your work through the mail and keeping it unopened with a postmark as proof of ownership is also unnecessary—and probably wouldn't be admissible in any legal proceeding.

Put a copyright notice on all materials you want to copyright. Don't get crazy and overprotective of your work.

Although you can claim copyright, you would have to defend it if anyone challenges it.

Let's say you make a fabulous new Dingy Duck cartoon from one of the scenarios in this book. But wait! I, the author, have a copyright on that Dingy Duck story! I've trademarked the character, too! What happens next? First I send out a threatening letter—just a note, on company stationery, saying in the strongest words possible that you should stop. I won't mince words. I write "stop using Dingy at once, and remove all materials from your website or immediate legal action will begin!" This isn't a legal notice, it is a threat, and you are free to comply—or not—as you see fit.

Next, I pay some lawyers to send a "cease and desist" letter, or C&D. This is a very specific legal document asking you to cut it out. It's still not against the law to ignore a C&D, because no crime has been proven. I *suspect* you have broken the law, but you could maintain that you have not. We're still fighting about it privately.

If you ignore the C&D, I may sue you. I pay to file the suit and to serve you papers.

A judge may consider the suit, and then we both pay lawyers to file briefs, attend hearings, make court dates, file affidavits, take depositions, etc. etc. etc. Before long, I've spent thousands of dollars of my own money, and there's still no proof that a law has been broken, no punishment, and no end in sight.

The judge will ask us to settle out of court. You will be asked to pay me something for your use of Dingy Duck. I'll be asked to accept what you offer. You'll be asked to sign papers promising you won't do it again.

If you refuse to settle, we go to trial. We turn in all the evidence and the judge makes the decision. If you're proven wrong, you have to pay me what I'm asking, *and* you get to pay all my fees for the trial. You didn't think I was going to lose in this example, did you?

The key points here are these:

- The authorities only step in at the last moment, when all other resources have been exhausted.
- You should always claim copyright, but never be surprised when you are ripped off.

137

Rights

Once you own the copyright to your work, you can grant rights to someone else to use it. What kinds of rights you grant and how you grant them is entirely up to you, but there are key things to watch.

Exclusive rights are granted when you only want one grantee to benefit. If I grant you exclusive rights to the new Dingy Duck cartoon, then I cannot let Disney or Nickelodeon show it—until your contract runs out. The amount of time you get exclusivity is called the *term of the rights granted*, and it should be specified in the contract. *Nonexclusive* rights are granted to as many grantees as you wish. They are all aware that they have nonexclusive rights. No one thinks they are the only ones who can exploit the property. All parties *must* be aware, or you could be liable for fraud.

Rights can also be split up. One party may have the rights to host it on the Internet, another can show it in movie theaters, and a third party can have TV rights. Home video rights may go to another party altogether. Each of these can be exclusive or nonexclusive, although most often you will grant companies exclusive rights for set periods of time.

What is the right term? Well, this depends. No one gives rights for less than a year, but one year is not enough time for anyone to make any money. Three-to-five-year terms are very common. You will also see the phrase "in perpetuity" in contracts. This means "forever and ever, world without end, amen." You must think very carefully about signing away rights for anything in perpetuity. It is essentially the same as selling it to someone outright.

You may also see the phrase "in this universe and any other," or "on these technologies and any yet to be invented." Or perhaps "in perpetuity and assignable to the parent company or any of its subsidiaries." These phrases, laughable as they seem, are no laughing matter if you agree to them. You are signing away rights to things that have not been invented yet. What if you had signed away these rights before they invented DVDs? You would be crying in your milk right now, and you could do nothing about it.

Remuneration— Getting Paid

So what do you get paid for your work? This is, once again, entirely up to you.

Single-time broadcast rights usually come for a cash price. With cartoon shorts, that's usually a pretty modest sum—it won't buy a house. Multiple broadcast rights should be more expensive—if they want to show it multiple times then this means they are going to sell advertising several times for your programming.

The rights for video usually involve royalties, although there may be a fee as well. A royalty is a percentage of the money your work will make. Some royalties are based on net profits—they kick in when the manufacturer has recouped its costs. So if Smegtron Video has invested $3,000 making a DVD of your work, they would start giving you your percentage on each unit sold after they have made back the initial $3,000 it took to make the discs. This can get tricky if the company folds their advertising revenue or the cost of making more discs into the

costs of the production. Your royalties won't start until they've paid off those expenses.

Other royalties are paid from gross sales, which means that no matter what the company spends in manufacturing or advertising, you receive a royalty based on the number of units sold.

In either case, you and the company negotiate the royalty rate, either in terms of an absolute value—so many pennies on the unit—or a percentage of the suggested retail price.

A DVD costs about $1 to make, with printing, if you go to an expensive pressing plant. A video distributor sells these to outlet stores at wholesale prices—usually about half the suggested retail price. So when you pay $19.99 for a DVD at Smell-Mart, Smegtron makes $8.99 (that's $9.99 minus the dollar it took to manufacture the disc) and the retailer makes $10 profit. If Smegtron has to pay you, let's say, a 5 percent royalty, then the total profit for you is 45 cents. For Smegtron: $8.54. For Smell-Mart: $10. The consumer paid the taxes at the checkout.

Your portion seems insignificant, but you didn't put up the investment to make DVDs, and you didn't stock them in your warehouse, or your stores, and you didn't advertise. You bore the creative costs, but on the business side, you took no risks. And the people who risked most get paid the most.

But if you had put a lot of your own money into making the cartoon, you've recouped very little of that on 45 cents per unit.

Your Own Business

You might do your own manufacturing and sales. You may start by burning individual copies of your cartoon and selling them from your website. At some point, if your DVD becomes popular, you may consider going from a one-at-a-time production to a professional, manufactured DVD.

There are DVD pressing plants all over the world, and most of them have competitive prices. Generally the minimum run is still a thousand copies, and the price is a little over $1 per unit plus tax and shipping. To avoid shipping costs, you should pick them up yourself if you live nearby—DVDs aren't heavy, but they do take up space if they're already packed in cases.

Be ready to tie up your money for a while—breaking into the DVD market isn't as easy as calling up Smell-Mart. Most retail chain outlets won't even return a phone call unless you're either a known distributor or you have an extensive catalog—at least five titles.

Good Luck!

If you've gotten this far, then you're well on the way to becoming a professional animator, and all from your home computer.

Hopefully this overview has been helpful in getting you to make your own cartoons. Feel free to take what you can from this book, and with patience, skill, and some luck, you'll be animating like the professionals.

Good luck to you and your projects. I, for one, look forward to seeing them.

OK, some of them.

Appendices

Appendix A:
Screenplay Format

Margins for Standard Screenplay Format

Page

Top	1"
Bottom	1"
Left	0"
Right	0"
Header	0.5"
Footer	0.5"

Slugline and Action Heading

Left	1.25"
Right	1.25"

Character Names

Left	3.25
Right	1.25

Dialogue

Left	2.25
Right	2.25

Title – Centered

Continued – 6.5" indented

Screenplays are single-spaced. A typewriter font, like Courier, is used. They are written in present tense, as if the action is occurring the moment it is being read. Screenplays are designed so that one page of script is roughly equivalent to one minute of screen time.

It is considered naïve to include the WGA registration number or a copyright on your cover page.

In addition, you will wish to observe the following:

Do not write for the camera

e.g., "The Camera swoops down to reveal the ruined Baroness."
e.g., "Tracking Shot through the broken glass!"

Do not refer to other, better movies

e.g., "It is just like that rad camera move in THE TERMINATOR."
e.g., "He looks like Humphrey Bogart did in THE MALTESE FALCON."

Do not write something impossible to convey

e.g., "He gives him a look that says 'I know you'd like to be with my girl, but she doesn't go for short guys.'"
e.g., " BOB is mad, but he's thinking about Uncle Harry."

Example Page from a Screenplay

INT. CENTER OF THE EARTH - LATER

Satan sits on a throne in the Lake of Fire, surrounded by obsequious toadies and minions.

 TOADIES
 Oh, Satan! We love you!

 SATAN
 Oh, really? How much do you love me?

 TOADIES
 A lot!

 SATAN
 Just a lot?

 TOADIES
 A VERY lot!

Satan smiles, his realistic vinyl-like skin crackling like a bowl of breakfast cereal. He chuckles, each spasm of his diaphragm sending up enough flame from his lungs to sear his nostril hairs.

 SATAN
 Good. I like it when you fawn on me.

 TOADIES
 O Father of Lies! O Evil One! O Most
 Fiery Lord of Infernal Darkness! O
 Wicked, Horned Goat! O Naughty,
 Naughty One!

 SATAN
 Hold it. What's this "naughty one"
 business? That's not one of my sacred
 names.

A particularly servile toadie, ROBERT, comes forward, bowing and scraping. He kowtows to the might of the Devil.

Appendix B:
Video Compression Chart

Standard-Definition Video

Name	Horiz.	Vert.	Aspect	Pixel
NTSC	640	480	4:3	square
NTSC DV	720	480	4:3	.9
NTSC D1	720	486	4:3	.9
NTSC D1	720	486	16:9	1.2
NTSC D1 (MPEG-2 DVD)	720	540	4:3	square
NTSC D1 (MPEG-2 DVD Wide)	864	486	16:9	square

High-Definition Video

Name	Horiz.	Vert.	Aspect	Pixel
HDTV 720p	720	1280	16:9	square
HDV 1080p	1080	1440	16:9	1.33
DVCPro 720p	960	720	16:9	1.33
DVCPro 1080p	1280	1080	16:9	1.5
HDTV (True)	1920	1080	16:9	square

Appendix C:
Animation Resources

For more information about the art and technique of classical animation, consult the masters. Even if you are a 3DCG animator, you will want to read these books and apply the old knowledge to your new work.

Blair, Preston, *Cartoon Animation,*
Laguna Hills, CA: Walter Foster, 1994.

Goldberg, Eric, *Character Animation Crash Course,*
Los Angeles, CA: Silman-James, 2008

Johnston, Ollie, and Thomas, Frank, *Illusion of Life*,
New York: Hyperion, 1981.

Laybourne, Kit, *The Animation Book*,
New York: Crown Publishers, 1979.

Lutz, E.G., *Animated Cartoons*,
New York: Charles Scribner's Sons, 1920.

Muybridge, Eadweard, *The Human Figure in Motion*,
New York: Dover, 1955.

Muybridge, Eadweard, *Animals in Motion*,
New York, Dover, 1957.

White, Tony, *The Animator's Workbook*,
New York, Watson-Guptill, 1986.

Whitaker, Harold and Halas, John, *Timing for Animation*, St. Louis, MO: Focal Press, 1981.

Williams, Richard, *The Animator's Survival Kit*,
London, New York: Faber & Faber, 2001.

In addition, these books will help you draw better.

Bridgman, George, *Bridgman's Life Drawing*,
New York: Sterling, 1961

Hamm, Jack, *Cartooning the Head and Figure*,
New York: Perigee, 1967

Hamm, Jack, *How to Draw Animals*,
New York: Perigee, 1969

And finally, there are some online sources you might consult for information.

Animation Meat –
www.animationmeat.com

ASIFA-Hollywood Animation Archive –
www.animationarchive.org

John Kricfalusi's Site –
johnkstuff.blogspot.com

These resources are also available in the accompanying DVD's Additional Content section.

Appendix D: Featured Artists

When the author's own scrawls have been inadequate, he has been fortunate to call upon the talents of the following featured artists.

Walt Holcombe

An enigmatic figure, Walt Holcombe is the award-winning cartoonist and author of *The King of Persia* and his latest collection *Things Just Get Away from You*.

Cecilia Hae-Jin Lee

Amongst Cecilia Hae-Jin Lee's talents are writing (she has authored cookbooks and travel guides), cooking (see previous), and photography. See more of her photos at www.littlececilia.com.

Guy Maddin

Guy Maddin is the director of *The Saddest Music in the World*, *My Winnipeg*, and *The Heart of the World*. These are all what you might call "art" films, and are well worth seeing.

Eileen O'Meara

It is undoubtedly because of Eileen O'Meara that I ever took up the practice of animation at all. Her films *That Strange Person* and *Agnes Escapes from the Nursing Home* are prime examples of unfettered imagination.

John Over

Animation producer and director John Over has won Emmy's, BAFTAs, and other awards no one can even remember for his work. www.overlandproductions.net.

Jim Woodring

Jim Woodring threw off the shackles of production animation to become a fine artist and illustrator, albeit one who still draws comics when he sees fit to do so. Marvel at his works at www.jimwoodring.com.

Links to these artists are also available in the accompanying DVD's Additional Content section.

Acknowledgments

Thanks go to Walt Holcombe, who wrote the first pamphlet version of this book with me. Thanks, appreciation, and admiration go to my generous collaborators—all listed in Appendix D.

Thanks also to the book designer, Renata Dmytrowski at RD Design and to the team at Watson-Guptill, including Candace Raney, Brian Phair, Jess Morphew, and Dominika Dmytrowski.

But most of all, thanks go to Hae-Jin, who endures so much from me. Everyone should find someone as encouraging, rational, and inspiring to keep them in line.

Glossary

The 180° Rule – A principle of staging meant to clarify the position of characters in space. Briefly, the "camera" should stay to one side of an imaginary line drawn between characters.

2K – Designation for an image size of 2048 pixels on the horizontal. Half of cinema resolution.

3:2 process – Conversion of 24-frame media to 60-field media requires printing an uneven number of frames to fields. This configuration alternates three fields of one film frame with two fields of the next.

4K – Designation for an image size of 4096 pixels on the horizontal. Cinema resolution.

Action safe – A portion of the video frame in which important action is normally staged. Outside the action safe area material may not be seen on all equipment. A characteristic of NTSC Standard Definition video.

ADR – Automated dialogue replacement. An actor duplicates his performance in a studio so that badly recorded dialogue can be replaced by clean recordings.

Aspect ratio – The size of a frame expressed as a comparison between horizontal and vertical measurements. A 4:3 aspect ratio is a frame 4 units wide by 3 units high.

Axis of Action – An invisible line drawn between characters. Used to determine the 180° Rule.

Bézier curves – Lines determined by a set of control points (at least two) that determine the angle of curvature. Used in most design software.

Bit depth – The number of computer bits used to determine a property. The bit depth of a picture would affect the resolution (and the color capacity) of the image. In sound, it determines the resolution (and therefore the quality) of the recording.

Blocking – Staging the movement of actors before the camera.

Blu-ray – DVD technology for high definition video. A blue laser (instead of the red laser used in standard DVD players) allows more data to be stored and read from a disc.

Breakdown – Complex scenes in animated movies must be "broken down" into smaller actions.

Checker-boarding – Dialogue is often arranged in an alternating fashion on two tracks. This resembles a checkerboard. It is done to facilitate dialogue editing.

Chroma subsampling – Many digital picture and video schema store less color information in order to keep file size down. JPEG and DV both sample color at a rate far lower than the luminance.

Cineon – The Kodak Company's proprietary format for storing 10-bit logarithmic color images. Designed to imitate the contrast and response of motion picture film.

CMYK – Cyan, magenta, yellow, and black. The colorspace used by printers. The "K" stands for "Karbon" and comes from German.

Cone of vision – The field of view around the point on which the eye is focusing.

dB, decibel, dBFS – A decibel is a measure of one quantity of sound over another. Decibels must have a reference quantity in order to make sense. By default this quantity is "dB SPL," or the sound pressure level of the

atmosphere. Digital sound is measured in dBFS, or "full scale," which refers to the maximum capacity of the digital media.

Discrete cosign transform function (DCT) – An algorithm by which a matrix of numbers can be "collapsed" into a much smaller series. Used by compression methods to reduce data size.

Distortion – In sound, non-melodic harmonics, usually caused by overloading equipment with sound energy, can cause a harsh, grating component to the sound.

DiVX – A video compression method used to reduce the file size of movies sent over the Internet. Almost exclusively used for home viewing.

DPI/PPI – The "dots-per-inch" or pixels-per-inch" of a computer image is the measurement of resolution.

Entropy encoding – Complicated math used in some forms of compression. A "lossless" data scheme by which symbols are assigned to data according to probability. Entropy encoding is a key component of MPEG.

Eyeline, eyeline match – An eyeline is an invisible line extending from the eyes of a character to the object of his glance. Effective composition and editing coordinates these eyelines so that characters appear to be talking to one another if they are not sharing the same frame.

FOSS – Free and open-source software. Open-source software projects are written with a general license that allows anyone to use, distribute, and modify the source code. Open-source

projects benefit from rapid development because many users attack problems with multiple solutions instead of one, monolithic development process.

Frequency – The number of times per second that an object oscillates to produce sound. Frequency is measured in Hz, or cycles per second.

Fundamental frequency – Complex sounds usually have a dominant frequency that characterizes them. Though other harmonic frequencies may be present, one "pitch" will define the sound.

Golden Mean/Golden Section – A division of a rectangle used in classical western composition. The Golden Section is achieved when the ratio of the entire rectangle to the large section is the same as the ratio of the large section to the smaller.

H.264 – A compression scheme used in part 10 of the MP4 specification. Used in some Blu-ray discs.

Harmonics – Multiples of the fundamental frequency. A chord is constructed of a fundamental and harmonics.

HDTV – High-definition television differs from standard-definition television in that it has a higher resolution (1920 pixels by 1080 pixels), a 16 x 9 aspect ration, and progressive frames.

Headroom (picture) – Compositions are generally more pleasing when a character is given some space above the head—the edge of the frame does not touch the top of the character.

Headroom (sound) – The amount of dynamic range from the reference level (the "0" on a VU meter) to the level of distortion.

Interlaced – Standard-definition video is transmitted at 60 fields a second. Each field is half of a frame of video, split up by scan lines. The A field consists of line 2,4,6,8, etc. The B field is comprised of the odd numbers, 1,3,5,7, 9, etc. Because these fields alternate scan lines, and because they combine to form one frame, they are said to be interlaced with each other.

Interframe compression – Compression applied to video frames in succession. The change from one frame to the next is quantified and compressed.

Intraframe compression – Compression applied to each frame of a video file.

Layout – A detailed but unfinished drawing of the background of each scene. In traditional animation, registration marks or character sketches would be included to help the animator determine sizes.

Level (sound) – The amount of sound energy. Sometimes erroneously called the "volume" of sound.

Look space – The space in front of a character into which he is looking.

Luminance quantizing – A digital compression method used by the JPEG specification whereby the upper values of brightness are all compressed into one single value.

Limited animation – A method of producing animation with as little artwork as possible yet still retain many characteristics of motion. Used in television cartoons primarily.

MP4 – MPEG-4 is a complex video compression standard that includes several "parts" that determine how data is compressed and stored. There are a number of "flavors" of MP4, including H.264, DiVX, XViD, and others.

NTSC – National Television Standards Committee. Also used to designate the standard-definition video specification used in North America and Japan.

Pan (picture) – A pan in live-action cinematography is a camera move in which the camera stays in one position but pivots around a common center. In animation, "pan" is sometimes used to describe an element moving along the x or horizontal axis. The analogous camera move in live-action cinematography is actually the tracking shot.

Pan (sound) – Directing a sound to one speaker or another in a multi-channel system creates the illusion of the sound coming from different parts of the room. Assigning that sound to any given speaker is called "panning."

Parallax – The appearance of displacement from two different lines of sight. The parallax effect is most notable while riding in a train or car and seeing the landscape pass by. Objects close to the vehicle appear to pass before the viewer much faster than objects that are distant.

Plan Americain – The "American Shot" is a pejorative term for compositions that cut off subjects at the knees.

Progressive – As opposed to interlaced frames, progressive frames store the information from scan lines in strict numerical order.

Pulldown – When transferring 24-frame media to 29.97-frame media, the 24-frame picture is slowed down so that 24 frames equal 30 frames in 1.1 second's worth of time. This slight decrease in speed is called "pulldown."

Quantizing – A continuous range of values is approximated by a limited number of symbols. Thus the values 42, 43, 45, and 41 might be quantized each to equal 40.

Rasterize – Converting from vector (resolution independent) information to pixel (fixed resolution) information.

RGB – The three primary colors of light. Used to denote the color space composed of red, green, and blue signals.

Sampling (sound) – A process of taking measurements of sound energy at specified intervals. These measurements, when played back, should reproduce a close approximation of the original sound.

SD – Standard-definition television is characterized by a 4:3 aspect ratio, a resolution of 640 pixels by 480 pixels, and a frame rate of 29.97 frames of interlaced video.

Sprue – A sprue is an extra piece of material attached to the original model so that a mold made from that model will have a channel for the casting material to pass through to the inner chamber.

Staging – How you place characters, props, and backgrounds in the frame. Includes planning camera movements.

Tangents – In order to define volume and shape, an animation drawing must "read" as a series of overlapping shapes. When lines from one shape touch another outline, form and volume are confused, and the drawing reads more flat.

Telecine – The process of transferring film to video. Telecine to NTSC involves not only the 3:2 process but pulldown.

Time code – Unique number identifiers given to each frame of video. The numbers are invisible. SMPTE Time code addresses these frame rates: 23.98 (film telecine pulldown rate), 24, 25 (PAL TV rate), 29.97 (NTSC color rate), and 30.

Timeline (editing) – a graphic representation of the order of video and audio clips, organized as a strip running from left to right. Most editing software has a timeline, upon which you can drag and arrange pictures, video, and sound. This is in contrast to the X-sheet, which is organized like a timeline, only turned 90˚ clockwise.

Title safe – Area of the frame that is far enough from the edges to display type without cutting off, distorting, or simply not displaying.

Tracking shot – In live-action cinematography, a shot in which the camera moves, usually along a track or rail. In animation a simulated tracking shot is often erroneously called a "pan."

UDF – Universal Disc Format. A file system used by the DVD and Blu-ray specifications.

VOB – Video object files. The format for video information on a DVD.

Index